Music of the Renaissance

The publisher and the University of California Press Foundation gratefully acknowledge the generous support of the Sonia H. Evers Endowment Fund in Renaissance Studies.

The translation of this work was funded by Geisteswissenschaften International—Translation Funding for Work in the Humanities and Social Sciences from Germany, a joint initiative of the Fritz Thyssen Foundation, the German Federal Foreign Office, the collecting society VG WORT, and the Börsenverein des Deutschen Buchhandels (German Publishers & Booksellers Association).

Music of the Renaissance

IMAGINATION AND REALITY OF
A CULTURAL PRACTICE

Laurenz Lütteken

Translated by James Steichen
With a Foreword by Christopher Reynolds

UNIVERSITY OF CALIFORNIA PRESS

University of California Press, one of the most distinguished university presses in the United States, enriches lives around the world by advancing scholarship in the humanities, social sciences, and natural sciences. Its activities are supported by the UC Press Foundation and by philanthropic contributions from individuals and institutions. For more information, visit www.ucpress.edu.

University of California Press
Oakland, California

Library of Congress Cataloging-in-Publication Data

Names: Lütteken, Laurenz, author. | Steichen, James, translator. | Reynolds, Christopher A., writer of foreword.
Title: Music of the Renaissance : imagination and reality of a cultural practice / Laurenz Lèutteken ; translated by James Steichen ; with a foreword by Christopher Reynolds.
Other titles: Musik der renaissance. English
Description: Oakland, California : University of California Press, [2019] | Includes bibliographical references and index. |
Identifiers: LCCN 2018019168 (print) | LCCN 2018021833 (ebook) | ISBN 9780520970069 (ebook) | ISBN 9780520297906 (cloth : alk. paper)
Subjects: LCSH: Music—15th century—History and criticism. | Music—16th century—History and criticism. | Arts, Renaissance.
Classification: LCC ML172 (ebook) | LCC ML172 .L8713 (print) | DDC 780.9/031—dc23
LC record available at https://lccn.loc.gov/2018019168

Manufactured in the United States of America

28 27 26 25 24 23 22 21 20 19
10 9 8 7 6 5 4 3 2 1

To the memory of Klaus Hortschansky

CONTENTS

FOREWORD

Titles matter. They have long struck me as having something in common with genre in the expectations that they can engender. They make a declaration of a book's subject, of course, but often they also reveal something of the author's approach. And when authors choose a title that quotes or plays on the titles of earlier books, they declare something more as well: a sense of tradition, intellectual affinity, and possibly, scholarly aspirations. Jacob Burckhardt's epochal book, *Die Cultur der Renaissance in Italien* (1860), was translated into English as *The Civilization of the Renaissance in Italy,* by S. G. C. Middlemore (1878). Since then, several historians have linked their own work to Burckhardt's in part by invoking that title. To cite just two of the most consequential instances, the imposing quartet of James Westfall Thompson, Ferdinand Schevill, George Rowley, and George Sarton summoned it up for their 1929 collection of essays, *The Civilization of the Renaissance,* and J. R. Hale recalled it recently, at a distance of 140 years, in his *The Civilization of Europe in the Renaissance* (2008).

While it is likely a coincidence of translation, the English title of Laurenz Lütteken's sweeping and ambitious book, which first appeared in 2011 as *Musik der Renaissance: Imagination und Wirklichkeit einer kulturellen Praxis,* nevertheless calls to mind two very different books entitled *Music in the Renaissance,* the first by Gustave Reese (1954), the second by Howard Mayer Brown (1976; 2nd ed. with Louise Stein, 1999). Yet both Reese and Brown had different aims and were thus more narrowly focused on descriptions of the stylistic evolution of music between roughly 1400 and 1600 and the biographies of the men who composed the music they described. As Louise Stein does in her revised edition of Brown's book (and as also occurs in other recent books that combine the words "Renaissance" and "music" in

their title), Lütteken begins by critiquing and then accepting the term "Renaissance" for the period he studies. While he focuses on the fifteenth and sixteenth centuries, his purview ranges from the ninth to the early seventeenth century. Lütteken signals his broader cultural focus in his subtitle, *Imagination and Reality of a Cultural Practice*. He is interested in such things as the contexts in which music was heard, the institutions that supported and required music, the relationship of music to the other arts, music and borders of all kinds, the development of composers as independent thinkers ("creators"), and the perceptions of time and space. His substantive discussions of art and architecture and their relation to music are not mere ornament.

Issues of cultural practice have also notably engaged Lawrence Kramer, in his *Music as Cultural Practice, 1800–1900* (1990). He described his interest in the following terms:

> Music, among other things, is a form of activity: a practice. If we take it in those terms, we should be able to understand it less as an attempt to *say* something than as an attempt to *do* something. As a practice, music should be subject to the same kinds of rigorous interpretations that we customarily apply to other cultural practices.

Although Lütteken has chosen historical and philosophical lenses rather than the literary-critical and hermeneutical approaches followed by Kramer, they share a desire to explain the place of music in the lives of musicians and nonmusicians alike. Lütteken understands the development of the concept of a musical work to be profoundly significant; indeed, he terms it "the most significant development since the emergence of notation." One of his goals in writing this book was to explore the expansion of musical consciousness that followed from the development of the musical work concept in the fifteenth century and to relate it to wider social, artistic, and philosophical contexts. This plays out in a series of discussions of paired topics: writing and literacy, authorship and professionalization, and, framing the book, history and memory.

From the very beginning, Lütteken connects his lines of inquiry to those that Burckhardt long ago articulated. Some of Burckhardt's principal concerns animate this study of music: the revival of antiquity, society and festivals, the development of the individual, and the rise of the state. With regard to the last of these, the international exchanges of music and musicians that had characterized much of the period waned and weakened in the last decades of the sixteenth century, as, for example, is evident in collections of

Italianate madrigals appearing in English, German, and Dutch for regional audiences. But in comparison with Burckhardt's troubled vision of violence prevailing in relations between competing states in the early modern period, Lütteken's discussion of the international practices of musicians and their networks emerges as a strong counter narrative.

Laurenz Lütteken has written a provocative book about music but still more about the kinds of activities and relationships that music fostered. Its translation is welcome for the dialogue it will open up between Anglophone and continental European scholars, between musicologists who for reasons of their own cultural practice have preferred to work toward large theories on the basis of individual case studies and those who reverse that path, attempting to explain smaller issues on the basis of a global overview. *Music of the Renaissance* is a welcome bridge between musicological traditions that remain too distinct.

Christopher Reynolds
University of California, Davis

PREFACE

This study is the product of many years of inquiry, which, on the one hand, has focused on the question of what "music in the Renaissance" might be understood to encompass, including whether such a concept even existed in the first place, as acknowledged by the very title of this book. On the other hand, seeking the answer to these questions has made it necessary to confront difficult underlying issues above and beyond this topic, which explicitly or implicitly touch upon broader questions of the meaning of music in the range of human cultural production, not only within the limitations of a system of the arts. This book naturally does not contain definitive answers to these fundamental questions but is committed to the phenomenon of "music in the Renaissance." Focused on an enormously consequential period of history, it represents one attempt to more precisely define the problems that music presents for the history and historiography of this period and offers multiple perspectives from which these problems can be approached.

The following pages thus are not a handbook, nor a survey of existing scholarship, nor a textbook or study guide. In this sense this book does not seek to compete with the well-regarded work of Gustave Reese, Ludwig Finscher, or Reinhard Strohm, and any comparison to these would be futile. Rather it is an attempt to give music its due as part of the cultural-historical panorama of this era. It proceeds without allegiance to any set methodological paradigms or theoretical agendas, including the term "cultural practice," which is used for lack of any other more suitable term. Setting aside certain concepts, theoretical approaches, or so-called strategies that have overwhelmed scholarly discussions, the focus of this book is more modest and pragmatic and is premised on the understanding that conceptual precision is not identical with methodological strictures, or as is especially relevant in the

case of history, dogmatic conceptions of *Weltanschauung.* It has thus been my goal not to fit music neatly into a cultural history of the Renaissance, but rather to take up the more audacious and perhaps misguided task of telling the cultural history of this era from a distinctly music-historical perspective. This book is thus addressed not only to specialists but to anyone with an interest in the broader topic, albeit in the hope that it will in turn spur renewed discussion of these issues in musicological circles.

The essayistic form of this book's chapters has made it necessary to keep evidence to a minimum, in most cases examples that are inevitable and indispensable. A modest list of selected references provides a guide for further reading in a vast body of research that has become increasingly difficult to navigate even in the somewhat narrowly defined field of music research. The relative brevity of this account is not an occasion for hasty conclusions, pointed intensifications, or underdeveloped arguments. It is not possible to survey such a vast topic lightly, and this insight was essential. But in order to understand the most significant aspects of this era it is not entirely necessary to go into explicit detail at every turn, and this study would otherwise run the risk of missing the forest for the trees. For this author it has been more important to consider a narrower range of phenomena from multiple directions.

I would like to thank all who contributed to the thoughts and conclusions in this text. To properly acknowledge every single stimulating conversation with friends and colleagues would far exceed the space afforded by this modest preface. Instead I wish to thank those individuals who had a direct hand in the preparation and review of this text, above all with their critical feedback on the manuscript itself: Karol Berger, Anna Maria Busse Berger, Kees Boeke, Ludwig Finscher, Inga Mai Groote, Hans-Joachim Hinrichsen, Seung-Yeun Huh, Isabel Mundry, Stefanie Stockhorst, Philippe Vendrix, and especially Melanie Wald-Fuhrmann. In 2009 the Université François-Rabelais de Tours invited me to serve as visiting professor at the Centre d'Études Supérieures de la Renaissance, an experience that helped set this project in motion. I am similarly grateful to the former director of the Herzog August Bibliothek, Helwig Schmidt-Glintzer, who in 2009 granted me a longer research fellowship in Wolfenbüttel during which time significant portions of this manuscript came together. The publishing houses and my editor Jutta Schmoll-Barthel have accepted the wishes of the author in the friendliest way. The staff at the Musikwissenchaftliches Institut at the University of Zurich, above all Michael Meyer and Michaela Kaufmann, assisted with editorial duties and preparation of the index.

NOTE ON THE ENGLISH EDITION

In the years since the German edition of this book appeared a great deal of literature has been published that sheds light on its themes and topics, among them the *Cambridge History of Fifteenth-Century Music* as well as many other studies of Josquin, the madrigal, Glarean, or the intellectual history of the era. Because they do not fundamentally change or contravene the underlying ideas of this book I have chosen not to make any changes to the original text. This book thus reflects the state of research at the time of its original publication in German. It would thus have been unseemly to add additional titles to the bibliography of this edition for cosmetic reasons, especially since it represents only a representative sampling of scholarship to begin with.

I would like to acknowledge several individuals who were instrumental in the preparation of this new English-language edition: Anna Maria Busse Berger, Richard Freedman, Lewis Lockwood, Raina Polivka, Christine Quentin, Christopher Reynolds, Jutta Schmoll-Barthel, and Christian Sprang. The translation was generously underwritten through Geisteswissenschaften International—with funding from the Fritz Thyssen Stiftung Köln, the Auswärtiges Amt (Foreign Office) of the Federal Republic of Germany, the VG Wort, and the Börsenverein des Deutschen Buchhandels. James Steichen took on the arduous task of translation in the midst of other obligations. The University of California Press has been an enthusiastic advocate and judicious steward of this project from conception to production. Franzisca Sagner oversaw the preparation of the index. To all of these individuals and organizations I offer my sincerest thanks.

Zurich, December 2017

The Era and Its Terms

AN ERA WITHOUT MUSIC

The emergence of the concept of the musical work fundamentally changed the ways in which human beings form relationships and interact with music. This change was one of the most salient moments of the fifteenth century. To be sure, a great deal of artful music, much of it transmitted through written means, existed for many centuries prior to this period. But these earlier forms of music were of a different character, closely related to rites, ceremonies, or occasions that shaped their form, and were often preserved in records at considerable historical remove from the moment of their creation. Without a doubt, notable traces of these developments can be discerned in fourteenth-century music, whether in its new forms of notation (themselves dependent upon thirteenth-century innovations), distinct modes of written transmission, or a new and more sensitive system of genres in which secular multivoice songs were especially prominent. Nevertheless, the conceptualization of music as an unchanging and self-contained work was clearly a product of the fifteenth century. This concept did not arise through any distinct foundational act, however, but was rather the end result of lengthy and complex processes that played out across multiple spheres of cultural activity and production, sometimes in isolation but just as often in tandem, among them writing and literacy, authorship and professionalization, historicity and historical memory, the position of music in the nascent system of the arts, and more. These activities redefined and sometimes expanded the parameters of what music could be, even as they were not always concerned with music alone. This fundamental change took place within the era most commonly referred to—thanks in no small part to the writings of Jacob Burckhardt—as

the "Renaissance."[1] But Burkhardt's account almost completely excluded music from its inquiries, except to discuss it as a locus of sociological activity, and thereby introduced doubts and uncertainties about the relationship between this period and its music. Nietzsche subsequently seemed to validate this exclusion, ascribing to music a certain intractable chronological belatedness. In a similar manner, Heinrich Besseler, building upon the work of Martin Heidegger and aware of the atrocities of the twentieth century, could not resist using the philosopher's concept of negative ontology to ascribe an intense pathos to the fifteenth century, characterizing it as an era in which a "humanization" of music took place.[2] At the same time, he was a harsh and unrelenting critic of the larger term "Renaissance" and regarded its use in music history as misguided.

As a result, ever since Burckhardt's 1860 *Die Cultur der Renaissance in Italien* (*The Civilization of the Renaissance in Italy*) matters have become ever more muddled. An era called the "Renaissance" exists, however one wishes to define it, and without which even the intentionally destabilizing interventions of postmodern cultural historiography, often operating by negative definition, would be unthinkable. But music in this era finds itself consigned to the margins of history, and even its liminal presence remains quite precarious. In the twentieth century little changed on this front in spite of unprecedented growth in research into both the "Renaissance" and music. Amid the many inquiries that have questioned the underlying structural power of historical eras—often heralded with loud and gleefully deconstructive fanfare— the problematic position of music has yet to be taken up and questioned. In fact, the assumption that music brought little if nothing to bear on the wider history of the period remains a perversely consistent feature of "Renaissance" historiography. If music did exist in the "Renaissance," it figures in it as a mere accident of history, at best a diffuse efflorescence of the social order that is historiographically meaningful as it relates to a certain subset of creative elites (as it is treated in Peter Burke's 1972 *Culture and Society in Renaissance Italy,* for example). Indeed, the history of the "Renaissance" has remained oddly content to adopt the contradictory position of being if not a history entirely without music, then a history at a certain remove from music. As a result the history of music, whether belated or not, has existed as a history apart from the "Renaissance." In Gustave Reese's landmark 1954 *Music of the Renaissance,* Burckhardt's name is not mentioned once, and in several other surveys of the period (many conceived of as handbooks), this conceptual problem is solved by consigning it to an introductory paragraph and gestur-

ing to a history that exists alongside the "Renaissance." Only a few authors, notably Ludwig Finscher in his 1989–90 *Die Musik des 15. und 16. Jahrhundert* (Music of the fifteenth and sixteenth centuries), have explicitly brought Burckhardt's viewpoint to the foreground, and even then only to corroborate his misgivings.

In significant ways, these challenges that the Renaissance has presented for music history remain unexplored, especially where the musical work concept is concerned. The era has been the subject of innumerable studies from a diverse array of cultural-historical disciplines and methodologies, including history, literary studies, and art history. (I understand "cultural history" not in the sense of any specialized or innovative methodology, but rather grounded on the simple and perhaps quaint premise that the activities that people undertake together in any given time and place must somehow relate to one another.) Music history, by contrast, has for the most part seemed content to confine itself in recent years to artistic or stylistic studies that only tangentially gesture to relevant external sociohistorical factors. And the decisive change that the musical work concept brought about—the most significant development since the emergence of notation—and the expansion of musical consciousness that it ushered in remain strangely decoupled from its wider context. An inquiry into the role of the work concept as it applies to music by no means forecloses other related inquiries, whether into the quality and production of music, its presence in writing versus performance, its meaning as a cognitive, emotional, or scholarly practice, or the changing meaning of non-notated or "nonartistic" music in the social, mental, and emotional activities of humans. But the existence of the musical work concept suddenly gives these questions, with which music is intimately concerned, a new and meaningful perspective.

In recent research such a notion has been met with considerable skepticism, with interest in the work concept regarded as elite, elevated, and detached from reality. But in fact the work concept granted musical practices a new dimension in the broadest possible sense, including areas that might seem to exist at considerable remove from one another. It gave rise to more complex and meaningful relationships with music, providing a new reference point that affected the priorities of both contemporaries and later generations. The relationship of humans to music was defined according to new limits, and it attained, whether intentionally or not, a new and distinct quality. What we refer to as the Renaissance—and from this point forward the scare quotes will be omitted—was significantly and profoundly shaped by its

music. And thus any meaningful inquiry into music in the Renaissance, while it should not be exclusively focused on the concept of the musical work, should take its genesis as an important point of departure.

At first glance this approach might seem to once again isolate music, insofar as, for example, the history of painting does not engage with such questions in a comparable manner (setting aside the question of under what conditions it is even possible to make a comparison between music and painting). But upon closer inspection many connections become apparent. Whether the new experience of reality revealed by Masaccio's techniques of perspective or the telescopic detail of Jan van Eyck's oil paintings, whether Leon Battista Alberti's new conceptualizations of space or the new relationship between language and the world revealed by Lorenzo Valla—none of these phenomena are the result of retrospective historiographical "construction." Taken as a whole they offer abundant evidence of something much more significant than Burckhardt's summary of the era as characterized by the "discovery of the world and of man."[3] The inflection point that the musical work represented has been previously brought into discussions of other changes in a superficial manner, even though it bears directly upon questions of musical perception, the relationship between language and music, not to mention more localized compositional innovations. It is a question first and foremost of perspective. It goes without saying that the Communion from Guillaume Dufay's *Missa Sancti Jacobi,* with its much-discussed fauxbourdon structure, should not be regarded as merely a discursive exemplar of new forms of perception, and neither would such a viewpoint be ascribed to Masaccio's 1425 Trinity fresco for Santa Maria Novella in Florence. And yet both this painting and mass setting (created around the same time) present a new human-oriented relationship to reality for their viewers and listeners. Such connections have seldom been researched and explored even though they were brought to the fore as much in the practice of music as in the realm of painting.

This effort to understand the music of the Renaissance as a cultural history in its own right, rather than reintegrating it into a larger cultural history, does not mean to assert that music exists as a discrete representational form. Its methods are grounded in the conviction that such a historical delineation, even as it presents certain limitations and must be prefaced by a long string of caveats, also makes good sense, since this "era" needs to be given back its music. This decision also has consequences for how this study must proceed. Its goal is to take phenomenological stock of distinctive situations and

describe complicated processes and sporadic events in a way that reveals relationships and draws connections without resorting to mere analogy. In light of the robust state of research such a goal seems promising and fruitful. Such connections concern not only the context of music, but in an important way the texts themselves. By this I mean a conception of text that is as capacious as possible, which the musical work elucidates in an especially sharp manner. Precisely because it is so difficult to determine what comprises the text of, for example, a Josquin chanson, one can draw such connections with a certain plausibility. For the activities of individuals in the past are revealed as much by the fact that trumpets were used in a royal ceremony as by the abundance of compositional decisions in a motet by Heinrich Isaac. Both presume upon on a textual character, albeit with different degrees of density and intentionality. Such norms and practices, premised upon complicated compositional decisions, cannot claim the supposed autonomy of an abstract or "ahistorical" material.

If one is to define the Renaissance as an era that was meaningfully defined by its music, the question arises as to what that might mean. While the musical work stands as the focus of inquiry, it cannot be the actual object of such a history, which would result in a kind of musical art history. A more fruitful approach is to attempt to circle in on the object by exploring significant areas of meaning. And in the interests of clarity one must set certain chronological and geographical boundaries and work within these limits to see what they yield. The chronological end of the period in question is easier to discern than its start, a somewhat unpredictable occurrence that nevertheless achieved a normative power within a remarkably short period of time: the invention of monody and figured bass around 1600. The changes that accompanied this occurrence are considerable. In the age of polyphony, three, four, or multipart settings were conceived of, at least in theory, as a network of equally significant voices, a rule that was somewhat conditionally suspended in the madrigal. In its place arose a completely new compositional idiom, in which the primary interaction was between the upper voice and bass lines and the unfolding of an underlying harmonic progression. The context and consequences of this shift will be considered later, but for now it is important to note the fundamental change in perspective that it fostered. Artful music was no longer sublimated into a polyphonic texture articulated by multiple people, but was instead the affective vehicle of an individual. This transition to a new mode of musical representation, toward the identification of the musical with a singing individual, provided the underlying premise for what

is arguably the most successful genre innovation in music history: the invention of opera. Much more could be said about the influence of this development in other areas, including instrumental music, non-notated music, the conception of musical affect, and the perception of music in general. These changes between the late sixteenth and early seventeenth centuries should be considered, admitting certain reservations, a paradigm shift on the model of the concepts of Thomas Kuhn.[4]

Deciding upon a comparably clear starting point is a more difficult prospect. The changes that took place around 1600 offer a bit of help, insofar as the polyphonic modes that were ultimately displaced by monody must have achieved dominance at some distinct moment. With a reasonable degree of certainty, the first twenty-five years of the fifteenth century present themselves as such a point in time. In fact multivoice music was polyphonic from the very beginning, and the introduction of multivoice features in the secular songs of the fourteenth century stands as a significant guidepost. But in the early fifteenth century the conception of polyphony underwent a decisive change. This was manifest first and foremost in the fascination borne out in a new conception of consonance using the intervals of the third and sixth. Whether this phenomenon was English in origin—as attested by two fifteenth-century witnesses, the chronicler Ulrich von Richenthal of Constance and the canon Martin Le Franc of Lausanne—can quickly be thrown into doubt by examining music created around 1400 in Italy. But more decisive than this conception of consonance is a related change in technique, whereby the relationship between consonance and dissonance was regulated in a new way. Polyphonic settings no longer consisted of a more or less open field between fixed points of consonance; instead, dissonances had to be prepared such that polyphonic settings led to them, and they were subsequently resolved via a more procedural operation. This shift can be observed in paradigmatic fashion in two motets of Guillaume Dufay (musical examples 1a and 1b). *Ecclesie militantis,* one of only a few five-voice works from before 1450, was written in 1431 for the coronation of Pope Eugene IV in Rome and shows, at least in principle, the "old" format, attributable perhaps to the challenges that a five-voice setting presented. The four-voice *Nuper rosarum flores,* composed for the same client in 1436, who consecrated the Cathedral of Florence during his exile, shows clear evidence of the new procedures. The contrast between the introductory duets of these two works illustrates a fundamental change in musical perception that will be discussed in greater detail later.

MUSICAL EXAMPLE IA. Guillaume Dufay, *Ecclesie militantis / Sanctorum arbitrio / Bella canunt / Ecce / Gabriel,* measures 1–14 (ed. Heinrich Besseler). Both motets, written only a few years apart, show quite different structures at the start. They begin with a duet of the higher voices. The older piece, *Ecclesie militantis,* is canonic (a hallmark of Dufay) and relies mostly on fifths and octaves within an octave range. The later work, *Nuper rosarum flores,* proceeds according to a fifth range, a melodic and sonic profile foreign to the earlier work.

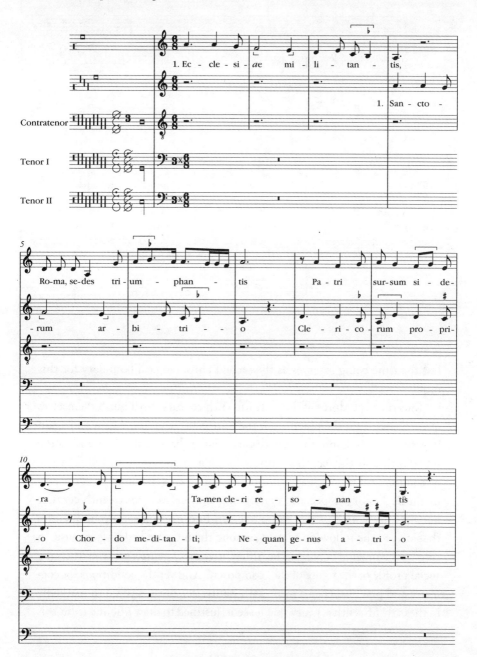

MUSICAL EXAMPLE 1B. Guillaume Dufay, *Nuper rosarum / Terribilis est locus iste,* measures 1–10 (ed. Heinrich Besseler).

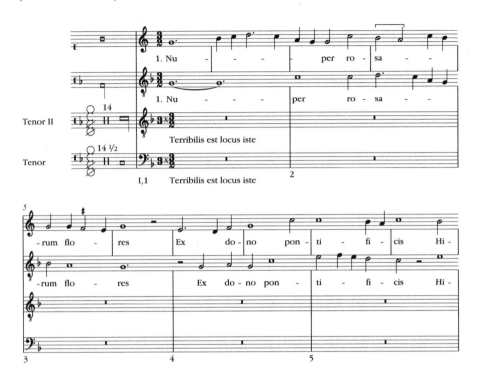

For the time being it serves as the second chronological boundary for this inquiry.[5]

Thus the procedures of the early fifteenth century distinguish themselves quite clearly from the practices of the fourteenth century. Again and again in general research into the Renaissance scholars have sought "origins" in the fourteenth and thirteenth centuries (often as a corrective to Burckhardt), often under rubrics such as "Protorenaissance." This has often been the case in music history, especially concerning music from fourteenth-century northern Italy. In this repertoire one can find many meaningful qualities that shaped the following century, among them the embedding of music in civic-governmental contexts, the differentiation of genres, and the emerging social profile of the figure of the "composer." And yet the conditions for cognitive and practical engagement with multivoice music shifted so markedly in the early fifteenth century that it seems justified to draw a boundary at this

moment. This is not to say that the motets of Guillaume de Machaut or the ballades of Lorenzo da Firenze should be consigned to an "antechamber" of the history of the musical work (in the sense of a "Protorenaissance"), which would be silly enough. Nevertheless it appears, or at least it is a premise of this book, that the fundamental changes that took place are of greater significance than such continuities. The musical history of the fourteenth century is a history in its own right and should be considered on its own terms. Examples from this previous era will be brought to bear only when they are absolutely indispensable to understanding the phenomenon under discussion.

Geographical boundaries are an even more difficult question. Burckhardt's already Eurocentric perspective was even more bounded by its focus on Italy, in part so that he could draw pessimistic connections between tyranny and cultural effloresence as a portent of modernity. In 1919 Johan Huizinga cast a view in a more northerly direction, most notably toward France, and in the provocatively titled *Herfsttij der middeleeuwen* (Autumn of the Middle Ages) explicitly threw into doubt Burckhardt's premise regarding the origins of modern humanity.[6] With regard to music history the situation becomes more difficult, in part because it is difficult to answer questions regarding center and periphery. There are musical centers of the fifteenth century about which almost nothing is known, such as Naples, while there are other musical centers, such as Cologne, where it is suspected that the concept of the composed musical work did not hold sway. And there are many allegedly peripheral locales that have suddenly revealed themselves as significant centers of music—for example, the Silesian village of Glogau (present-day Glogow). At the same time, all of the fifteenth century and a good portion of the sixteenth are marked by a high degree of geographic mobility on the part of the compositional elite, which throws into question any sharp regional distinctions that might be drawn. This same caution should apply to smaller spheres of activity—such as cities, courts, cathedrals, and cloisters—which were distinct and yet are marked by identical musical phenomena that make stark systemization all the more challenging. The fact that the international success of the musical institution of the "chapel" has its roots in the curial reforms of the fourteenth century also makes it difficult to narrow one's focus. In short, while the idea of strict geographical boundaries is problematic, a certain demarcation of scope is necessary and reasonable, even as one must remember that the musical horizons of the sixteenth century encompassed regions beyond Europe.

A perennial problem of all research into the Renaissance is the question of the era's relationship to antiquity (originally considered of utmost relevance and subsequently downplayed), an issue of renewed importance in recent research. In music history it has long been held, at least since August Wilhelm Ambros, that there is no meaningful evidence of musical antiquity upon which one might build such an argument.[7] This alleged deficit was first posited by Leo Schrade to justify the exclusion of music from histories of the Renaissance, since the musical legacy of antiquity could be connected to the Renaissance only through written means, and as a result music was the only field for which one could dispute the very concept of a Renaissance.[8] In fact there is a strong case to be made that the relationship between antiquity and the present is stronger in the case of music than has previously been acknowledged, owing, on the one hand, to changes in approaches to the study of antiquity, and, on the other, to changes in what one considers to be perceptible phenomena, including the concept of the composed work. The specific issues that surround this topic are significant and relevant for the present study.

As noted already, among the least contested issues is the existence of music as a sociohistorical musical reality. But it is considerably more difficult to discern with any precision the various facets of this reality itself and how this reality intersected with other spheres of lived experience. Among the most notable instances of this area of interaction is the emergence of the system of the arts, which in a complicated and productive manner foreground the often dichotomous character of music as an active human practice and an abstract "ars liberalis." During this time the musical elites active in Europe (and beyond) were comprised mostly but not exclusively of composer-singers. There were also renowned singers who did not compose, instrumentalists of all sorts, not to mention areas in which literary social elites were active in an intensely musical way (such as the madrigal) without being part of a musical elite per se. In any case, the creation of musical professionalism—in explicit distinction from the work of "amateurs"—ranks as one of the most significant developments of the Renaissance. The organizational structure of the chapel was decisive in spurring this change, with the performance of complex and demanding polyphonic music understood as the collective enterprise of a group of professionals. The concept of compositional individuality—that is, the immutability of the musical work—is closely tied to the collective organizational structure of this field of production. And all of these endeavors were exceedingly costly, in many cases requiring quite vast sums of money. Indeed, intensive and demanding musical cultures, whether composed

polyphony or any other complex musical endeavor, always bear evidence of both a certain will of representation and significant investments of capital.

Since the Middle Ages the history of music has been a history with dual modes of written transmission—music in written form and writings about music, or put differently, thinking through music and thinking about music. This has resulted in no small amount of critical and interpretive frisson, but far from being a source of stress and contention alone, this situation is also quite productive and dynamic. Broadly speaking, the relationship between these two forms of transmission was brought to a new level during the Renaissance, and while these tensions were by no means fully resolved, there were significant attempts to describe it with more precision and understand it in new ways. This played out in many different spheres, from more specialized and focused treatises on music theory to broader discussions of music in nonmusical contexts, whether in letters or genres such as chronicles. Such "nonmusical" sources should not be understood as existing outside or alongside music, but as musical objects in and of themselves. The complexity of these interactions is reflected in the nuanced system of genres that arose during this time, which while fully embraced by composers who regarded its rules as virtually compulsory, nevertheless did not give rise, as difficult as it might be to comprehend, to a fully realized theoretical framework. It was under these conditions that individuals interacted with music as a medium of expression, in both implicit and explicit dialogue with new categories and genres. And it was under these same conditions that new and more complex levels and systems of musical writing were developed, which, while a distinct manifestation of the larger history of literacy and writing, cannot ultimately be separated from it.

A musically oriented cultural history of the Renaissance must necessarily be attuned to and bound by the era's modes of perception, which have been transmitted as much through general sources as through the concrete compositional decisions latent in individual musical works. Such modes are not exclusively bound to the acoustic, since serious music has always had a nonacoustic existence in writing. The central premises of such musical phenomena are time (the defining dimension of music as a whole) and space (as the place of its manifestation as an acoustical event). Both emerge as explicit dimensions for compositional engagement in the Renaissance, whether in the isorhythmic motets of Guillaume Dufay (time) or in the use of multiple choirs by Andrea Gabrieli (space). In a fundamental way both concepts require that one confront the relationship between text and context, and the complex and

conscious interaction of these areas comprises one of the defining characteristics of the Renaissance. This tension also concerns the significance of text and word, which regardless of the mighty power of fixed instrumental music was a fundamental element of Renaissance music. During the Renaissance a multiplicity of languages (derived mostly from Latin) as well as musical languages engaged in an intensive interaction would result in new relationships between speech and music. Music had the potential to bring new life to poetic language, and music could also, through speech, give rise to ritual and ceremonial realities. Moreover, such rhetorical concepts helped foster a new relationship with reality for a type of music that was previously somewhat accidental in nature: instrumental music. The ennobling of music without words, instrumental music—comparable to the new prestige accorded to painting during the era—is more than just a sociohistorical occurrence but rather a conceptual development of the highest order.

Even Jacob Burckhardt seems to have already understood that the era he was describing was intensely concerned with the creation of historical memory and perception. The way in which this process played out in musical terms has scarcely been examined, even though music provides the ideal parameters for precisely such an inquiry. The entry of music into the sphere of intentional memory gave rise to musical historicity: that is, the idea that music—in part but not only in the guise of genre—possessed its own kind of consciousness. This change can be understood as not just a collective reality, but can be observed in specific individual cases. The transfer of the time-bound art of music into the sphere of memory and history is a development that is at once spectacular and admittedly difficult to describe, and in the end represents a moment of rupture with antiquity that gives rise to a new musical reality. This process eventually laid the groundwork for monody and opera and thus can scarcely be written off as "belated," but reveals itself as a particularly striking point of inflection between historicity and musical practice, even though the conditions that gave rise to these new practices would ultimately be left behind.

Although all of these dimensions must be brought to bear upon a musical-cultural history of the Renaissance, in the pages that follow they will be sketched out only in part, as most of them require detailed study in and of themselves. The broad overview that follows hopes to make it easier to draw such connections in future studies. In the end, music was as central to the phenomenon known as the Renaissance as architecture, painting, literature, philosophy, and the political dealings of individuals at all levels of society.

The question of when music entered the historical record does not necessarily lead to speculation about the origins of music itself. More pragmatically, the question can be framed in terms of understanding the different ways in which music's entrance into history took place. With additional clarity about this process, which was hardly one-dimensional or linear in its trajectory, a second question can then be posed, namely, from what point in time did music come to possess a history in its own right? Both of these questions are of utmost importance for making sense of a Renaissance in music, even as they rest on certain assumptions (whether intentional or not) about what one attends to when dealing with music. The earliest traces of cultural transmission provide evidence of intense conflicts regarding music. But even as ancient sources speak at great length regarding music, the observations are often somewhat oblique in character, attuned to its effects, its ethical efficacy and dangers, its technical qualities, or its rational underpinnings. The mediated observations found in philosophical texts cannot be clearly differentiated from similar details present in mythological traditions or images and iconography. In the Old Testament—for example, in the songs of praise of Miriam and Deborah recorded in Exodus—music is not a material practice but an affective and ritual act to be completed. For Boethius, whose theoretical writings from the early sixth century would be canonized by Carolingian scholars, music existed as a practice bound to a specific time and place—in his case, Ravenna during the reign of Theoderic the Great—which provided the occasion for his observations. But he does not record in any tangible detail the qualities of the singing he heard in Ravenna around AD 500, described in his prefatory remarks as seizing the ears as much as the soul.[9] This made it easy for Carolingian intellectuals to draw connections between Boethius's text, which was instrumental in helping Theoderic transmit zither odes to King Clovis, and the music of their own times, chant. The music of antiquity is thus lost not only because it was not recorded in written notation, with the few fragmentary artifacts supplying neither a systematic understanding nor reliable information on their musical realities. This music also disappeared because it was given only mediated presence in secondary sources.

At first glance it appears that this situation changed fundamentally during the High Middle Ages, with representations of music present in many chronicles and poetic texts. But upon closer examination it becomes clear that these instances for the most part reveal the use of music in rites and

ceremonies or provide fictional depictions of musical functions, contexts, or experiences—for example, in *Tristan,* written by the musically adept Gottfried von Strassburg around 1210. Martin Warnke has demonstrated the relevance of such texts for understanding the sociological meaning of medieval architecture, and Sabine Žak has been similarly able to assemble a remarkable array of musical evidence from the era.[10] Žak consciously placed historical and literary texts side by side, since it was clear that both types of sources were comparably relevant for understanding musical functions. But neither type of text—accounts of ritual or ceremonial uses in historical sources or their idealized representation in poetic works—necessarily has anything to do with musical reality. For example, in 1119 it is recorded that for the occasion of a reliquary transfer, Bishop Landulf of Benevento authorized the use of a vehicle upon which were placed an array of bells, metallic percussion instruments, trumpets, horns, "tympana mirabiliter percussa" (incomparably and wonderfully played drums), as well as strings.[11] The document in which this information is recorded is both remarkable and baffling, describing the use of a wide range of percussion instruments, but nevertheless reveals nothing about the musical reality of the event. The *Romance of Alexander* by Ulrich von Etzenbach, from the mid-1280s, contains numerous depictions of music—for example, at splendid feasts at which "sweet" tunes were performed by "many hands" on an array of string instruments ("dâ was süezes dônes vil / von manger hande seitenspil"), all of which are catalogued in scrupulous detail.[12] But from this and other comparable passages a reader gains no real understanding of what this music actually sounded like. The *Remede de Fortune,* written in the middle of the fourteenth century by Guillaume de Machaut—a cleric, diplomat, poet, and a composer to boot—similarly contains a celebrated passage that details a wide range of musical instruments.[13] But this representation is animated not by a documentary impulse but rather strives to create a poetic ideal, and says nothing about the music itself, including the work of Machaut himself. Similarly, in the work of the scholar Johannes de Grocheo, inspired by Aristotelian concepts around 1300 to explore strategies for understanding perception and reality in general and monophonic and polyphony music in particular, the contours of musical reality remain remarkably unclear, prompting the question of whether Grocheo was even interested in documenting them in the first place.[14]

Despite their distance from musical realities, such witnesses nevertheless provide invaluable insights about the musical cultures in which they were active, including the condition and use of musical instruments, the contexts

in which music was produced, and the organization of musical genres. But there exists a rupture in their relationship to musical reality, and they are not characterized by a desire to record concrete musical relations. It appears that only in the late fourteenth and then in the fifteenth century was a process set in motion that would change both the conception of musical reality and the desire to recognize it as such. Music thus became in a new and distinct manner the object of history in the widest sense of the word. The most important witnesses of this shift come from a chronicle and a poetic text, the already-mentioned informant Ulrich von Richenthal (ca. 1376–1436) and Martin Le Franc (ca. 1410–1461). In 1418 Richenthal mentions, whether rightly or not, the special qualities produced by the English music he was able to hear during the Council of Constance. He reports not in generalities but rather of concrete and quantifiable musical effects that arose from specific instances of composed music. The fact that this quality of perception was unusual is corroborated by details related to the transmission of these observations. They were recorded only in the second version of the chronicle, as Richenthal in 1415 described the exact same occasion—the feast of Saint Thomas à Becket—with nearly identical words but without referring specifically to the song. Moreover, these notes are preserved in only one version of the text, lending its transmission a certain philological instability.[15]

In 1441–42, Martin Le Franc, the provost of the Cathedral of Lausanne and subject of the Burgundian dukes, authored an epic poem whose fourth book includes a small passage about music. Martin speaks of a specific kind of music, which he contrasts with ancient music (noting that it was not as "auctentique" as the music typically heard at the time). This music had a powerful effect on him, an effect that he memorably labeled "frisque concordance" and "contenance Angloise," as the new English sound was designated.[16] Thus in his observations, which have been preserved with more philological stability, we encounter not the perception of music as a general phenomenon, but a focus on a specific kind of music. In contrast to Richenthal, Martin connects these impressions with the names of specific composers and the qualities of specific musical works. Although these witnesses have assumed outsized significance in scholarly circles—and their canonization has possibly occasioned more confusion than clarity about their intentions—they have seldom been examined in isolation in this respect. And in fact there are many documents from the first half of the fifteenth century that contain similar dynamics, recording not the overall effect of music nor the mere context of a musical act, but rather the specific impressions of specific kinds of music. For instance, in 1436 the

Florentine politician Giannozzo Manetti (1396–1459) described the highly charged occasion of the consecration of the Florence Cathedral by Pope Eugene IV, including the music that was heard.[17] It is completely unclear what music Manetti is exactly referring to, but in his account of the celebratory mass he describes extraordinary singing and instrumental accompaniment. It is admittedly hard to say how his rhetorical ekphrasis and desire for concrete description relate to one another. Manetti's report nevertheless represents an attempt to describe music not only as fulfilling a ritual function but as contributing to a specific occasion in which its singular qualities were notable.

The tone of such accounts represents a new quality in intellectual engagement with music, a quality that was previously present only in oblique or intuitive ways. The desire to ensure the precise character of a musical event—even if only rendered through stereotypical representations—presents itself as a different and new way in which music enters into the historical record. It is thus not important whether Manetti wanted to describe a specific piece of music—for instance, Dufay's motet *Nuper rosarum flores,* the only surviving composition that can be conclusively linked to the occasion. It is more important that he situates the music as an integral part of the event he recounts, with the music not reduced to or equated with its ritual functions. This new sense of musical contemporaneity in turn accords music a new place in historical memory. This memory is not limited to the musical work but is dependent upon it. In 1433 the city of Dijon petitioned the Burgundian duke Philip the Good for permission to use trumpets rather than the usual horns as the musical signifier for their Count, and the subsequent ducal permit explicitly referred to the more beautiful sound of the trumpet.[18] Thus in this instance the musical contemporaneity of the sound played an important and perhaps decisive role, and the fact that the decision took place in the sphere of one of most influential court chapels in Europe at the time was by no means random. This new focus on the specificities of sound and occasion became a continual focus of debates over music throughout the fifteenth and sixteenth centuries, especially in crises that witnessed intense human conflict. The intentional destruction of musical items during the Reformation in Zurich (1525) or during the Anabaptist rule of Münster (1534), the first modern dictatorship, paradoxically reveals music as grounded in the present moment, insofar as it must be completely done away with once and for all.

The terms by which one can describe such changes—occasion, presence, memory—are admittedly imprecise and disparate, since one must attempt to describe not a set of discrete facts but rather a contentious process whereby

music is "present" in contradictory ways, markedly different from the way it is manifest in the visual arts, for instance. It is by no means the sole province of these written accounts to give form to this new sense of musical contemporaneity. To the contrary, music as an event reveals itself in quite meaningful ways in images, which display clear historical significance even as it manifests itself in unpredictable ways, and this significance shows it was worthy of recording not just because of the particularities of the occasion or "performance" itself that is depicted. One such example is the angel musicians in the 1432 Ghent Altarpiece of Jan van Eyck (fig. 1). These figures comprise part of a wider image that encompasses the instruments of Eve and the figure of Adam as singer. But these musician angels stand not as just another instance of a convention handed down from previous centuries and especially prevalent in Marian iconography. They appear in a new and distinct manner that is attuned to corporeal realities, a hallmark of Van Eyck's style, offering an embodiment of the sonic reality of a musical event, with concrete and somewhat bizarre and contorted physiognomies for the singers. Music is present in them in a new manner, depicted as the product of active (and reactive) agents.

Beginning in the fifteenth century this new and previously unarticulated sense of musical presence is manifest in numerous paintings. For especially ambitious artists tackling complex images, it can be manifest in revisions, expansions, and refractions without compromising the presence the images contain. A famous painting from around 1505–10 attributed to Giorgione depicts an enigmatic musical scene—two musicians playing a flute and a lute with no reference to contemporary notated or composed music—that was labeled "pastoral" in the eighteenth century and was subsequently given the even more anachronistic moniker "country concert" (fig. 2). Despite the utterly vague and puzzling context and conceit of the painting, music is nevertheless present in a clear and dramatic fashion and legible as a functional act. This sort of functional act had been a hallmark of musical depictions for at least the previous 150 years—that is, of clearly defined ritual or ceremonial contexts—making them available to more than initiated insiders. The distinctive quality of Giorgione's painting lies in the fact that it makes music present in a new and distinctive manner.

Painters of the late fifteenth and sixteenth centuries conjure this new musical presence in quite different ways. The inlay work for the Urbino *studiolo* of Federico da Montefeltro (likely completed in 1476) includes depictions of musical manuscripts (a motet and a song) that represent a striking innovation, insofar as they show specific musical works removed from the context of their realization in performance (figs. 3a, 3b). The positions of the two manuscripts

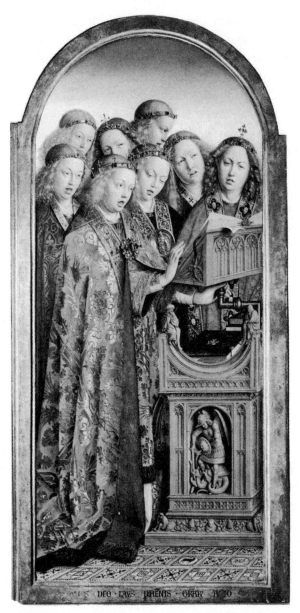

FIGURE 1. Jan van Eyck, *Singing Angels,* left interior panel of altarpiece, oil on wood, 161.7 × 69.3 cm, 1432, Cathedral of St. Bavo, Ghent. The Ghent Altarpiece shows among other figures eight singing angels around a music stand adorned with a likeness of Saint George. Aside from the question of whether they are singing polyphonic music, the differences among their physiognomies and bodily positions are notable, suggesting that they are depicting the production of actual sounds.

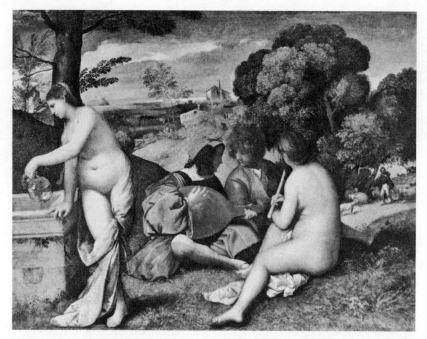

FIGURE 2. Attributed to Giorgione, *Pastoral Concert,* oil on canvas, 110 × 130 cm, ca. 1505–10, Paris, Musée du Louvre. Attributed to Giorgione and later given the title *Pastoral Concert,* this painting has inspired numerous interpretations. The musical scene in the center shows a nude woman with a flute, a lutenist, and possibly a singer.

are clearly delineated: the secular song appears in a book amid other books, while the motet is one object in a cabinet of curiosities. What is striking is how both of these objects are housed in spaces that are not primarily musical in nature, but rather places in which courtly memories were recorded. In other words, music has come to be preserved and remembered.

Such cases reveal a new sense of history especially clearly, and this holds true for many paintings that depict manuscripts of polyphonic music. The English composer Walter Frye, who likely died around the middle of the 1470s, is famous for a three-part setting of *Ave regina celorum,* a work that achieved considerable renown and circulated widely. The music's notation, or at the very least excerpts of it, is preserved in two oil paintings and a mural from the late fifteenth century, all at considerable geographical remove from one another. Through such depictions of musical notation in painting, music gains not only a new presence but historical permanence as well. In 1547 the Westphalian painter Hermann tom Ring (1521–1596) immortalized a

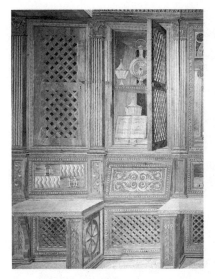

FIGURES 3A, 3B. Inlay from an anonymous *studiolo,* 1476[?], Palazzo Ducale, Urbino. *Left,* detail from the western wall: cabinet of curiosities with the anonymous motet *Bella gerit musaque colit. Right,* detail from the northern wall: bookshelf with scarf (decorated with the regalia of the Hosenband order), strips of paper (with the Virgilian aphorism "VIRTVTIBVS ITVR AD ASTRA"), as well as a chansonnier with the anonymous rondeau *J'ay pris amour.* Both inlay panels on the western and northern walls of the *studiolo* of the ducal palace of Federico da Montefeltro (likely completed around 1476) depict the various ways music was contextualized. The handwritten manuscript of the secular song is housed on a bookshelf, while a motet is placed in a cabinet of curiosities alongside other art objects.

Münster civic official in a painting that included a legible madrigal manuscript, an unusual occurrence in the region. The identity of the composition by Philippe Verdelot reveals the intention of the painting: a groom courting a bride. The picture thus posits music not just as something to be remembered, but as a phenomenon with a highly personal meaning.

This new sensibility is present even in paintings that depict not actual music but rather musical instruments. Among the inlay work designed in 1524–25 by Lorenzo Lotto (ca. 1480–1556) for the Basilica of Santa Maria Maggiore in Bergamo is a panel dedicated to music (fig. 4). Under the title *Quid* appears a music book, which despite including the expected mensural notation contains no polyphonic music but a discernible melody. Its accompanying text is recorded as "La virtù nòse pol seguire." Accompanying the music are four flutes as well as an unrealistic and unplayable organ that in no way correlates to any object in the real world. Even though everything seems off about this depiction, which seems far removed from actual musical realities,

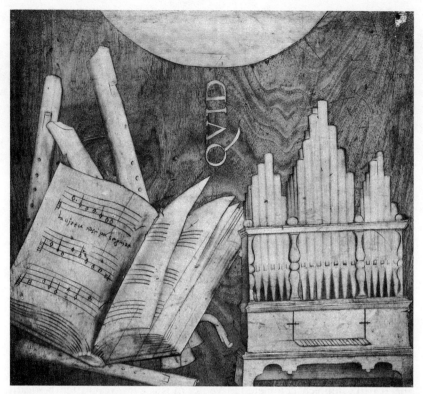

FIGURE 4. Lorenzo Lotto, inlay on the left side of the inlay cycle for choir stalls, completed by various inlay artists, 29.9 × 33.9 cm, 1525, Santa Maria Maggiore, Bergamo. Lotto's 1524–25 inlay designs for the Basilica of Santa Maria Maggiore in Bergamo are complex in their conception. One panel is dedicated to music and includes a pipe organ not based on an actual instrument that one would be able to play, and yet it is evident that the image is meant to depict the production of actual music.

music nevertheless has an immediate presence. The content of this representation is complicated and not entirely legible to present-day viewers. But what is decisive is the presence of music removed from any functional, ceremonial, or ritual exigencies. Music is manifest as music, and thus enters into history in its own right in a way that would have been unthinkable only a century earlier.

Similar examples are numerous, and their breadth and diversity provide further evidence of this shift. But a comparable development in a related area provides additional corroboration of these changes. From the time of the Middle Ages ecclesiastical spaces were noted as places in which certain singers participated in liturgical rites and ceremonies. But in the fifteenth century the

chancel, an area of the church explicitly circumscribed as the domain of musicians, becomes an architectural feature, allowing music to enclose itself in a distinct sphere, often in quite spectacular circumstances. The chancel designed between 1431 and 1438 by Donatello and Luca della Robbia for the Cathedral of Santa Maria del Fiore (regrettably dismantled and sold off in 1688) created a distinct place for music, with a design—much like Van Eyck's angels—that delineated and rendered music more legible and memorable as music in and of itself. An especially dramatic example of this is the chancel of the Sistine Chapel (consecrated in 1483). In this space the singers themselves devised a strange system of representation, recording their names in graffiti scratched into the stone walls, with layer upon layer added over succeeding decades. Indeed, the Sistine Chapel contains among its wall carvings the only verifiable "autograph" of Josquin. It is difficult to imagine a more visible and indeed tangible manifestation of this new relationship to music (fig. 5).

The quantity of chancels, and later organ lofts and consoles, in which concepts of musical presence and memory were intermingled, has not yet been systematically studied. But there is no lack of striking examples—for instance, the extravagantly decorated loft completed in 1534 by Vincenzo Grandi for Santa Maria Maggiore in Trent. It is even possible to identify a comparable tendency in secular architecture toward musical representation—for example, the Teatro Olimpico, completed in Venice in 1585 a few years after the death of Palladio. Indeed there exists any manner of examples that reflect this changing relationship between music and history. Of course this relationship remains dynamic to a significant degree, owing to the fundamental tension between the ephemeral character of music and the intent to lend it more permanence. But in the fifteenth century it gained a new stability that had been steadily growing and evolving over many previous centuries.

In the process, music became in a wider sense a new object of transmission, albeit not in a merely functional sense of being preserved for future performance, but was granted a new form of permanence. What applies to historical chronicles and poetry or painting and architectural monuments holds true for the immediate transcription of musical texts. The presence that music thereby acquired corresponds to the material reality that it is accorded. The Renaissance is not just a period in which organizational forms achieved new stability, including but not limited to the institution of chapels. This period witnessed an explosion of bills, papers, receipts, and other transactional documents pertaining to music and eventually the emergence of the figure of the kapellmeister. Such records have everything to do with the lived realities

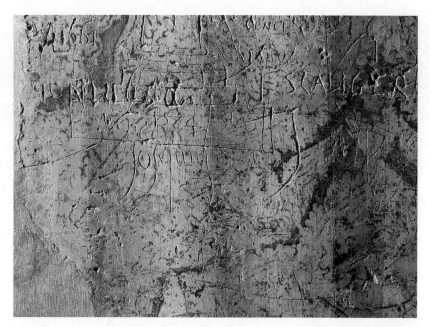

FIGURE 5. Detail of the western wall of the chancel (after restoration), Sistine Chapel, Vatican City. Restoration work on the Sistine Chapel uncovered previously hidden graffiti in which singers in the papal chapel inscribed their names and other identifiable attributes on the walls. The practice evidently began while the chapel was still under construction, as evidenced by the presence of the name of Josquin Desprez. Other chapel musicians immortalized in these markings include Jacques Arcadelt, Carpentras, and Annibale Zoilo.

of music and help secure its historical presence in a way that the previous century could not have imagined. The idea that the reproduction or production of music could be quantified in a material manner created a new set of conditions and circumstances that had not been previously present. At the same time it allowed music to enter history in another distinct manner. Among the most remarkable aspects of this process is its irreversibility: music ever since has not been considered part of the kind of "diffuse" history in which it existed through the fourteenth century.

BOUNDARIES AND SPACES

The compositional changes that took place in the first decades of the fifteenth century and the last decades of the sixteenth century were part of a larger transformation of perception, which will be addressed later at greater

length. These changes give the era its contours and also define its boundaries. But what transpired within these boundaries, or put differently, what are the boundaries of the musical itself? There exists a considerable gap between, for example, the everyday use of signal tone at the Doge's Palace in Venice (about whose precise form nothing is known) and the rich complexity of a motet by Adrian Willaert, and although it would be possible to make comparisons between them, it is difficult to draw definitive connections. But both of these phenomenological extremes were facets of the sonic reality of Venice in the mid-sixteenth century. And they coexisted in a field of musical activity that did not previously exist and first began to coalesce during the fourteenth century. The different challenges that such phenomena present are all too self-evident, insofar as a signal tone, which was transmitted orally, was clearly defined and even mundane in its meaning, although it possessed a precise function in the real world and was lacking in historical stability. A motet, by contrast, set down in writing or even in print, possesses an abiding historical presence, insofar as it has entered into history and to a certain extent remains legible independent of the real-world function for which it was created. It goes without saying that the boundaries of such a work of art remain somewhat vague, since written transmission is a reflection of only certain aspects—that is, whatever was understood to be indispensable or most essential. Such written sources conceal rather than reveal the subtleties of the original sonic manifestation, which only in conjunction with the rise of instrumental music in the seventeenth century came to be regarded as worthy of recording, including specifications regarding instrumentation, tempo, and dynamics.

During the Renaissance the term "music" thus became diffuse and somewhat balkanized in meaning in previously unknown ways. A rich set of daily musical experiences was available to people regardless of their social standing and was accessible and meaningful to relatively large segments of the population: signals, bells, songs, and unfathomable quantities of instrumental and, above all, dance music. At the same time the corpus of liturgical music—which previously consisted only of monophonic chant, whose artistic character was seldom explicitly acknowledged until the time of the Council of Trent (that is, for the duration of the Renaissance)—came to be enriched by new compositions, including work by notable composers whose authorship was legible only obliquely through records such as contracts. Only at the end of the Renaissance, during the Counter-Reformation around 1600, and specifically in the reductionist *Editio Medicaea* of 1614, was the repertoire of

monophonic music in effect removed from history, and from this point on, in part thanks to the consequential separation of the sacred and profane in compositional history, was not permitted to be enlarged or changed. And at the top of the hierarchy of musical perception stood musical works created and realized by professional musicians, capable of producing a multitude of effects and enormous subtle gradations. The spectrum between an anonymous fauxbourdon of the early fifteenth century and the forty-voice *Spem in alium* (before 1572) by Thomas Tallis (ca. 1505–1585) represents diversity of perception that did not exist prior to the fifteenth century and is not easily explained. In any case, the boundaries of the musical began to open from this point moving forward, to the extent that they become difficult to discern with any clarity. This new multiplicity presented new challenges for listeners, especially for those who, whether intentionally or not, were confronted with some if not all of these phenomena at the same time.

At what point these boundaries came to be intentionally defined and even called into question is of special historical significance, since it allows us to understand to what extent they were consciously and productively put to use. Italian civic culture of the fourteenth century was characterized by the competitive demarcation of individual *signorie* through representational self-fashioning and self-preservation not only by means of painting, literature, and architecture but also through music. The spread of a rich vernacular (and nevertheless clerical) musical culture in the first decades of the century in Florence, Padua, and other city-states was embedded in a wider musical landscape whose components—with the exception of the multivoice songs recorded by subsequent generations—are for the most part lost. For whatever reason, it was not a priority to grant comprehensive permanence to this culture but rather to selectively preserve certain elements after the fact. And yet there are certain exceptions to this rule that thus hold special significance. In northern Italy around 1400 a manuscript was produced (perhaps incomplete and first recovered in London in 1876) containing two- and three-voice pieces in which, curiously enough, fifteen monophonic pieces are set down in mensural notation—that is, the written system of polyphonic music (fig. 6).[19] They evidently consist of instrumental settings, some of which bear titles—the most of famous of which is *Lamento di Tristano*—although without any indication of their composer or any other specifications. The hypothesis that these pieces, owing to their formal resemblance to the lai, might consist of "devocalized" vocal settings cannot be completely tested based on the evidence at hand. But setting such concerns aside, this written source was clearly

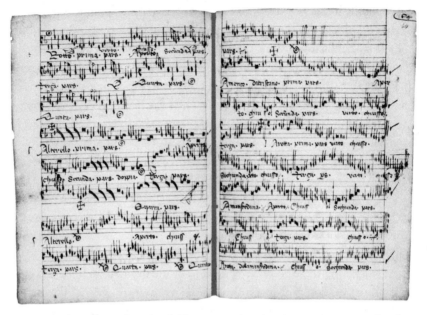

FIGURE 6. Anonymous, *Lamento di Tristano,* parchment, 26 × 19.5 cm, ca. 1400, London, British Library, MS Add. 29987, f. 63v/64r. Today located in London but originally created in northern Italy (perhaps Venice), the manuscript records monophonic pieces in black mensural notation, consisting mostly if not entirely of dances. Many are designated with genres (*[S]altarello,* f. 63v), and some bear evocative titles such as *Lamento di Tristano.* An isolated instance of transmission, this manuscript represents an exceptional case and can offer only limited insights into wider practices.

a moment of boundary crossing, with written methods applied to a kind of music that was not typically accorded such treatment. As difficult as this manuscript is to evaluate—and for centuries these pieces have been implausibly included in countless compilations as exemplary instances of instrumental music from around 1400—it is all the more distinctive for this reason. What is most remarkable is not the deficit of information by which it might be reckoned a loss, but rather considered in a positive light it stands as a spectacular instance of boundary crossing. This exceptional case shows how the recording of this music in written notation was imagined as a possibility, and since it was something not normally done, it was a clearly intentional act.

Such examples become increasingly evident in the fifteenth century and reveal the development of normative boundaries for music. Another quite different example can help illustrate this. In Venice during the first half of the fifteenth century, Leonardo Giustinian (ca. 1383–1446), a poet and politician

hailing from a distinguished patrician family, evidently accompanied himself on a stringed instrument during the recitation of vernacular poetry, according to surviving literary sources. According to his contemporaries this activity was undisputedly artistic in character. But for whatever reason, Giustinian declined to record his musical accompaniments in written form, preserving only the texts of his works, which were first published in 1472 and subsequently republished in multiple editions.[20] On the one hand, it is correct to regard such a practice as a continuation of the work of troubadors and trouvères in previous centuries. But, on the other hand, aside from the fact that Giustinian did not nor would not have wanted to conceive of himself as a troubadour-like figure, his songs would have been heard by listeners who for almost an entire generation had become accustomed to hearing complex polyphonic music. It is thus likely that Giustinian was not only aware of this but consciously shaped his practice as a means of transgressing the boundaries of the musical in a distinct manner. When one considers the fact that at the same time in the 1430s the cantor of San Marco in Venice, Johannes de Quadris, was likely busy assembling the monumental musical manuscript containing the secular works of Guillaume Dufay,[21] Giustinian's persistence with respect to orality reveals itself as not only an intentional decision, but rather as one in which a desire for the unmediated presence of a musical "moment" superseded all other considerations. What is more, Giustinian's documentary practices became something of an inscrutable "underground" musical practice in certain patrician and elite circles. Serafino de' Ciminelli dall'Aquila (1466–1500), who worked in the service of Cardinal Ascanio Sforza in Rome beginning in 1484, where he was in contact with Josquin Desprez, accompanied himself on the lute when singing Petrarchan sonnets. Somewhat later, according to secondhand witnesses, Isabella d'Este accompanied herself on a keyboard instrument when singing, a practice described by Alberti and termed by Baldassare Castiglione as "cantare alla viola per recitare" (singing to the viola for recitation). Even though Castiglione professed to enjoy "molte sorti di musica" (many kinds of music) he nevertheless noted that he preferred the practice of "cantar bene à libro sicuramente & con bella maniera" (good, secure singing according to notation and in a beautiful manner).[22] The seventy pieces for voice and lute published by the Bosnian lutenist Franciscus Bossinensis in 1509 in Venice (with a second collection published in 1511) consist mostly of treatments of polyphonic *frottole* and preserve only a notion of this practice.

The boundaries of the musical also reveal themselves in "alternate" worlds, thematized at first somewhat hesitantly and then more emphatically. These

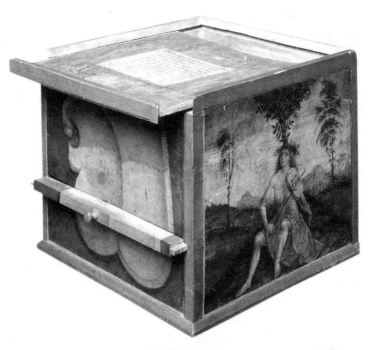

FIGURE 7. Anonymous, so-called Celtis Box, 31 × 31 × 31 cm, 1508, Vienna, Kunsthistorisches Museum. This box was commissioned by Konrad Celtis (1459–1508) in the year of his death for the insignia for his coronation to *poeta laureatus* and recalls his elevation to poet laureate in 1478 by Emperor Frederick III in Nuremberg. Beginning in 1497 he taught at the university in Vienna, where the box was discovered. The fiddle-playing Apollo on Parnassus invokes his self-fashioning as a poet and depicts the music of antiquity without lending it any concrete form.

consist, on the one hand, of mythological musical scenes, which in an increasingly distinct manner thematize a music that was for all intents and purposes entirely lost, but which, on the other hand, was nevertheless understood to have been of utmost significance. Konrad Celtis preserved the insignia of his poetic laurels on a box created in 1508, decorated with, among other figures, a fiddle-playing Apollo on Parnassus (fig. 7). A commitment to the music of antiquity is thus present, even though Celtis is obviously aware that it cannot be engaged with in any realistic manner. Raphael's altarpiece featuring Saint Cecilia (1513–16), commissioned by Elena Duglioli dall'Olio for the chapel of San Giovanni in Monte in Bologna, similarly invokes a Platonic conception of music, depicted by a (mirror-inverted) organ in disrepair and other instruments strewn about, a somewhat literal representation of the silenced sounds

of a music that is entirely inaccessible through mortal means. At the same time it depicts angels singing (with written music) toward the open heavens.

These alternate worlds can also have an entirely different character. This is evident in many of Josquin's chansons (such as *El grillo*), assuming that it is even possible to understand their contours based on only their depictions in art music. This is true of Lasso's *Villanelle* of 1581, whose grotesque and obscene texts move music into a quite different realm, as its allegedly "rustic" aesthetics are in fact the product of elite courtly practitioners, which nevertheless made their way into a printed version.[23] Such boundaries first acquired new and distinct contours on the operatic stage, where actors were physically separated from those who viewed and heard them, which had an effect on musical practice as a whole, with a separation between performers and audience emerging as a central dimension.

A consciousness of this tension that pervaded musical reality was not only a defining characteristic of the Renaissance and a new quality of its musical culture. It was productive in a manner that can scarcely be understood, since the abundant varieties of music (unknown to the fourteenth century) were, whether intentionally or not, thrust in front of eyes and ears. The differentiation of musical worlds as a principal marker of nascent modernity has its beginnings here, with the knowledge of the breathtaking greatness, invoked by Castiglione, of the boundaries of music itself. The peculiarity of this experience and its increasing differentiation also represent a distinct development, since in the end it required that music be perceived and musical spheres be defined and considered in different ways, and that these were to be preserved in the present through various means or allowed to be forgotten. Johannes Franchois de Gemblaco, the Succentor (or Deputy of the Cantor) active in 1420 in Lüttich, not only dared to compose a Marian motet using five voices, but went so far as to designate one voice as "trompetta" and perform it in this way. This represents a very early example of the productive tension between different musical spheres. This process is one of the central characteristics of the Renaissance, and this dynamic was brought to a temporary halt only in the triumphant age of the technological reproducibility of music, in which all forms not only exist side by side but are recorded and preserved through similar means.

The forms in which music was manifest are closely tied to spaces. First and foremost, and by no means incidental, is the category of geographic space. The musical culture of the fifteenth century was exceedingly international, a trend that receded in the course of the sixteenth century in favor of more

clearly defined regional profiles. This means that a mobile and musically skilled elite at first traversed wide distances with an astounding ease, both through their own physical travels and through the circulation of their repertoires. These elites hailed for the most part from present-day Belgium and northern France—for reasons that will be discussed later—and as a result French was the most important language after Latin. Indeed, at first French was without exception the leading language after Latin, followed by Italian (the most important vernacular in music after 1500), German, Spanish, and Dutch. At first the geographical regions were almost incidental to the languages used in music, while in the sixteenth century they became more closely linked, especially with respect to the culture of madrigals, in which Italian was the prevailing language. The international character of musical culture did not recede completely in the sixteenth century, however. Born in the diocese of Cambrai, Guillaume Dufay in the course of his life is reported to have spent time (often on multiple occasions) in Cambrai, Constance, Rimini, Bologna, Rome, Florence, Ferrara, Geneva, Lausanne, Chambéry, Freiburg, and Basel, and likely also in Padua, Venice, the Peloponnesian islands, Bari, not to mention other places where his musical activities were not recorded. In all of these places he found himself in a similar institutional role as a musician, as a cleric performing a similar kind of liturgical music. These journeys were very much those of a musician (in stark contrast to those of Machaut, who traveled in his capacity as a diplomat and politician) and no doubt were consequential in shaping musical repertoires, which were by degrees understood as regionally specific. The explosive proliferation of a European musical culture around 1400 and afterward followed the increased differentiation of regional, liturgical, and dynastic conditions. A court kapellmeister such as Lasso remained in Munich for many decades, and his international renown was closely tied, in sharp contrast to the case of Dufay, to the renown of the Munich court and its chapel.

Equally important for this process was the refinement of the musical landscape after 1400. In the late fourteenth century there were very few institutions that produced and reproduced complex polyphony, the papal chapel being the most renowned, while by 1600 the situation was so complex as to be unfathomable, with activity in northern, southern, western, and eastern Europe in addition to outposts in Central and South America. These exports were by no means merely culturally hegemonic actions but were closely adapted to local practices, as they were in central Europe. This process was enormously complex, and this internationalization was not without conse-

quences for the everyday practices of music (and vice versa). This musical geography reveals itself as a complex exchange between local demands for a certain artful music and musical features that were appropriate to the lived experience of a particular region. Both sides interacted in a way that is difficult to understand, and in which the competing sides cannot be definitively separated. Music in the Renaissance cannot be reduced to music in Italy (or music in France), and the opposition of the late Middle Ages (France) and the Renaissance (Italy) is an utterly flawed formulation, since the major figures of the early fifteenth century throughout Europe for the most part came from only one region. Only in one late case, that of Philippe de Montes, a northern Frenchman active in the intensely Italian-dominated court of Emperor Rudolf II in Prague, are the remains of this opposition recognizable.

Musical geography is not the only significant element. The question arises of how musical spaces in a more narrow sense should be defined. It goes without saying that music is dependent upon social configurations. Musical production and reproduction were part of a system comprised for the most part of professional specialists, although in the Renaissance there were few spaces exclusively reserved for music alone. Music rang out, with clear hierarchical gradations, in various spaces, but not in specifically musical venues such as the opera house of the seventeenth century or the concert hall of the eighteenth century. The church remained a central space for music—on the one hand, the cathedral or parish church, which had their own chapels, and on the other hand chapels attached to courts. In these spaces quite different musical practices were bound together: chant, about whose performance in the sixteenth century almost nothing is known, but which was the subject of considerable discussion at the Council of Trent; vernacular liturgical songs, established especially in regions affected by the Lutheran Reformation; organ playing, which had become a central feature of almost all churches since the High Middle Ages; and finally polyphonic musical works, whether as part of the mass or the liturgy of hours. Instruments were also put to use in these spaces, as noted by Manetti's report on the consecration of the Florentine cathedral. And the sixteenth century gave rise to other ideas about the use of music, including but not limited to the reforms of Zwingli and Calvin, which called for the complete elimination of music from religious contexts.

Beginning in the late fourteenth century, courts were provided with a new formal and social outlet for musical patronage through the new institution of the chapel, and by the start of the fifteenth century it had clearly emerged as a central locus in music history. Music was now integral to dynastic

representation and demarcation on every conceivable level. At the same time there existed at court, somewhat astonishingly, no genuine place for music in and of itself. Music rang out at precise moments upon virtually every occasion, but evidently not in contexts exclusively designated for music alone. Court music always unfolded in accordance with larger contexts subject to multiple exigencies and boundaries, whether in the form of powerful trumpets, a novelty in the regulation of time that would be subsequently augmented by percussion in the fifteenth century, or in intricate secular songs presented by only a handful of individuals. Courtly music was also characterized by linguistic conventions and idiosyncrasies, whether in the fifteenth century's preference for French music or the sixteenth century's favoring of Italian music. The presence of French chansons in northern Italy in the 1430s attests to such trends as much as the wide circulation of Italian madrigals in German-speaking lands in the 1560s. Music at court occupied no explicitly delineated sphere, in contrast to the church, in which areas such as lofts comprised distinct if not entirely separate spaces. The same holds true for music in cities, which with the exception of Italian city-states of the early Renaissance was more modest and functional and often limited to instrumental music. Such music was seldom built up into a fully realized system, and such practices were above all a feature of the religious states in northwestern Germany (Cologne, Münster, Minden, Hildesheim, Paderborn), where instrumental (and thus ephemeral) representation was practiced at court as an alternative to polyphonic music. Such examples show how the overall institutional homogeneity of musical spaces was not without certain alternatives and was not a precondition of the Renaissance but rather one of its results.

One characteristic quality of musical spaces lies in the contrast between inside and outside. Unlike almost all other sensible representational phenomena, music was mobile, and could thus be used not only in churches or courtly chambers, but in processions, grand entrances, and other actions involving large crowds. Such differences were articulated in numerous ways, and not just in the separation of "loud" wind ensembles (*musica alta*) from "soft" ensembles of strings (*musica bassa*). Throughout the Middle Ages public representations of music created new connections, evident in the spectacular Carnival processions of the 1480s in Florence, in which instrumental and vocal forms of starkly contrasting character were combined. Large festive parades such as the ducal wedding celebration in Landshut (1475) emerged as a musical emblem of the era and required enormous effort on the part of the musicians engaged in them. Even the imaginary triumphal procession of

Emperor Maximilian in the Burgkmair wood carvings shows an entire chapel "in motion" atop a wagon.

This expansion did not result in a strict separation of "inside" and "outside." On the contrary, these splendid and extravagant representations continued into the large interior spaces, even as smaller and more intimate outdoor spaces such as gardens hosted performances of madrigals. Even the somewhat inscrutable term formulated in 1552 by the idiosyncratic learned musician Adrian Petit Coclico to denote a certain type of music, namely, "musica reservata," did not aim to address the question of physical space in a literal sense.[24] Different from their use in the seventeenth century, "inside" and "outside" remained quite relative terms that led to complex exchanges and overlap rather than strict demarcation. In this way it was possible to open up the concept of space, and one of the most fascinating characteristics of the Renaissance is the way in which the era conceived of music as spatially porous, a more expansive conception than ever before.

Representation and intimacy thus stand not as irreconcilable characteristics of musical culture. If Dufay's motet *Supremum est mortalibus* was in fact heard at the 1433 coronation of Emperor Sigismund in Rome, it was for a variety of ceremonial reasons only possible at the moment in which the emperor and pope met on the steps of the old St. Peter's church. St. Peter's Square was filled with hundreds if not thousands of people, and aside from the lack of any precise details regarding the performance, the question arises of not just how many people in the audience were at this moment receptive to listening to a complex isorhythmic motet, but how many people might have even been able to hear it to begin with. Although there is no way of knowing for sure, it unlikely that such a conflict was even understood to be potentially problematic. The continuous presence of all possible gradations of music is thus a unique feature of the era, and the intricate interplay between representation and intimacy in sharply contrasting spatial, social, and personal circumstances stands as not a precondition but rather as a result of this constellation of forces.

The tendency toward precise texture in musical works and the varied practices of music making that resist being pinned down similarly stand in an unstable and at first glance confusing relationship. It is unfortunately difficult to answer the simple question of when and what instruments were used in the performances of large motets by Josquin—for example, the *Miserere mei Deus* created in the early years of the sixteenth century in Ferrara, as no reliable indications have survived, or at least the musical text itself yields no answers

on this front. Conversely, it is difficult to say what exactly would have been sung by a composer with a fine singing voice, such as Johannes Ockeghem, and whether his "repertoire" was in fact greater than what surviving compositions might indicate, and if so, how and in what manner. And the acoustic space that music occupied remains completely unclear. The quest for fixed parameters for historical reconstruction of musical spaces of the fifteenth and sixteenth centuries offers, in contrast to later centuries, countless disappointments, perhaps because there did not yet exist norms and standards such as emerged in the seventeenth century. In any case the many intertwining and opaque boundaries of the musical stand in an immediate and interdependent relationship with the fluid gradations among musical spaces. The consequential changes in the musical culture of the early fifteenth century evidently called forth a multitude of possibilities, which only in the course of a long and varied process brought about a standardization that for its part rarely dovetails with the compositional changes that took place around 1600. This multiplicity of musical spaces and boundaries, which has not yet been fully investigated in existing research and stands as one of the era's defining characteristics, would be subsequently supplanted by new systematizations.

ANTIQUITY AND CONTEMPORANEITY

Few topics have shaped the study and reception of the Renaissance more than the question of the era's relationship to antiquity. The idea that ancient civilizations were "rediscovered" during the fourteenth and fifteenth centuries has been subject to numerous corrections, especially in the second half of the twentieth century, with many noting how antiquity had never been entirely "lost" to begin with. The creation of the Carolingian empire in the eighth and ninth centuries was premised in multiple ways on Roman traditions, including with respect to music. It has been emphasized even more consistently in research that if the Renaissance did not represent a rediscovery of antiquity, it at least brought it into a new relationship, animated not by a desire to recreate ancient culture itself but rather to revive its golden age. The stance was defined not by imitation but rather by an increasingly clear and intense sense of productive competition. With respect to music, the earlier stance was forced to confront a fundamental deficit. There were sadly no sources of ancient music with which one might engage productively. Only in the realm of music theory could a relationship to antiquity play a role, but

with this exception it had, with certain limitations, a continuous presence since the founding of the discipline of music theory in the ninth century. This was largely owing to the featured role that the treatises of Boethius played in this discourse. His concepts were complemented by engagement with Greek music-theoretical texts, at least in the regions around Venice and Padua during the fifteenth century, and granted greater significance following the Ottoman conquest of Constantinople in 1453. Greek scholars who emigrated to Venice and from thence to points farther west brought with them not only linguistic skills but also, as has been demonstrated by recent scholarship, knowledge of Greek writings on music and even the physical texts themselves. The meaningful connections that may have resulted from these interactions have only begun to be studied. Isaac Argyropoulos (d. 1508), imprisoned by the Ottomans in Constantinople in 1453, was active at the court of the Sforza family in Milan beginning in 1456 after being ransomed, and from 1474 was at the papal court in Rome, where he distinguished himself with a significant treatise on human dignity. But he was not just a scholar with Greek linguistic skills, but also an organ virtuoso whose abilities caused quite a stir as late as the 1490s. It is difficult to imagine that he did not have some sort of impact on the musical cultures of Rome and Milan (with diffuse influence on the work of Gaffurius).

Upon closer inspection it becomes evident that new and decisive relationships with antiquity appear in musical scholarship—for example, with respect to the modal system—but come about relatively late and often in a generalized manner. As a result, much research has operated under the assumption that an explicit and recognizable relationship to antiquity existed only in music theory and that music was thus somewhat "belated." Even in the middle of the sixteenth century the thesis of Heinrich Loriti (1488–1563), known by the name of his native canton, Glareanus, maintained that there were not eight but rather twelve modes,[25] a concept developed according to ancient theories, whose tonal system in the end could not be uncovered but only reconstructed in a very vague manner. It is also notable that these concepts appeared in the writings of a musically literate scholar—and a poet laureate and university affiliate—whose isolated position in musical scholarship of the sixteenth century has led to considerable discussion of the status of his book and his musical competence. Unlike literature and philosophy, in which ancient authors influenced various linguistic traditions, or ancient architecture, sculpture, and painting, which influenced art making in fundamental ways, music did not have similar points of reference to fall back on.

Only in the late sixteenth century, as will be discussed later, did antiquity come to influence the musical imagination in an unconventional yet sustained manner.

This deficit of knowledge, which in many ambitious studies of the Renaissance is posited as an argument against using the term in relation to music, reveals itself as complex and problematic, especially since contemporaries were quite aware of it themselves. Only in the fifteenth century did scholars begin taking stock of the few surviving fragments of ancient "notation," and until the seventeenth century much of musical scholarship was at a loss as to how to make sense of them. The music revealed nothing, and it was impossible to make serendipitous "discoveries," such as Poggio Bracciolini's identification of Quintilian's *Rhetoric* in the library of St. Gall in December 1416, immediately and eagerly heralded in written correspondence. One could not visit a ruined building, or even a surviving one considered to be authentic, such as Filippo Brunelleschi's Florence Baptistry. There were no sculptures such as *Laocoön*, discovered on January 14, 1506, in an underground chamber in a vineyard in Esquilin and celebrated in Rome and elsewhere as a revelation. There were no paintings from which at least fragments could be recovered, such as the famous surreal grotesques in the Domus Aurea of Nero, which were uncovered piece by piece beginning in the 1480s. Ancient music was ultimately rendered mute, since it had no evidence other than visual representations and texts. This loss stands as a special and unique characteristic, but the use of this condition as grounds for the exclusion of music from its surrounding circumstances is more a product of the influence of the idealistic aesthetics of 1800 than a reflection of conditions in 1500.

As early as the later fourteenth century, with its new empirically minded understanding of perception—specifically, in the Aristotelian realm of northern Italy, and above all the university at Padua—this circumstance had already come to be viewed as a distinct consequence of music history. Born in the north, Johannes Ciconia (ca. 1370/75–1412) first served in Padua for the Carrara family and following the conquest of Venice in 1405 worked for the new elite of the Venetian oligarchy in a new mode of musical writing that was different from fourteenth-century practices in fundamental ways. Ciconia's works (whether a mass setting, a Latin motet, or a folk song) represent a fundamentally new way of realizing a text in music, making it audible in an elemental sense.[26] Music appears here as a way to give sensuous form to a text, to reproduce it in the presence of listeners. This procedure was not of a piece with polyphony, which in general consisted of three-voice settings,

since these were not focused on the intelligibility of text in the sense of audible comprehension. The works of Machaut, also quite present in northern Italy, stand as a proof of this. Among the qualities of Ciconia's style is thus a desire to dispense with this tradition of complex composition. The accompanying simplification—in contrast to the incomparably complex contemporaneous works of the French followers of Machaut, Ciconia's works seem almost banal with respect to form and technique—demonstrates even six hundred years later an elemental discovery of the dimension of sound, closely tied to a fundamentally new relationship to text setting (musical example 2).

This fundamental transformation of perception does not comprise a "discovery" within the boundaries of the musical work, but it reflected a new and changing way of perceiving reality more generally. At the very least it is tied foremost to a republican culture of permanent public representation and self-fashioning at all levels. The related change in musical perception reveals itself as decisive on a deeper level. In the case of Ciconia's compositions, their sonic technique and declamatory text setting make it clear that music is to be produced in the presence of listeners and is directed at them such that, in the best-case scenario, they will be convinced by the music. This performative and persuasive habitus of music is connected to the prestige previously claimed and regulated as the sole province of rhetoric beginning in the fourteenth century, with Giotto as one of its most notable exponents in painting. Ciconia's works complete this shift to persuasive musical representation in a way that leaves in its wake all earlier attempts in the fourteenth century in accordance with the received norms of polyphonic composition. This new direction of music not only lent the musical work a different status, but was closely aligned with the ancient concept of rhetoric. Different from the case of painting, in which Alberti noted, viewing the (lost) Navicella mosaic of Giotto in Rome, how the presentation of multiple affects through a central concept was a characteristic of representation (for in painting this simultaneity was completely possible, such that the same affect could be expressed through the depiction and arrangement of multiple figures), music concentrated not on the plural, but on the moment—the absolute present, the singular. It was possible to bring these into harmony with concepts borrowed from the ancient world—that is, the simultaneous and varied presentation of a single affect for an observer as well as its realization in the moment of presentation for a listener. This recourse to rhetoric lent music a completely new and hitherto unknown form of contemporaneity.

MUSICAL EXAMPLE 2. Johannes Ciconia, *Ut te per omnes / Ingens alumnus,* measures 1–10 (ed. Margaret Bent and Anne Hallmark). At the very beginning of the work a completely new sonic technique is recognizable. The concatenation of small units leads to an intensification of the sound, evidently taking into account the participation of instruments. This reflects back on the musical handling of the language, which is not fundamentally different from this model.

For Ciconia this habitus was part of a broader legitimating musical discourse that also had its origins in antiquity. This new text-oriented mode of musical composition was aligned with a learned tradition with a direct connection to the ancient world through the concept of "right" proportion. Ciconia's wide-ranging writings on music, which contain only a brief passage on proportion, demonstrate this in a remarkable way.[27] Curiously this particular constellation of concepts in Ciconia has not been exhaustively discussed in previous research—that is, the evidence of complex mensural proportions in his works, above all in the motets, and the detailed explanations that accompany them in scholarly writings. The fact that these were evidently compatible has everything to do with the roots of both aspects in ancient models, since the idealized proportions in music could thus be given perceptible form, with music thereby drawn closer to rhetoric and more available for representation. Nevertheless he asks in his preface with regard to the lost status of ancient music, whether anyone had previously heard the "declinationes musice que sunt in cantibus"—that is, the musical "declinations" that figured in contemporary song.

The new contemporaneity of music went hand in glove with the assurance that musical performance possessed its own primary meaning in a rhetorical sense. In the 1470s, composer and theorist Johannes Tinctoris (ca. 1435–1511), also from the north but active in Naples, authored a counterpoint textbook that remained unpublished. The center of the work, dedicated from the outset to Horace, are its much-discussed eight rules, and in particular the claims in the last rule regarding "varietas." The author enumerates six exemplary compositions by name, in pairs corresponding with the three polyphonic genres of mass, motet, and chanson, of which only one has survived in written transmission.[28] What is important is the fact that the rhetorical concept "varietas"—looking back on the previous forty years, as he notes—is posited as the measure of compositional success. "Varietas" exists within a wider network of representational rules—between absolute and perfunctory fulfillment of norms ("satietas") and their complete and obfuscating abandonment ("obscuritas")—as the sole principle of legitimate deviation from norms by which one can achieve pleasure ("delectatio"). This rule of Tinctoris is not just significant as the first explicit and aesthetically oriented term to be used as a measure of compositional quality. What is more, it contains within it the concept, first realized in composition by Ciconia, that music orients itself outwardly toward listeners. The performative and persuasive action—as explicated by Leon Battista Alberti in his 1436 treatise on painting, *Della*

pittura (exactly forty years prior to Tinctoris and precisely the period that he references in his discussion)—uses rhetorical categories only as a background, whereas Tinctoris explicitly invokes Cicero and Quintilian. Such a fundamentally new perspective on the musical work must have had significant effects on music as a whole. Thus what stands as most significant is not the reception and engagement with writings from musical antiquity, but the adaptation of categories that were never intended to apply to music in the first place. "Varietas" stands as a term with special meaning for the era, denoting an elevated sense of plurality with dimensions not defined by clear contours within the boundaries of the musical.

The fact that musical contemporaneity was produced and created with the assistance of intellectual concepts from antiquity was a development with momentous consequences. It not only affected the musical work but had lasting effects on musical consciousness in all other areas of music making. The incorporation of music into the great festive occasions of the Renaissance provides one illustration of this. On February 17, 1454, a large celebration took place in the Palais du Rihour in Lille through which Duke Philip the Good hoped to inspire a crusade against the Turks, who in the previous year had conquered Constantinople, culminating in man-to-man duels with Sultan Mehmed II. At the center of this exorbitant and incomparable occasion planned by Olivier de la Marche, inspired by the duel between Aeneas and Turnus recounted in the *Aeneid,* stood the symbol of the pheasant. Music also played a meaningful role, as documented by numerous reports. None of it has survived, although it has been verified that Guillaume Dufay was responsible for at least four different works for the occasion and that one of the most well-known songs of the fifteenth century, "L'homme armé," was likely created for this event. What is notable is the fact that music—as sonic signifier, as instrumental accompaniment, or as complicated and fully realized musical work—contributed decisively to the character and atmosphere of this specific occasion. Music was no longer an ornate adornment but rather a substantial component with a concrete role in a complex and extravagantly executed event. In the century prior such a function for music would have been unthinkable.

This new presence of music can be understood as the product of engagement with antiquity, and it led to fundamental changes—namely, that music was now directed at a "listener," however this was defined. Several compositions from around 1500 provide instructive evidence that this engagement was pursued in a highly self-conscious manner. During the entirety of the

Renaissance, at least until the end of the sixteenth century, one can observe a strange hesitancy regarding the musicalization of ancient texts. Most research comments on this fact with a certain degree of befuddlement. But if engagement with antiquity led to an awareness of irrevocable musical loss and thus to a new sense of musical contemporaneity, this reluctance makes more sense. In literature and architecture, ancient works were not merely copied but rather incorporated into new works. Setting an ancient text to music, by contrast, seemed more like making a copy from which one would want to distance oneself. If one had recourse to ancient sources—for example, the Dido's lament by Isabella d'Este sung in Mantua—it was presumed that one could dispense with textual fidelity to a source. In the exceptional cases when ancient texts were used as the basis of composition they typically have the status of an exemplar.

Examples from around 1500 display two contradictory interests and approaches. In the intellectual circles of Emperor Maximilian, ancient poetry, above all the odes of Horace, were set to music with multiple parts—that is, not in the non-notated practice of monophonic song with accompaniment. At the center of this stood Petrus Tritonius (ca. 1470–1524/25).[29] It is not clear whether the protagonists truly believed that they were approximating the music of antiquity. It is just as likely that the idea itself was inspirational, and that these metrical structures coupled with the possibilities afforded by mensural notation led to the creation of multipart settings, at first in the simplest form of only two rhythmical values. This provided a path that had not been previously present in polyphonic practice, or at least only present in a subordinate role in the form of attention to metrical relations as a mere analogy. It was doubtless an experiment and in the history of sixteenth-century music stands as a curiosity. The cost of this analogy was considerably high: the complete renouncement of the possibilities of elaborate polyphonic settings in a musical work. Even when notable composers engaged in the practice (such as Martin Agricola or Ludwig Senfl), it appears not to have been regarded as an experiment. The procedure has less to do with the reception of antiquity than with the construction of a metrical-rhythmic analogy with respect to the possibilities of mensural notation. It was also inconsequential, since beginning in the 1530s the madrigal developed entirely different techniques for the interaction of meter and music.

The second discernible way also consists of an experiment, but one of a very different type. From 1500 there is a small group of musical settings of ancient texts, which, differently from the ode, did not abandon the

possibilities of polyphonic practice. One such work is Heinrich Isaac's setting of Seneca, *Quis dabit pacem populo timenti* (from *Hercules Oetaeus*), composed in Florence in 1492 as a funerary tribute for his patron Lorenzo de' Medici. Another is a small group of related settings of short excerpts from Virgil's *Aeneid,* perhaps originating at the court of Isabella d'Este, or possibly at the court of the governor of the Netherlands, Margaret of Austria. At the center of the otherwise authorless pieces are two works by Josquin Desprez setting verses from book 4, *Fama malum* (4.174–77), and especially the lament of the abandoned Dido, *Dulces exuviae* (4.651–54). This four-voice work, the key moment in which Dido decides to kill herself, is musically unusual in formal, tonal, and technical terms.

But it does not break the rules then in place for four-voice polyphony. Josquin handles the text the same way he had done on many other occasions in his ambitious motets. The ancient text thus, quite differently from the ode compositions, did not change his "writing style" in any meaningful way. But it thus becomes apparent that the setting is not a reconstruction of a lost musical phenomenon, but rather an entirely intentional application of contemporary composition to an older text (musical example 3).

The musical reveals itself as an attempt to make the text rhetorically relevant, to lend it presence, and represent it through compositional means. To this end ancient rhetoric offered the category of ekphrasis or *descriptio,* above all understood as the evocative description of images, by which one could turn listeners into viewers. Beginning in the fifteenth century, ekphrasis as a rhetorical technique played a decisive role in discussions of painting, which as an "ars mechanica" was at first not regarded as theoretically sophisticated. And it is no coincidence that the first descriptions of paintings are not found in texts, but rather this consciousness was developed in paintings themselves—for instance, in images of a church window and a wall fresco evident in Jan van Eyck's *Annunciation* (today in Washington, DC). In music, ekphrasis appears to have had a similar dual function. On the one hand, it was the premise for the description of compositional practices that went above and beyond the technical. The exhaustive "work discussions" in Glarean's *Dodekachordon,* the first of its kind, demonstrates this clearly. As ekphrasis, composition itself could be grasped: as musical illustration of the content of the text via a new "text" and thus approaching the rhetorical technique of outbidding. Josquin's exemplary settings of ancient texts demonstrate this precisely—that is, the illustration of the text via the most advanced and sophisticated compositional means, namely, the motet, and thereby

MUSICAL EXAMPLE 3. Josquin Desprez, *Dulces exuviae,* measures 1–10 (ed. David Fallows). What is striking about Josquin's setting of Virgil is not the reconstruction of ancient techniques, as was the case with metrical experiments involving odes. As evident in the imitative beginning, the piece is indebted to the contemporary practices of the motet. It thus comprises a conscious confrontation between an "old" text and a "new" technique, with the intention of exploring this distance.

creating an absolute presence. Such a presence could be produced only by music because it had a distance from the ancient source of the text. The spectacular, experimental character of the Virgil settings, and especially those of Josquin, which not incidentally were collected in a single manuscript, lies in the way they explore and clarify in a systematic and intentional manner the relationship between contemporary practice and antiquity. But here the complex polyphonic setting in the sense of ekphrasis becomes a means by which the era can clarify and use the loss of musical antiquity as a specific musical quality. If it had been a significant interest since the fifteenth century to engage antiquity in a productive and varied competition, music and music alone was uniquely positioned to fulfill this role in an unsparing and radical manner. With this background in mind, Josquin's settings of Virgil thus present themselves as demonstrations. The distance is not bridged, but rather made accessible in a way that is possible only for music. The expressionistic portrait of Virgil created by Luca Signorelli (ca. 1450–1523) for the Cathedral of Orvieto is unable to accomplish this, since it consists of an imaginary image in which distance cannot be made present (fig. 8).

The ease with which musical writings, including music theory in a narrow sense, reconcile the experiential horizon of antiquity with contemporary musical practice is premised on the special constitution of music itself. This is evident in authors such as Franchinus Gaffurius (1451–1522), whose 1492 *Theorica Musice* is an especially striking example, but also in the *Recanetum* (1533) of the Augustinian choirmaster Stefano Vanneo (ca. 1493–after 1540). The connection to the discipline of rhetoric made it possible for music to be

FIGURE 8. Luca Signorelli, *Vergil*, fresco, 1499–1500, chapel of San Brizio, Cathedral of Orvieto. In its expressionistic gestures the Virgil portrait created by Luca Signorelli is an oddity, but it remains, despite the special demeanor and setting, a picture of the present, since the painting itself—regardless of the work scenes that surround it—is unable to create any sense of distance.

understood as a new form of presence, and with this background it could be productively separated from antiquity, whose music no longer existed. This awareness of a wider experiential realm legitimated by ancient rhetoric sufficed as the basis for protagonists from the late fourteenth and the middle of the sixteenth centuries. With the exception of the ode there were no other systematic approaches to ancient texts, and even the new conditions of the vastly different French chanson and the madrigal after 1500 did not lead to further changes in this regard. Only in the second half of the sixteenth century do signs of discontent begin to accumulate, which led to a new reflection

upon antiquity and thus to an entirely different breakthrough of the ancient world into musical culture. This was by no means a sign of "belated" musical reception of antiquity, but rather a symptom of a fundamental crisis in perception, whose end result was a spectacular new musical-literary genre, opera. By this point the premises of the Renaissance had been left behind.

Social Reality and Cultural Interaction

THE SYSTEM OF THE ARTS

Since antiquity, debates over music have been characterized by two properties whose relationship continues to shape music history well into the twenty-first century and which are of the greatest and most productive significance. On the one hand, stand the great effects that music is able to produce on the spirit and soul of mankind. These effects are considered elemental and somewhat magical, such as in the story of Orpheus, whose singing was able to calm and soothe Pluto, the ruler of the underworld. And used for the wrong purposes they could be dangerous, such that Odysseus had to stop up his ears in order to endure the destructive sounds of the sirens without being harmed. Music lay at the source of inspiration itself, and the three Muses concerned with it—Euterpe, Erato, and Terpsichore—derived their powers from the Hippocrene, the stream brought to life when the winged horse Pegasus alighted atop Mount Parnassus. On the other hand, in the circle of the Pythagoreans, music was a rational science, based on the order of numbers, with the elemental relationships in the intervals of the octave (2:1), fifth (3:2), and fourth (4:3). Music existed in an epistemological relationship with the numerical sciences of arithmetic, astronomy, and geometry. Thus began a long, complicated, and somewhat contradictory process, essentially begun by Plato, at the end of which in late antiquity it was concluded that human knowledge had withered through a focus on acquisition and exchange, as opposed to the pursuit of knowledge in and of itself. These divisions were tied to classifications through which knowledge was ordered, resulting in the formation of disciplines called "artes." These arts comprised, as noted by Cicero, all of the various activities and undertakings of mankind. Since they were all

premised upon reason, they were characterized as "liberal" or "free." Music thus belonged to the *artes liberales,* since they were worthy of a free man—in other words, representing an undertaking not concerned with acquisition, exchange, or bodily labor, but rather with knowledge.

Late antiquity's system of the *artes liberales,* defined by Martianus Capella (*De nuptiis Philologiae et Mercurii*) in the middle of the fifth century as seven, a number not entirely binding but widely acknowledged and accepted, consisted of the trivium of the elementary sciences of grammar, rhetoric, and dialectic (that is, writing, speaking, and thinking) and the quadrivium of arithmetic, geometry, astronomy, and music (that is, the sciences of numbers, bodies, spaces, and their ordering). In the Middle Ages this classification came to be not just accepted but was emphatically strengthened. The musical writings of Boethius, a key touchstone in the transmission of the system of the arts, were canonized by the same Carolingian intellectuals who were interested in codifying chant as the purported legacy of antiquity. It is no accident that the earliest surviving witnesses of the texts of Boethius and Martianus as well as the first neumes all derive from the ninth century. Music as a free undertaking of knowledge production was not only held up as a rational undertaking of mankind but was reflected in the music that rang out in praise of God in liturgy. The differentiation among *musica mundana, musica humana,* and *musica instrumentalis,* as outlined by Boethius, reflected this, although there were even further gradations of musical reality, from epistemological categories to the "created" music of mankind. As first codified by the Carolingian scholar Regino von Prüm (d. 915), this resulted in the differentiation between *musica naturalis,* the divinely inspired chant, and the mathematically derived *musica artificialis.* The constitutive separation of reason and emotion, between *ratio* and *affectus,* is reflected by this construction and closely tied to the Boethian classification of music. The Carolingian scholars further maintained that this system was contingent and free of any contradiction.

But soon certain contradictions entered in, since, on the one hand, music participated in the rational sciences, but, on the other, thanks in part to the invention of notation, the dynamics of a separate musical art history began to unfold and distanced it not only from monophonic chant but from the premises of the other *artes.* These two processes—the one by which musical scholarship was inaugurated through the canonization of Boethius's writings in the ninth century, and the other the rapid development of written music itself—did not proceed entirely in tandem, but this was perhaps not even

perceived as a fault. As long as the individual who created, wrote, or composed music did not exist as a discernible figure—and the withholding of names in the transmission of polyphonic music well into the fourteenth century demonstrates this clearly—then no actual contradiction of scholarly concepts could exist, and they stood immune in relation to musical reality, in which a moment of activity would contravene the principle of an *ars liberalis*. In the fourteenth and even more so in the fifteenth century this situation changed substantially, with significant consequences for musical writing, composed music, the working individual, the system of the arts, and all aspects related to them.

One initial essential shift was the invention of mensural notation around 1280, which fundamentally changed the relationship to musical time, of which more will be said later. In this case it is important that with this new form of notation the history of polyphony entered a new phase. For the first time it was possible to create a truly individualized composition based on newly available musical decisions and directions. Astonishingly, preoccupation with mensural notation became an integral part of musical writing, and in the fourteenth century, the very period of its theoretical flourishing, it could justify its own existence. This penetration of a primarily compositionally defined practice into theoretical writings was perhaps the most massive breach of the tradition of the *artes*. This was intensified by a directly related phenomenon. The discussion of notation-specific problems remained pointless without illustrations, and thus concrete compositional examples began to infiltrate these writings—that is, examples of the practice of composition entered into musical scholarship, with the most prominent case being the philologically complex *Ars Nova* treatise of Philippe de Vitry from the second decade of the fourteenth century. This breakthrough of musical-compositional reality into theoretical expressions, which had not existed in the realm of chant, marked the beginning of a fundamental paradigm shift within music as a whole. The differentiation of compositional practice accordingly led to a reaction within scholarly discussions, even if these at first focused only on technical matters.

With the creation of a new realm of musical experience after 1400—that is, the conception first dramatically sketched by Ciconia that composed music was the representation of a text for listeners—the problem once again became pointed, since musical scholarship, still dependent upon the *artes liberales,* had no categories with which to make sense of this. The term "varietas," as introduced by Tinctoris in 1477 as a rhetorical categorization,

represents perhaps the first attempt to overcome the challenges of a compositional event. Even though the compositional rules that he posited remained quite elementary, and even though his discussion of concrete examples rested on technical questions of notation, his conclusions point to a use of music in the sense of a new experience of reality. The parallels with the introduction of the term "varietas" to painting by Alberti are significant, but represent a change in perception only in the most elemental sense. In his 1486 treatise *De hominis dignitate* (On the dignity of man), Giovanni Pico della Mirandola, murdered in 1496 and one of the *incunabili* of Florentine Platonism, described *varietas* as one of the central qualities of the protean nature of man and of significant consequence for these findings as a whole. The attempts to determine anew the dignity of man—and in 1452 Giannozzo Manetti had already devoted a treatise to the subject—led him in the very introduction of his posthumously published text to the realization that it was not the unity but rather the variety of his possibilities that distinguished man: "varia ac multiformis et desultoria natura" (the multifarious and multiform and mercurial nature).[1] The fact that this treatise was produced only ten years after the counterpoint handbook of Tinctoris is hardly as coincidental as the fact that Naples—the point of origin for the treatise, and where Franchinus Gaffurius spent time from 1478 to 1480—had already seen the founding of an academy in the spirit of Neoplatonism, the Academia Ponaniana of 1458. In Castiglione's *Book of the Courtier* (1528) the term "varietas," also broadened to include varieties of music, is employed as a signifier to describe courtly life as a whole, uniquely able to lend contours to its many conditions and realities.

The introduction of a rhetorical term as a norm for compositional and receptive behavior brought music into closer proximity with the other arts, whose essence no longer lay primarily in their ability to give presence to things by analogy, but rather to give rise to sensuous effects on individuals. This process contained a systemic logic and coerciveness. For as the result of rational concerns promoted above all by scholastics, the soul was separated into individual "powers," which accommodated and to a large degree regulated different kinds of sensuous perception. By contrast, a substantial feature of changing conceptions of humanity, which first reached a high point in Pico della Mirandola's *Oratio,* lay in an emphasis on the unity of the soul and its epistemological faculties. Thus the impressions of the senses could be brought together, and in rhetoric they found an instance of a similar instrument of aesthetic control. At the same time perceptions entered into a competition

with each other, a *paragone,* forcefully articulated by Leonardo da Vinci's well-known treatise on painting (posthumously assembled from fragments), which, owing to painting's clear relationship with nature, is decided in its favor. An imaginary unity of the arts as human activity with the capacity to produce effects on the senses was thereby given an immediate emphasis. In the case of painting such theoretical efforts were part of an astounding success story, which reached a pinnacle in the monumental collection of painters' lives assembled by Giorgio Vasari (first published in 1550 and produced under the patronage of the Medici family), in part owing to its linkage of sensuous experience with hagiographic idealization. Beginning with Alberti, success lay in creating a theory for art forms that were part of the *artes mechanicae,* the product of "unfree" labor and tied to physical labor, which at first seemed to resist theorization. The rise of painting as an essential characteristic of the Renaissance affected the wider kinds of perception, the possibilities of representation, and the relationship to nature, but also the social position of the painter in society and his duties and modes of existence.

With music, however, this reorientation toward human perception proceeded with more consternation, imbued with ruptures and uncertainties. The secure status of music as one of the *artes liberales* granted it the privilege of a free undertaking. This conception had been posited as early as the ninth century in the distinction set forth by Aurelianus Reomensis between the *musicus,* who is part of the musically learned, and the *cantor,* who must make himself the tool or instrument of *musica naturalis.* The cantor was not only placed in a lower social position: he implicitly claimed the status of the liberal art, in part thanks to the wider status that music as a whole possessed. With the development of the musical work, however, there arose a somewhat unbridgeable gap between traditional writing and the new demands presented by a changing musical reality. The shift toward the sensuous presence of music articulated by so many witnesses (not all of them written) in the fifteenth century, including musical scholarship, in the end helped bring about the loss of music's erstwhile special status. This loss not only represented a certain social descent but also occasioned a certain lack of orientation. If theoretical writings were to keep up with these rapidly changing claims it was necessary to make difficult and complex accommodations. For example, a pragmatist such as Giovanni Spataro (1459–1541), the cantor of S. Petronio in Bologna, set his sights on the instance of musical ability. We have him to thank for not just his level-headed *Trattato di musica* (1531), but a wider correspondence at the heart of which stands a turn toward composed music.

The increasing focus of musical discussions on compositional work and the possible perspectives of perception rendered moments of inspiration more important, first clearly articulated by Glarean but also discernible in earlier sources. The woodcut illustration that served as the title page of Stefano Vanneo's 1533 musical treatise shows the author instructing a group of students (fig. 9).[2] The group stands at the foot of Mount Parnassus, upon which Apollo with his fiddle and the nine Muses are seated. One of the boys is filling a barrel with water from the Hippocrene. There can be no clearer demonstration of the connection between musical knowledge and the moment of inspiration, but in the end this undermines music's status as a liberal art: where craft and inspiration are present there is less space for free and unfettered activity.

This reorientation was connected not only to social consequences for the actors themselves—that is, the composers—who at the beginning of the fifteenth century were honored not for their musical undertakings, but thanks to their clerical careers, which had meant that their social status did not depend upon their musical accomplishment. In this way music in its many profusions became more of a dynamic maelstrom of changes and reevaluations. Instrumental musicians more clearly reclaimed their own status, which in its emphasis on "craft" resembled the mechanisms by which painters had been elevated, going so far as to call upon the Old Testament models and King David in particular. Everyday musical experiences were not only made note of but cultivated and reflected upon, including in the realm of painting. The turn toward musical themes, musical scenes, depictions of instruments, and many other derivative musical "illustrations" is already noticeable in the fifteenth century and by the sixteenth century impossible to ignore. To the extent that the "making" of music was capable of depiction it was also deemed worthy of discussion and evaluation. Titian's depiction of Venus and Amor quite consciously includes a lutenist, playing from written notation no less (fig. 10). By contrast, Venus holds a flute in her hand, perhaps an erotic symbol, and also has written notation in front of her. This is an astounding depiction of a musical situation for which there is otherwise no other explicit evidence.[3]

The *artes liberales* lost their prestige, in particular in the realm of music. And although it is something of an overstatement, it could be argued that music has yet to recover from this loss into the present day. The newly established system of the arts consisted of unequal factions, since the ennobling of painting benefited from the scholastic valorization (not without its skeptics) of sight; while the turn to the musical work presented musical scholarship

Pieridum custos Phœbo residente cathedra.

Colligite o iuuenes & tempora cingite sertis.

Vanneus hic Stephanus uiolas & candida donat.

Stephanus Vanneus.

Lilia :purpureis cunctis cum floribus una .

FIGURE 9. Title page, Stefano Vanneo, *Recanetvm de mvsica avrea* [...] (Rome: Doricus, 1533), unidentified woodcut, 24.5 × 16.5 cm. Stefano Vanneo (ca. 1493–1540?) was a *frater* or lay brother of the Augustinian hermits in Ascoli Piceno and was active as a singer and organist at its cathedral. The title of his *Recanetum* is a play on its place of origin (Recanati). The work is divided into three books (elementary lessons, mensural notation, and counterpoint) and is undisputedly pragmatic in orientation.

FIGURE 10. Titian Vecellio, *Venus with Amor and Lutenist,* oil on canvas, 150.5 × 196.8 cm, 1560–65, Cambridge, Fitzwilliam Museum of Art. Titian (1488/90–1570) treated the motive of the reclining Venus in various ways, inspired by Giorgione's *Sleeping Venus.* What is notable is the interchangeability of the lute and organ, both of which instruments could be most immediately connected to the concept of *virtus.*

and with it the definition of music as a concept with a nearly impossible task that could result in a loss of prestige. Guillaume Dufay no doubt considered himself to be something of a musical scholar, but he did not have the ability to articulate this in the social and structural context of his clerical lifestyle, whether as a *musicus* or as a composer. By contrast, Orlando di Lasso conceived of himself not only as a composer, but his existence was shaped by numerous advantages, gifts, and even a title of nobility, by which he attained a status comparable to his employers and patrons. While Dufay was at least somewhat concerned with bringing his musical undertakings into harmony with a traditional concept of music—as expressed in a lost theoretical treatise—the well-read, well-educated, and multilingual Lasso evidently showed no such concern. Thus while compositional and musical practice had achieved a certain success, musical scholarship remained to a certain extent self-conscious. In the end the system of the arts presents a considerable chal-

lenge for music, to the extent that new encyclopedic writings such as Athanasius Kircher's *Musurgia universalis* (Rome, 1650) are compelled to offer solutions to this problem by incorporating concrete examples of composed music into their anagogic-musical conceptions of the world.

A fundamental change in the Renaissance was a turn toward the sensuous dimension of music, its identity as an event. In the end this loosed the discipline decidedly if not completely from the medieval system of the arts. But its new placement within a system that related the human soul to human senses opened it up to a new dimension of competition as well. Music now had to compete with other human endeavors, and the standards of rhetoric would decide to what extent it succeeded or failed in relation to other art forms. The collective conception of the senses opened a new dimension of experience for music that could not have existed previously in the context of the *artes*. At the same time, this difficult transformation of systems was understood to be a special challenge. It should not be overlooked to what extent this change unleashed a somewhat productive anxiety that can be observed at many different levels. Two notable examples will suffice. The intense quest for compositional norms that pervades the extensive output of Josquin Desprez around 1500, evident above all in the selective setting of texts in imitative textures, is a clear example of an attempt to define a genuine musical language founded on the mechanisms of rhetoric. The somewhat mystical and in any case numinous musical sense in the works of Orlando di Lasso's final years—especially the *Lagrime di San Pietro* (1594), in which the perils associated with sacred madrigals are brought to the surface—demonstrates how even the most individuated modes of musical writing had not abandoned the idea that music both represented and participated in a larger world order, and was in fact responsible for its production in the first place.

This numinous moment not only represented a new dimension for composition but was also oriented to the character of compensation. If music was once again placed in wider context, newly unfettered from the *artes liberales* and into the arts, as noted by Neoplatonists such as Marsilio Ficino, this did not occur on the basis of its rational qualities. Much more central were its numinous and even magical aspects—in other words, the irrationality of music stands as one of its essential properties. In this aspect lay the new, vaunted wholeness that threatened to overwhelm it following its release from the *artes liberales*. It was not by accident that Castiglione invoked the spirits, the "spiriti" of music or, in fact, the spirits of various musicians. In the sense of *varietas* it can be said that this new orientation, quite in contrast to the

case of painting, did not create a coherent system and perhaps did not even want to create one. The system of the arts was based not on the actual integration of music, but only on its coming into a closer relationship. This would change significantly only in the eighteenth century with the idea of the arts collectively imitating nature, with the paradoxical result that music would be considered an allegedly autonomous art that could be exempted from such imitation. Music was thus more decisively separated from the other arts than it had ever been at any moment in the course of the Renaissance.

MUSICAL ELITES

The Renaissance era expanded the boundaries of the musical in a way that is closely related to music's place in the nascent system of the arts—that is, in a theoretically grounded interest in sensuous perception. The expansion of boundaries was also propelled by changing social realities and is thus similarly related to the ongoing professionalization of music. This change was originally attributed to the particular challenges that accompanied the musical work, but in fact it did not come about because of this alone. On the contrary, the Renaissance is characterized by comprehensive changes to the institutional relationships that underpinned all areas of musical reality. Thus, on the one hand, the question arises, on what structures did this new professionalism model itself, or, in other words, how did it become part of musical reality? On the other hand, the second closely related question—how was this elite class of musicians recruited and developed?—is more difficult to answer, and can be approached only in relation to the first question.

Demanding polyphonic music required, with the exceptional case of music for keyboard instruments and a few gut-string instruments, a group of well-trained specialists, typically singers. These singers had to be doubly literate, fluent in Latin as well as the complexities of mensural notation. They also had to be able to reproduce individual parts of polyphony, and beginning in the late fifteenth century this meant using completely separate part books. Composers were an even more specialized and knowledgeable subset of these specialists, and from the start of the fifteenth century they stood atop the musical hierarchy. In contrast to the other arts, whether the artist's workshop or the mostly solitary practices of poets, musical works required a complicated collective organization in order to be reproduced. Their internal structures needed to be arranged in a clear and hierarchical manner, since the

presentation of a mass setting or a motet necessitated a definite form of inner organization in order to be deemed a success.

The model for this form of organization was the chapel. The chapel, a term with a difficult if well-documented history rife with problems, has its roots in the fourteenth century and is indebted to a certain form of ecclesiastical architecture. Since Carolingian times—that is, since the beginning of the written transmission of music—it was understood that for the presentation of complex or demanding Gregorian chant it was necessary to assemble a special and distinct group of clerics. These clerics would be engaged in wider liturgical matters but especially concerned with music. As early as the ninth century, in this environment there arose in cloisters and cathedrals, at least as a prospective concept, evidence of the elaborate coupling of numerous groups of voices, albeit without fundamentally altering the character of monophonic chant. This was true of the singers in the dedicated group of clerics who worked in service to the pope. A fundamental change took place in the wake of the curial reforms that affected the papal court during the first period in Avignon (the first decades of the fourteenth century). Owing to the effect of the new possibilities afforded by mensural notation, the group of clerics who supported papal liturgy was divided into two groups: one was responsible for liturgical duties that included some musical aspects, while the second was primarily focused on musical concerns albeit with distinct liturgical functions. This is an astounding development not the least because in a papal constitution of 1324/25 written by John XXII (1316–34) the new possibilities of mensural notation and the temporal division of chant had been the subject of stern critique.[4]

It is thus not easy to determine the reasons that this separation took place or to take stock of this musical differentiation, and whether it had anything to do with the presentation of complex polyphony. But the separation of liturgical responsibilities and musical duties suggests, regardless of the actual intentions of the pope, two important consequences: the turn toward a decidedly musical professionalization and the spread of an organizational model that would hold sway for almost three centuries, and whose effects are still felt in the present. This papal model had yet another notable quality. Ambitious singers were part of a clerical elite, concerned with liturgy (and thus in musical terms, chant) and the administrative demands that went along with it. Professionalization was thus closely connected to a form of organization that had already been tested somewhat. In the fourteenth century the papal chapel already stood as an exemplar for secular residences as well. Similar

organizations were created at some French courts, the most significant being the chapel of the Burgundian duchy. The differences from the papal model are also significant, as they did away with the double structure that had been introduced. There was only one chapel, a college of religious concerned with musical and liturgical representation. But another dimension also remained. The clerics of the papal chapel belonged to the inner circle, to the "familia" of the pope, and were his "continui commensales" or constant companions at table. They thus enjoyed high social prestige thanks to their immediate access to power. This privilege, perhaps a residual effect of the *ars liberalis*, remained a characteristic of the institution of the chapel in courtly contexts, and after the spread of its corporate structure became part of the identity of the kapell-meister (*magister capellae*). The personal relationships that the cleric Philippe de Monte in Prague and Orlando di Lasso (no longer a cleric at the time) in Munich enjoyed with their patrons even in the late sixteenth century are powerful evidence of this special status.

But the success of the chapel model throughout Europe first began in the fifteenth century, favored by the new reforms of Pope Eugene IV (1431–47). Eugene came from the influential Venetian mercantile Condulmer family and thanks to his experiences with the Republic's relationship to the state church evidently had concrete ideas about the mechanisms of public representation. Following the end of the schism in 1417 the pope took up residence in Rome unchallenged, and Eugene strove to protect this newly won status on all sides, even when he was forced to flee the city in 1433 only to return in 1443. It is no accident that the new system of the arts, with its turn to meaningful sensuous perception, appears to have taken root at the court of Eugene, where figures such as Leon Battista Alberti, Lorenzo Valla, Poggio Bracciolini, Giannozzo Manetti, Pisanello, Ghiberti, Fra Angelico, and Guillaume Dufay enjoyed immediate and in part institutionalized connections to the papal court.[5] Eugene's clear regulation of the institution of papal singers came to be a model for all European courts and many cathedrals, especially after being officially codified in four administrative acts by Sixtus IV (1471–84), who, inspired by the newly constructed papal chapel, lent the musical institution its name, the *Sixtina,* and thereby further elevated the status of this group of singers. While the map of serious musical institutions is relatively sparse around 1400, confined to a few isolated cases, by 1600 it was so full and complex as to resist any attempt at creating reliable or comprehensive musical topography even to this day. It appears, moreover, that very few alternatives to this model were ever developed, with the exception

of the conscious avoidance of the institution in the religious states of the German northwest, where instrumental representation was favored. On the contrary, through a somewhat painful process the somewhat outsider instrumental musicians came to be integrated into the chapel structure, albeit in a clearly subordinate social and hierarchical position. The model's stability led to two self-evident and obvious consequences. Since it originated in the clerical sphere, in principle it was not differentiated according to the site to which it was connected. Whether located at court or at a cathedral the structure of the chapel was in theory the same, and even collegiate and cloister churches did not develop a different organizational form. Throughout Europe and later in the cathedrals of Central America the same musical relationships held sway. By 1530 the Cathedral of Mexico City had a chapel (at first consisting entirely of indigenous singers), led by the Franciscan Pedro de Gante, and the Cathedral of Bogotá also had a chapel and kapellmeister. The Protestant Kantorei inaugurated by Johann Walter in Torgau (1525), facilitated by Martin Luther, relied on this model in large part because Walter had been acculturated in it, and in the wake of the dissolution of the Saxon court chapel he was not able or did not want to organize it in any other manner. The second, perhaps less self-evident quality lies in the fact that musical professionalism relied upon regulated aesthetic structures. The normalization of polyphonic styles in the fifteenth and sixteenth centuries could take place only because it was possible to perform four-part motets in each institution. This meant that repertoire could be transferred from one location to another without significant problems.

The members of the chapel were thus professional musicians, but were not regarded as such in their social reality. At least until 1500 their status as clerics was paramount, and the few spectacular exceptions—perhaps John Dunstable and certainly Heinrich Isaac—only serve to prove the rule. This means that musicians were integrated into the professional profile of the cleric and the system of prebends. Such prebends, which were difficult to secure and demanded a great deal of administrative skill to maintain, afforded a remarkable level of institutional independence. When a musician belonged to a chapel, by contrast, he was dependent upon a patron but not in a complete or existential sense. This condition generated not only a high degree of mobility among the musical-clerical elite but also a certain self-reliance. The fact that well into the fifteenth century a genuinely musical career path did not exist speaks to the dominance of this structure. The gravestone of Guillaume Dufay (located in present-day Lille) betrays this self-awareness of the composer

and musical scholar, bearing the inscription "vir magister guillermus du fay musicus baccalarius in decretis olim [. . .] choralis deinde canonicus." But his career proceeded exclusively within clerical boundaries, with one notable exception. Dufay endeavored to build up his clerical position above and beyond what was usual, by consolidating a comparatively large number of prebends and securing other privileges. This shows how he, as a papal "magister cappellae" or kapellmeister, while not better paid than his fellow members of the chapel, attempted to build up his clerical position to match his musical reputation. Two generations later in the case of Josquin Desprez this problem had already been solved, although he was still a cleric. But only by chance has it been proven that he was heavily recruited to be the kapellmeister at Ferrara even though his financial demands were considerable and his desire for unquestionable musical-compositional services were subjected to clear boundaries. Nevertheless Josquin went to Ferrara in 1503, from whence he fled in 1504 because of the encroachment of the plague.

After 1500 the institutional model underwent considerable refinement, and as a result the chapel as a musical institution was able to create clear internal hierarchies, with the composer kapellmeister—an entirely new institution in the 1430s—at the top and the instrumental musicians at the bottom. A sense of the elite underpinned these internal differentiations, and there was now within the musical organization once again an elite class. At this point there began a strict separation between court and cathedral chapels, which for both financial and organizational reasons (related to the position of clerics) were no longer regarded as equivalent. Even an exceptional case such as the twenty singers of the chapel of San Marco in Venice, who earned unparalleled renown during their thirty-five years under the direction of Adrian Willaert (ca. 1490–1562)—and it is unclear whether Willaert actually wanted to be a cleric—is in fact not actually an exception, since it was the chapel of the Doge's Palace, and thus enjoyed a high level of stability and continuity despite changes in office. The price of this accommodation was literally high. A material equivalence for compositional effort was fixed, with composition and the reproduction of music now expressly understood as an occupation in the sense of breadwinning. But at the same time, like all members of the court, musicians were the subordinates of their patrons and dependent upon them to a large extent. A composer such as Gaspar van Weerbeke (ca. 1445–after 1517), after the spectacular assassination of Galeazzo Maria Sforza on December 26, 1476, in the Milan Cathedral, was provided for thanks to his clerical status and was able to seek out a new position with

a certain degree of independence (in Rome in 1480), while a mere half century later Ludwig Senfl, in dire straits following the dissolution of the court chapel a year after the death of Maximilian I in 1519, eventually found employment in 1523 after securing a position at the Bavarian court of Wilhelm IV.

The development of the chapel as a professional musical institution produced yet another, perhaps unanticipated result. The uniformity of structures (even in the fifteenth century) and the mobility of the elite throughout Europe produced at least the nucleus of an international repertoire. Johannes Brassart (ca. 1405–1455) worked as a papal chapel singer as well as kapellmeister of the emperor's chapel (where his title was "rector cappelle"), which indicates that the repertoires of the two institutions were not substantially different. A full century later the situation had changed markedly. Orlando di Lasso and Palestrina, both no longer clerics, served in succession as kapellmeister at St. John Lateran. But while Palestrina spent his life in Rome, Lasso later made his way to Munich. The repertoires developed in the last decades of the sixteenth century at the Munich court chapel and the papal chapel were fundamentally different, despite the multiple connections among the individuals active in both. By the second half of the sixteenth century the chapel had become an instrument of institutional and even dynastic distinction, part of a larger system of artistic representation. The repertoire of a chapel reflected the priorities of its patron.

This institutional history is of course closely connected to the multiplicity of music previously discussed. This affected the perception of music as a whole, the organization of state musicians, the role of instrumentalists and organists, the Minstrel's Guild instituted in 1469 by the English Crown, and the development of the cantorate and cathedral choirs, respectively, in the wake of the Lutheran and English reformations. It is also relevant for musical subcultures, which either broke away from or implicitly or explicitly defined themselves against official institutions, such as the guild-like master singer organizations in Nuremberg and Strasbourg or the musically inclined fraternities in Bruges and Venice. The new form of patrician musical culture in the sixteenth century was marked by the profuse production of madrigals, using either Italian or German "ersatz" texts and later English sources, chansons newly popularized in France, and eventually the great corpus of German songs, which after 1560 were blended with the procedures of madrigals. These practices were cultivated by a literate and musically fluent elite, whose musical abilities differed significantly from the professional institutions, but

would nonetheless be unthinkable without them. In this cultural sphere women singers and musicians were more or less officially recognized, and even though until the end of the sixteenth century musical institutions were restricted to men, in 1562 the papal chapel and subsequently other courts began to incorporate the new voice type of the castrati, which brought about a new social reality. The numerous everyday musical practitioners in the city and country, whose number and identity are lost, had a more precisely defined subcultural status, in relation to this new sense of a "music profession."

As a professional institution the chapel made possible the further development of musical taste and judgment, not only in musical writings but as a social practice. An interest in outstanding composers, important and effective singers, and even excellent instrumentalists (above all organists) reflects the hierarchically defined recognition of musical accomplishments and the willingness to reward them commensurately in material terms. Selection for a court chapel, which was in and of itself prestigious, was in turn based on deeply cultivated musical perception. The new social realities in which musicians existed beginning in the fifteenth century represent the counterpart to the start of a new theoretical understanding of music as a sensuous event. But this understanding was much more pragmatic, since musical activity could for the first time be transformed into real-world decisions with wider meaning. These in turn had compositional consequences, since musical works beginning in the fifteenth century were fitted exactly, down to the smallest compositional detail, to the occasion for which they were produced. Polyphonic works were also specific to their occasions, such as the motets of Vitry. This ability of a work to be present in a radical sense was altogether new.

The question of how these musical elites were recruited and the agents who worked in this system has many layers and cannot be answered in a one-dimensional manner. The curial reforms enacted at the papal court in Avignon were closely tied to educational standards for young clerics, which resulted in the organization of a dedicated educational site, precipitating the founding of the *maîtrises*. Affiliated for the most part with cathedrals, these entities educated boys in the *artes* and also in liturgy, and in the northern French and Burgundian realms in musical matters as well. The model was enormously successful, since the prebend system made possible the establishment of more and more schools. By redirecting the income of one or two prebends a cathedral could provide for the establishment of a boys school and the installation of a master (*magister*). In the late fourteenth and fifteenth centuries this master (*magister puerorum*) began to take on considerable

musical responsibilities, and even composers such as Nicolas Grenon and Dufay worked at least for a time as the master of such schools. Although is difficult to discern the internal structures of these *maîtrises,* or *psallettes,* their overall mission was clear: the transmission of elementary knowledge of the *artes,* liturgical and musical education including the intricacies of mensural notation, and liturgical observance (singing the liturgy of hours and mass). Places in these schools were highly sought-after, and they often served as a means of providing for the illegitimate offspring of clerics.

It is thus not easy, at least in the fifteenth century, to reconstruct the biographies of musicians, since musical biography as a concept did not exist. As best we can tell, most musicians went through one of these schools (and were often of illegitimate parentage). Since the model was for the most part northern French and Burgundian in origin, for the first half of the sixteenth century most musicians came from this region, including the early madrigalists Philippe Verdelot and Jacques Arcadelt. For this reason even in the eighteenth century—for example, in Zedler's *Universal-Lexicon*—and especially in the early nineteenth century, these musicians are labeled as being from "the Netherlands."[6] The equally cumbersome and no less plausible term "Franco-Flemish" that has taken its place is not as incorrect as later critics might suggest. It denotes the reality of a social situation and has nothing to do with a sudden explosion of talent, but rather with the possibilities afforded by a normalized educational system. Abilities that were not at one's disposal were neither discovered nor encouraged. In older music-historical representations these individuals were construed as "Netherlandish school(s)," which is not entirely false, if viewed somewhat differently. It was not the case that composers handed down practical knowledge to their students, as took place in painters' workshops, at least not most notably. But almost all individuals in this system went through this same type of school. The musical-clerical elite throughout Europe thus found themselves not just in the same kinds of institutions, but among the same kinds of colleagues. They all came from a certain region, had completed the same education, and (at least in the fifteenth century) quite often bore the ecclesiastically problematic status of illegitimacy. In the midst of an astoundingly mobile system, these conditions thus granted it a high degree of stability.

The importation of this model to other contexts met with mixed success. Under Pope Eugene IV, a pragmatist of courtly representation, a whole series of such boys schools was established alongside cathedrals in the Holy See, and for a short time, between 1437 and 1441 (after a failed first attempt from

1425 to 1427), one was even attached to the papal chapel. Evidently musical elites had to be explicitly cultivated. This attempt met with limited success, with the output of the students somewhat insignificant, and boys remained outside the sphere of the papal chapel, where upper parts were covered by men singing falsetto. During the Lutheran Reformation the model was newly revived in the form of civic Latin schools in which musical instruction was emphasized. This regulated educational system remained current for a long time and in the form of the Latin school was successful. But the targeted development of musical talent functioned with great limitations, in contrast to the English cathedral schools, which were more closely modeled on the structure of the *maîtrises*.

Even though the *maîtrises* existed up to the time of the French Revolution and had to be partially founded again in the nineteenth century, they lost much of their exclusivity in the sixteenth century. The increasing differentiation of musical professionalism led to musical talent being not left to the selection of students, but rather, in a new mode of recruitment, discovered in a more targeted manner. Around 1496 Ludwig Senfl was employed by an agent of the emperor to seek out beautiful voices. It seems that such talent scouts were to be found throughout Europe, and almost nothing is known of their practices, critical faculties, and professional standards, and neither is it known when and on what basis singers were educated to become composers. After his sojourn in Rome, Gaspar van Weerbeke returned to Milan in 1489 and was subsequently engaged to recruit singers, traveling to the north and to Florence, and evidently not to the satisfaction of his patron, whose vociferous complaints over his results were deemed worthy of recording, further evidence of precise modes of evaluation. The musical upbringing and education of such talents could unfold in quite different constellations, but attained their decisive contours through the influence of a teacher. The more promising the talent, the more famous the teacher became. This represents an important contrast with seventeenth-century practices, in which a musician made his way to a teacher, above all to Italy such as in the case of Heinrich Schütz, who, like many other musicians from the north were sent to Venice to study under Giovanni Gabrieli. The teacher-student relationship previously developed from a mode of recruitment and increased in stature from there. Ludwig Senfl described himself as a student of Isaac not only in his song *Lust hab ich ghabt zur Musica* but also on his gravestone. The number of students who were associated with Lasso for a considerable period of time is astounding, and even a somewhat checkered figure like Adrian Petit

Coclico identified himself, whether rightly or not, as a student of Josquin. The transmission of musical knowledge as a practical art completely negated its original status as a liberal art, but contributed to professionalization as a distinctly new approach. This new "craftiness" of music in turn influenced other areas, in which the model had been previously present, but not in the sense of an ennobled relationship between teacher and student: singers, instrumentalists, and organists were recruited according to the same models, and the (not medieval) guild organizations of civic musicians are notable evidence of this. In the end the Renaissance was not an age in which a musical elite was newly formed, but was rather an era that witnessed the full realization of a musical elite in and of itself. With the adoption of the teacher-student relationship music no longer distinguished itself from painting in the system of the arts, but also lacked (at least for a while) genealogical roots such as Vasari's *Vite*. One distinctive mark of this difference lies in the fact that demanding music was always tied to an organized institution, and its increasingly intricate internal structures stand as one of the decisive characteristics of the era. This holds true for music that in a certain secondary manner could infiltrate the amateur sphere in the form of madrigals or other instrumental works. With the abandonment of polyphony and the turn toward an instrumentally based chapel in the seventeenth century the structure and education of musical elites moved in an entirely different direction, without giving up the standards of professionalization that had been established.

COLLECTIVE IDENTITY AND COMPOSITIONAL INDIVIDUALITY

With the emergence of the musical work the composer not only emerged from anonymous obscurity but at the same time attained a special and indeed unique position in the group of musical specialists (the chapel) with enormous effects on music as a whole within the system of the arts. This did not occur as a discrete event but was rather a complex and multifaceted process. At its end, in the middle of the sixteenth century, the figure of the composer had clear contours: as the kapellmeister he stood atop a carefully balanced institutional hierarchy in clear social circumstances. At the beginning of this process, in the early fifteenth century, these relationships were significantly more diffuse. Even the designation "magister cappellae" at first had many alternatives, and at the court of the emperor around 1440 there was instead

a "rector cappellae." Moreover, the position was not primarily focused on music but was more of a clerical and administrative office. In the 1430s Guillaume Dufay acted as the kapellmeister of the papal chapel (evidently in 1435/36 as "magister cappellae"), but his predecessor was a bishop with no discernible musical accomplishments. Although he was something of a court composer for Pope Eugene IV, Dufay received no increase in salary as recognition, but instead was given the decidedly nonmusical privilege of distributing payments to his fellow chapel singers. This structure can even be seen after 1500 at the chapel of Emperor Maximilian. The "court composer" Heinrich Isaac, unsuited for the position of kapellmeister as a noncleric, worked under Georg Slatkonia (1456–1522), a high ecclesiastic official and later bishop of Vienna, and his duties as kapellmeister were strictly administrative in nature; at any rate only one uninspiring composition can be attributed to him, and even so there are doubts about its provenance. The collective identity of the composer within the chapel and the strictly regimented organization of clerics made it difficult to develop compositional personality, perhaps because individual fame and clerical humility were regarded as contradictory impulses.

The composer in this new conceptualization possessed two by no means incidental qualities, a name and a work—that is, an oeuvre consisting of two or three compositions that could be attributed to him. Thus strictly defined, Johannes Ciconia would be considered the first "composer," since he had a name, biography, and a complex body of work transmitted among his contemporaries. In the early fourteenth century the situation was more complex. For the first time there appear in documents the names of composers other than those who were famous, albeit through the use of nominalistic figures instead of musical individuals, specifically Leoninus and Perotinus Magnus. These "labels" were evidently popularized by an anonymous English scholar in the late thirteenth century (ca. 1280) in order to make sense of the various types of music that had been created eighty years prior to his own lifetime or perhaps earlier.[7] But the actual names of musicians in the fourteenth century are difficult to evaluate. In the case of Guillaume de Machaut (ca. 1300–1377) his musical works can be understood as the compositional output of a poet, and were recorded as such—a unique and exceptional case—in the form of poetic manuscripts. The work of Philippe de Vitry (1291–1361), a cleric with music-theoretical ambitions and later a bishop, "emerged" essentially from the new and by no means unproblematic practice of contemporary musical research. Only four compositions of his are recorded in manuscripts, and

about even these four there are some doubts, with all others attributed to him through a difficult and somewhat contradictory process of analogy. By contrast, the names of other French or English composers of the fourteenth century have been transmitted but are associated only with one or two compositions, or essentially no work.

In the case of Italian composers of the fourteenth century, almost all of whom were clerics, the results are somewhat different. For some of them, such as Jacopo da Bologna, there is an actual oeuvre, but most of it was recorded only posthumously. For these composers, thanks to the representational practice (and the obligation to do it) of the northern Italian *signorie,* one can recognize a kind of individual tonal language or approach. These include such qualities as textual emphasis and cadential structures, which often resemble those of madrigals and ballades, although transmitted under different names. But classification of these pieces remains difficult, since almost none of them were recorded in manuscripts dated prior to 1400. The recognizable "push to textualization" can be more clearly observed, and in this sense is especially important for one reason. In these pieces musical authorship—whether composers, their biographies, institutional relationships and activity—reveals itself at best as a vague sketch (according to their position in monastic spheres) and for the most part as a retrospective construction. Very few traces lead back directly to the sphere and time of activity of these composers, whether the regional, social, or institutional circumstances in which they arose. Thus name and transmission rarely align, and there exists a gap that is difficult to fill, at least without a great deal of imaginative speculation. A good example of this is Francesco Landini (d. 1397), who was a special case in his generation with respect to his social standing, not being a cleric, and the density of works transmitted. But the 154 works attributed to him are with one exception all preserved in manuscripts that were in part clearly created after his lifetime.[8]

For Ciconia the situation is entirely different. Here there is a relatively clearly defined oeuvre, which at least in part—in a fragmentary manuscript located in Padua—was documented during his lifetime or immediately afterward. Only some of these compositions were recorded decades later in the middle of the 1430s,[9] and in their case it has been claimed by researchers that they were in part reworked through the addition of a fourth voice, the countertenor, from their original three-part settings. Nevertheless the surviving pieces by Ciconia—in their uniqueness, their new sonic profile, their habitus, their ability to make text sensuously present—appear to be the first actual

compositional oeuvre. In his case there is a recognizable unity of the work, since his pieces, a remarkable collection in different genres, are transmitted with his name: eleven partially connected mass settings, nine motets (one in fragments), sixteen Italian songs, three Latin songs, and three French songs. This assigning of names to compositions appears to be a somewhat banal requirement for the delineation of a composing individual from the collective identity of the group. But this reveals itself as by no means as self-evident as the case of Ciconia might lead one to believe. Even a cursory glance at surviving indices of musical manuscripts from the first half of the fifteenth century provides abundant evidence that musical authorship was only one of several criteria used to identify works, and not even a dominant one at that. Well into the 1460s the anonymous transmission of music was the statistically dominant habit, and citing a composer by name only later became the norm.

As difficult as the gradations of these findings are to evaluate, the larger tendency that they reveal is clear. Beginning with the printing practices of polyphonic music, starting in 1501 with Ottaviano Petrucci's Venetian press (almost a half century after the advent of the printing press), ascribing authorship to works became a standard procedure, perhaps not as much for complex theoretical reasons as owing to mercantile concerns. With print the name of a composer, in addition to other factors such as genre and instrumentation, became a trait that affected marketability, evident especially early in three books of masses (in particular the first two from 1502 and 1505) through which Petrucci to a certain extent explored the market value of Josquin Desprez, and it is unclear whether he did so with or without the composer's consent and participation. What is clear is that this mercantile conceptualization of the composer brought to completion the process that had begun in a decisive way with Ciconia. Thus in the first years of the 1500s a situation was institutionalized in musical practice that could no longer be ignored. Only in this context did the lives of composers, and along with them the attempt to draw life and work into dialogue, become relevant, in the way that Glarean undertook systematically in his 1547 *Dodekachordon,* also drawing on Josquin. It is no coincidence that he employed some compositions that could have been Josquin's but have since been shown not to be his.

Along with an interest in the names of composers there arose a need to affirm their presence, not only through reports on incidents in their lives. The sixteenth century saw the beginning of the notable series of composer portraits, which are in part embedded in the era's affinity for the new genre of individual representation. But this was also part of a need to give fixed

form to the creative individuality and even physicality of a musician. Aside from a few stylized examples from the fifteenth century, this was a phenomenon of the sixteenth century, enabled by print culture and the graphic possibilities of woodcut and copperplate techniques. It was possible to ascribe the authoritative power of a portrait to a print object, such as in the case of an unattributed image of Adrian Willaert and his *Musica Nova* of 1559, a unique publication that mixed madrigals and motets (fig. 11). This attitude made its way into provincial realms—for example, in the portrait of the lutenist and composer Hans Gerle (ca. 1500–1570), whose graphical and artistic failure makes the will toward representation all the more evident, especially in the stylization of the composer with a scroll of notes and the consignment of his instrument to the caption ("Lutenist"), not to mention the curious coat of arms (fig. 12). What is notable is the wider circumstance, as the connection between "work" and "personality" is above all a music-historical concern, certainly analogous to Vasari's *Vite,* which conversely resulted in the exclusion of musicians, with the sole exception of Lasso, from sixteenth-century collections of *Viri illustres.*

There are spectacular composer portraits, such as one of Jacob Obrecht produced in the area of Memling in 1496, that are only identifiable as such thanks to their labels.[10] They are neutral with respect to attributes, and it is only in the course of the sixteenth century—aside from instrumentalists, whose "tools" could be included—that additions for composers are recognizable, typically in the form of either written or printed notation. Not every recognizable line of notes in a painting points to a composer, since other connections were also possible, such as in Hermann tom Ring's portrait of Johann Münstermann, in which the notation is used in a semantic sense (noting his availability for marriage), not as a mark of self-identification. And sometimes details in portraits have no further discernible meaning. In one quite early example, previously attributed to Paris Bordone and created around 1521, a cleric is depicted with an open songbook (fig. 13). Although the notes are legible, they have as yet not been identified. The man depicted is thus in all likelihood a kapellmeister, unless an unmistakable mark of identification were to emerge today that might confirm his identity. The history of musical portraiture remains more or less unwritten apart from a few initial observations, especially for the period prior to 1600, nor has anyone taken stock of the phenomenon as a whole. The documentary evidence is astounding, with paintings, graphics (often connected with printed sources), memorial sculptures on tombs, and an even more remarkable series of medallions,

FIGURE 11 (RIGHT). Anonymous, Adrian Willaert, front-facing half-length portrait, monogrammed (L.C.) woodcut, 25 × 18 cm (Bl.), in *Musica Nova* (Venice: Gardano, 1559). Text surrounding the image reads: ADRIANI WILLAERT FRANDRII EFFIGIES.

FIGURE 12 (BOTTOM). Anonymous, Hans Gerle, left-facing half-length portrait, unknown copperplate engraving, 10.2 × 8 cm (Pl.), in *Musica teutsch* (Nuremberg, 1532). Caption reads: HANNS.GERLE LVTENIST. IN NURNBERG ANNO 1532.

These two images (figs. 11 and 12), one of the kapellmeister of San Marco, Adrian Willaert (ca. 1490–1562, depicted without any attributes), and the other of the Nuremberg instrument maker and lutenist Hans Gerle (ca. 1500–1570, shown with a scroll of notes and a coat of arms), represent the extremes of musical portraiture, one showing the elegant self-representation of Venetian painting, and the other a dilettantish and somewhat grotesque self-display.

HANNS. GERLE LVTENIST.
IN NURNBERG ANNO 1532.

FIGURE 13. Anonymous (previously attributed to Paris Bordone), *Portrait of a Musician*, oil on wood, 87 × 74.5 cm, ca. 1521, Prague, Národní Galerie. This image of a man belongs to a group of portraits whose subjects are shown to be literate musicians and even composers, owing to attributes such as the inclusion of written notes. The inclusion of notes did not necessarily denote a musical identity for the subject, but most of these representations do in fact depict musical scholars or composers. Exact identification is nevertheless only rarely possible.

beginning in the fifteenth century and reaching an early high point in Senfl (four medallions with his Latin motto were produced during his life) as well as Heinrich Finck (one memorial medallion was produced after his death in 1527). In any case in such portraits the composer most definitively emerges from anonymity and is physically perceptible through his name, work, and visage. Representations of entire chapels appear, if not as symbolic of the musical patronage of a ruler, then as part of the pictorial documentation of a kapellmeister, as was the case at the Munich court chapel. The group was depicted by the court painter Hans Mielich (1516–1573) as the "instrument" of Lasso.[11]

Toward a definition of compositional individuality, the idea that the plurality of a musician's works could be present, through whatever particular aspects, in a singular work is the most significant conceptual background. Notable pieces of evidence for this concept abound, as well as indications of how composers themselves helped shape this process. The series of hymns composed by Guillaume Dufay in the 1430s first developed the idea that a work concept could be present in relatively simple pieces composed under the rubric of a mass or motet through their combination as a cycle. The cycle concept was one of the central innovations of the fifteenth century and was manifest in multiple ways: first in the idea of setting all parts of the mass ordinary as a cycle; in the cycle of settings of propers created by Guillaume Dufay (anonymously and transmitted in fragments) and Heinrich Isaac; in the cycle of six complete mass settings composed upon *L'homme armé*,

located today in a manuscript in Naples (the names of the author or authors were later removed from the manuscript along with the first pages);[12] and in motet cycles by various composers from Milan around 1470 used in place of settings of the ordinary ("motetti missales"). Soon enough this cyclical mind-set could be extended to an entire body of work. In the last fifteen years of his life, Dufay evidently employed a scribe to systematically compile his works. At the latest, the remains of these manuscripts were destroyed in the course of the French Revolution, during which Dufay's "home" cathedral of Cambrai was also demolished. Ottaviano Petrucci dedicated his earliest individual printing to Josquin, notably designating a first book of masses as "liber primus," evidently with the intention of creating a "work."[13] Further "works" of this kind would follow with unnumbered books of masses in 1503 by Obrecht, Brumel, Ghiselin, and Pierre de la Rue and the broadening of the principle to other genres, first in the *Hymnorum I* of Johannes Martini (1430/40–1497), the court composer at Ferrara, for whom it would serve as a tribute in the sense of a memorial. This principle already existed in manuscripts. Even if it is not conclusive who was behind the so-called Chigi Codex,[14] one of the most opulent musical manuscripts of the period just prior to 1500, it is nevertheless clear that it was created with memorial intent, specifically the collection and preservation of the works of Johannes Ockeghem (ca. 1405–1497), essentially a "collected works" produced shortly after his death. The paradoxical consequence for the present reveals the stakes of this undertaking: had the manuscript not survived, the composer Ockeghem, who enjoyed so much renown in his day, would have become a music-historical phantom. Both practices, of collecting works and memorializing, significantly shaped the sixteenth century. After Lasso's death his sons Rudolph and Ferdinand set about to preserve his works, above all the motets, in a monumental memorial edition.[15]

Two aspects of this process are important. The composer has emerged from the collective identity of the chapel, but not with a single "work," but rather a series of compositions that through multiple perspectives lead to a work. This process is always connected to the institutional consolidation of the chapel model. The creation of a new collective identity for musicians in general set the stage and made it possible for the figure of the composer to be constituted at the same time. This figure eventually became manifest in the terms "virtus" and "ingenium" by authors in the sixteenth century, who brought it into connection with a creative theory. The musical ingenuity and creative ability of the individual draw him forth from the collective identity

but in the end derive from an originary connection with the *artes*. The composer of work that branches out into manifold genres is propelled by this ingenuity, as noted by several contemporary observers of Josquin. Different from painting, this dimension is treated in an unsystematic manner by these observers, since it appears that the evaluation of composition always resonates with the insight that it is not necessary to quell or subdue contradictory material, a condition that in the self-conception of Michelangelo, for example, was of fundamental importance.

In only one area of music did authorship remain withheld even as it comprised one of the chapel's principal duties: chant. Until the Council of Trent chant repertoire was constantly added to, always without authorization, and even the Tridentine reforms under Pope Gregory XIII in 1577 were demonstrably dependent upon the authority of Giovanni Pierluigui da Palestrina (1525?–1594) and Annibale Zoilo (ca. 1537–1592), even though they were not credited by name for this work. (A curious side effect of this was the lawsuit that Iginio Palestrina brought after his father's death regarding printings of his surviving editions, one of the earliest court cases regarding musical copyright.) This withholding derives clearly from the particular status of chant but astoundingly remained in effect long after chant had ceased to be regarded as something already "made." It is known that in 1457/58 Guillaume Dufay composed a new monophonic Marian liturgy for the Cathedral of Cambrai (*Recollectio festorum B. M. V.*), and quite successfully, as noted by the circulation of news of the event. But this is known only thanks to the chance preservation of a contract that Dufay entered into, found not in the place where this chant was composed but during his time in Savoy. The situation is confusing, since the composition of chant stood as a unique compositional task, and accordingly famous experts such as Dufay or Palestrina were no doubt desireable. But since no evidence of any meaningful size has been identified, it cannot be said how many composers also composed chant, and how chant was enriched by the influence of polyphony.

The idea that the "work" of a composer consisted of the quantity of his works together had a wide influence on compositional practice. Compositional individuality thus manifests itself as the result of a systematic exploration of the norms of polyphonic writing. This systematic view can be understood as an innovation, as one encounters it in part with Ciconia, more completely in the case of Dufay, and to a lesser extent with John Dunstable and Gilles Binchois. If one sets aside Dufay's secular songs, in particular his rondeaux, it becomes clear that an entirely new compositional mind-set is in evidence.

Within the clearly defined boundaries of a genre, the composer systematically develops the idea that composing is oriented toward a thinking through of different categories of problem solving, in something of a theoretical paradox: the resulting instances are mutually exclusive and equally valid. The sources for this procedure can be quite varied and are in part shaped by the task at hand; but in principle the "handiwork" of the composer is defined as something serious, in a modern sense with implications into the present day. The individualization of a composer thus reveals itself as less a mark of distinction that in previous research was vaguely termed "style." Much more, it is founded in this systemic mind-set in which composition is defined as a process of posing and solving problems. The singular work thus presents itself as the attempt—or depending on the case, the result—of creating something with an unchanging shape. Different from scholastic practices, where a respective "quaestio" produces a clear and distinct answer, and like compositional instances such as the clausulae of Notre Dame polyphony, the goal here is not a one-dimensional solution. The possibility that individual solutions could be correct in a single case but contradictory when taken together was designated by the term "antinomy" in Quintilian's *Institutio oratoria,* rediscovered in 1416. Through this term music entered into a debate with the concept of the beautiful, whose champions distanced themselves from scholastic traditions and were interested in empirical forms and their effects. Beauty in this sense is, in an exemplary sense, unitary and multidimensional—that is, it participates in its antinomy through a sense of *varietas* oriented toward unity.

In Dufay's rondeau *Hé compaignons,* created in 1426 and intended for the court chapel of the Malatesta, the main interest of the composition is the clear differentiation of vocal and instrumental parts through a change in compositional languages: the declamatory representation of each verse against clear instrumental interludes (musical example 4a). The somewhat later rondeau *Se ma dame je puis veir,* preserved in the same manuscript, is concerned with a different sort of problem and solution (musical example 4b). The continuous text declamation stands in the center, with the verse structure of the poetry immediately represented, particularly clear in the melismatic form of the intoned syllables. In the one case the interest was thus to create a verse structure and make it musically useful, while in the other the goal was to mirror the declamation of a text and its verse structure with a compositional procedure. Both possibilities have their merits, even though they could not be used together. And both possibilities

assume detailed knowledge of contemporary compositional standards of the recent past.[16]

This pattern is replicated by Dunstable in a different manner, which will be discussed at greater length later, and also holds for Josquin's masses as well as the elaborate motets of Costanzo Festa, and for Arcadelt's madrigals and Victoria's antiphons. But with Dufay there is something different in play. While he could proceed in a somewhat prototypical manner, composers around 1500 and afterward had to confront the contours of an existing musical history, the unfolding of a *longue durée* of compositional problem solving. Antinomian thinking always viewed itself in comparison to the available

MUSICAL EXAMPLE 4B. Guillaume Dufay, *Se ma dame je puis veir,* measures 1–5 (ed. David Fallows). The discovery of multiple musical problems and solutions is one of the characteristic qualities of Renaissance music. In *Hé compaignons* the separation of verse and the syllabic structure of the text (5–6), and the instrumental or diminutive habitus (7–8) is clearly recognizable. In *Se ma dame* this differentiation is not present. But melismata are systematically built up on stressed words and verses, and it does not, by contrast, distinguish between verse and instrumental sections but rather creates a larger structure. Both procedures thus create structures but on different levels.

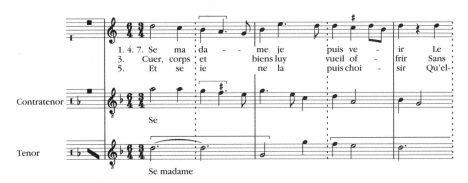

results of the preceding generation. This could unfold in different ways, whether Senfl's productive transcendence of Josquin's example or Willaert's sensitive retreat from it. And in a third possibility, existing compositions could be taken up by a procedure often referred to in research as "parody," an especially expressive and by no means isolated signifier. Only the fundamental changes in the years around 1600 brought an end to the dominance of this antinomian thinking, with music discussed instead as *creatio* with categories such as discovery (*inventio*) tied to concepts like norm violation, surprise, and conviction. Thus in 1605 Claudio Monteverdi treated the link between posing and solving problems as a historical concern in his contrast between the old "prima prattica" of polyphony and the new "seconda prattica" of monody. The realization of compositional individuality in the antinomian sense was relegated to history in favor of this new paradigm of appropriateness in musical representation.

PATRONAGE AND THE VARIETIES OF THE MUSICAL

Music history as a form of art history and thus as a history of works of art was a product of the Renaissance, not least owing to the fact that writing was a

precondition for historical memory. But owing to a lack of firsthand evidence that might confirm them, two aspects of this trend have typically remained in the background. Musical works arose in the fifteenth and sixteenth centuries and beyond with clearly defined contractual parameters, which are often only partially visible or entirely invisible. These musical works, moreover, comprise only a small part of a wider musical culture created by the same participants, sometimes with more or less effort or a comparable amount. All are important when considering the varieties of music, and both are closely connected to the changing meaning of the term "music." The difficulty in finding evidence for these phenomena is seldom characterized as a deficit but as part of the intractability of the issues themselves. As part of liturgical practice, court culture, and to a somewhat lesser extent civic representation, music was embedded in a continuum of regulated rituals and ceremonial sequences, which means that although there is a great deal of evidence for music's larger situation, there is seldom much preserved about its actual form. The integration of the musical work into these spheres produced significant changes.

Nowhere is a paradigm shift more evident than in the fact that music became part of a contract-based system of production that also affected the other arts. This system of production was organized as a dyad, like all client-patron relationships: the service, whether compositional or musical, is related to compensation as well as protection and a place in the center of society. In the case of music the situation is especially intricate, since music required a twofold patronage, the creation of an institution and the contracting of composition. These two did not necessarily have to go together, although the differences between singers and instrumentalists, at least in the fifteenth century, opened up possibilities of separation—instrumental representation and the musical work—that for the most part disappeared in the sixteenth century. In any case music, especially when it was connected with musical works, cost a great deal of money. It is difficult to get a clear view of how much was invested in music. But it appears that Italian composers of the fourteenth century were part of a patrician-clerical elite in which targeted patronage did not exist. Even the environment of a composer such as Ciconia is somewhat diffuse, as it is difficult to tell with any precision what and how the Carrara family in Padua invested in music. This could be related to the fact that the services of a composer-cleric did not or could not be assigned a material equivalent value. On the one hand, their social standing forbade such equivalences, and, on the other, composing and singing incurred no discrete material costs, with the exception of papers from court offices and

the occasional parchment. The case was somewhat different for instrumentalists, although they were not the cause of the explosion of costs in musical patronage but rather its beneficiaries.

The situation began changing at the beginning of the fifteenth century. Founding a chapel for the purposes of musical representation, and in this case court and cathedral were not different in principle, required financial investment and a determination of patronage. From a business perspective this was unwise and in fact not advisable, since capital was being invested in an enterprise that brought no literal "yield." But precisely for this reason the consciousness of the decision should not be underestimated. The creation of a chapel required capital that had to come from somewhere. But the corporate-clerical structure in which it first operated required the maintenance of collective conditions, including room, board, and clothing. At the papal court Dufay was compensated with these "Naturalien," or payments "in kind," such as vestments. Such practices did not entirely disappear from musical culture, and Protestant cantors at Latin schools were in part paid in this manner, and even a composer such as Johann Grabbe (1585–1655) received from his patron Count Simon VI of Lippe in Brake a considerable sum of money in 1611 in order to buy a house. Prior to this Lasso had been given real estate in Munich. Even the basic costs of musical patronage were immense, and they rose with the increasing detachment of musicians from the clerical sphere. Money played a completely central role in the recruitment of Josquin to Ferrara, as the composer demanded an exorbitant honorarium evidently to match his own sense of his worth.

The materialization of music made the chapel into an increasingly expensive instrument of courtly representation, and turned the kapellmeister into a highly compensated specialist. This process proceeded with some difficulty, since the musical product could not be immediately measured with material equivalents. A painting, building, or even an adulatory poem had a concrete and permanent function, and through its formation of materials created an enduring object that sealed the patron-client relationship in perpetuity. As an ephemeral acoustic event music enjoyed no such enduring qualities, and the only thing that lent it a certain permanence was the chapel itself. Only by bringing together these efforts into "works"—that is, in manuscripts—could such a material component be created. Eventually print culture made it possible to project patronage externally in the form of dedications, at a time when the costs of musical production had already multiplied. The fifteenth century can be understood in musical-historical terms as the century not only of insti-

tutionalization but also of the materialization of compositional service. In the case of Dufay's work at the papal chapel, there is no evidence of any single payment connected with his compositional duties. Honoraria consisted only of additional recognition in the form of gifts. Gilles Binchois, a special servant at the Burgundian court, was paid on May 29, 1438, for a (now-lost) book of "Passions en nouvelles manieres."[17] Aside from the question of what this might have meant, it is not clear whether the composer or the scribe was the person compensated. Only in the course of the fifteenth century did the terms become clearer. The agent of Ercole I, who was tasked with recruiting Josquin to Ferrara in 1502, made note of not only the composer's high financial expectations, but the fact that the service being purchased—composition—could not be clearly accounted for.[18] In 1557 Pierre Sandrin (d. 1560) explicitly appears in documents of the royal chapel as "compositeur." In 1557 Thomas Tallis (d. 1585) was granted by Queen Mary a lucrative lease (together with Richard Bower) on an estate in Kent, but when this no longer sufficed, in 1575 Elizabeth I resorted to a more immediate way of materializing music, granting him and his student William Byrd a printing privilege with guaranteed income. Even a composer's renown, the most important new concept promoted by the "work" of the era, was influenced by patrons. On his gravestone in Vienna's St. Stephen Cathedral Georg Slatkonia is described as "caesaris archimusicus," an idiosyncratic title also held in Vienna by Heinrich Finck.

The materialization of musical service led to social consequences for those engaged in the system of musical production, and in this respect music became part of the other arts. As a result musical patronage was both able and willing to be manifest in its products. There were two sides to this circumstance, on account of the rarity of performances and the scarcity of performers. Both became integral components of the system of musical production. There are a few spectacular cases in which a project was kept secret, such as Lasso's setting of penitential psalms. But as a rule the products were public, eventually in print, and their distribution brought not only renown to the patron but also special distinction to the institution receiving the patronage. The chapel thus became, on the one hand, an instrument of dynastic individuality but, on the other hand, a nexus of Pan-European culture. In the fifteenth century the clerical elite oversaw this sphere, while in the sixteenth century highly mobile repertoires were disseminated through an unsystematic system of distribution.

At the same time, the process of materialization was also concerned with control. In the case of institutions this control depended in large part on the

capital invested, albeit in a completely protected structure. The Heidelberg court chapel of Johann von Soest was not structurally different from the papal chapel of Sixtus IV, but the two likely differed in terms of the quality of the singers and composers they employed. The same holds true for the chapel of Count of Schaumburg-Lippe under Johann Grabbe and for the ducal chapel in Mantua under Claudio Monteverdi. More important was the influence of the patron on the form of the repertoire itself, and this control of the musical work is closely tied to the genesis of the concept and fundamentally changed areas far beyond, notably music for instrumental ensembles, and these were also affected by writing and professionalization. The new plasticity in the musical text settings of Johannes Ciconia can hardly be understood as a personal decision on the part of the composer, but the result of a complex act of commissioning. The fact that this matter is for the most part obscure is closely related to the uniqueness of musical commissions. For paintings, contracts existed not only because the painter did not find himself in a corporate structure that might regulate his activity. The more important motivation was to quantify and estimate the use of materials. The fact that through this process the determining factors of the work of art were settled upon is the very premise of a contract. In the case of music the corporate structure and the lack of material usage made such fixed determinations superfluous, with no grounds on which one might fix them.

The spectacular series of representative compositions written by Guillaume Dufay for the papal court of Eugene IV betrays a complicated program related to other aspects of his pontificate. They are evident not in a secondary manner but rather in the compositions themselves, but thus must be carefully reconstructed. At the same time there is a remarkable consistency to this constellation in which one can discern clear contours and thus a clear agenda behind the commission. Beginning in the fifteenth century there are many other comparable phenomena, always perceptible through the evidence of the works themselves. The profile that Galeazzo Maria Sforza lent to his court chapel in Milan in the 1470s is revealed in the works of many composers. Among others Josquin's activity in Ferrara can be seen as one notable example. The mass *Hercules Dux Ferrarie* served not just as a means of foregrounding the name of its patron through a solmization of the tenor (*re-ut-re ut re-fa-mi-re*), but the incorporation of the ruler into the sacrifice of the mass was in fact part of a complex theological and political agenda. This agenda also reveals itself in the monumental setting of the penitential psalm *Miserere mei Deus,* whose structure relies upon a psalm meditation by Savonarola that was

particularly prized by Ercole I. The preference given to Spanish singers in the papal chapel of Paul III was not just a curious proclivity for a certain vocal color, but rather had a clear and unique effect on the tonal qualities of the works produced for them. Cristóbal de Morales (d. 1553) was one of seven Spaniards in this group, and the individual art of "his" manner of composition should be understood as a product of this constellation of individuals. Even negative actions, such as the lack of a chapel and polyphonic music at the Cologne Cathedral or the low esteem in which singers were held (and the consequential preference for instrumentalists) at the court of Henry VIII of England, were based on not lack of knowledge or ignorance, but rather the will to organize musical representation through the entirely different means of extravagant instrumental music.

The fact that musical patronage was depicted in fixed, written form in only the rarest cases makes it difficult to evaluate its results. Composition was elucidated only occasionally and for the most part for unambiguous reasons. Nevertheless one must assume that there was a close connection between the guidance and the result even in the details of the work's structure. The case of Josquin's *Miserere* and its connection to Savonarola's psalm meditation shows that these concerns depended upon a wide range of experiential realms, from conceptions of piety, forms of representation, and many other features that some might regard as secondary. Heinrich Isaac's use of a new form of musico-poetic representation around 1500 no doubt is closely related to the politics at the court of Emperor Maximilian, and it is also notable that Ludwig Senfl, despite being indebted to his teacher Isaac unto the last, went in different directions in Munich. Thomas Stoltzer was compelled to take on the extraordinary experiment of creating four large-scale motets using the psalm translations of Martin Luther (Psalms 12, 13, 37, and 86), a monumental scale that no one had ever attempted. In a letter written on February 23, 1526, from Ofen to his employer, Albrecht von Brandenburg, Stoltzer explains the terms of the commission: Queen Mary of Hungary and Bohemia had "given him the task of composing the Psalm 'Noli Emulam' as rendered by Luther in German" (mir den Psalm Noli Emulam durch Luthern verteutscht zu Componieren auffgelegt).[19] But the demanding theological and musical agenda of the commission can only be somewhat obliquely viewed. In the same letter the composer reports that he had "recently out of sinful lust for the exceedingly beautiful words" set the Latin Psalm 29 *Exaltabo te* to music (neulich aus sunderem Lust zu dem überschönen worten gesetzt),[20] but this curious evidence of an intrinsically motivated

composition is an extremely isolated instance, and it remains unclear why the composer felt that it was worthy of reporting.

A history of musical patronage in the Renaissance has not yet been written, although numerous case studies exist, in part because a comparative history of musical institutions also exists only in a formative state. The musical work stood in a concrete and, as it appears, somewhat resilient relationship between the desires, guidance, and needs of a patron—who could be a person (such as a count) but also an institution (such as a cathedral chapter)—and the ingenuity of a composer. It is not always easy to reconstruct this field of production after the fact. But it affected the realm of musical experience in the widest sense and is one of the essential sources of the musical variety that characterizes the era. The idea that music could participate in creating dynastic distinction as well as a competitive system of distribution had a productive effect that is difficult to conceive. The materialization of practices was a central premise for this and can be discerned from the scale of investment. The capital that was invested in music, musical representation, and structures and institutions around 1600 cannot even be compared with the state of affairs around 1400. A great deal of additional evidence bolsters this observation. From Roman tariff registries from 1470 to 1483 it is evident that an unbelievable quantity of musical instruments was carried along the Tiber (with the exception of the tariff-excepted curia).[21] It is completely unclear what these instruments were used for or what music was played on them—only the financial investment is evident. For the fifteenth and sixteenth centuries there are receipts for civic expenditures in the city of Venice including churches apart from San Marco.[22] But only the costs of the considerable and differentiated expenditures of patronage are documented, and nothing can be discerned from the contents. When "quatro pifari" from the Scuola di Santa Maria e San Gallo degli Albanesi were paid in 1442 in order to play for the vigil of Saint Gall ("sonar la vigilia di San Gallo"), it is entirely unclear what this meant. The varieties of music must have been astounding, even for Adrian Willaert, who as kapellmeister of San Marco was confronted with this reality on a daily basis.

THREE

Text and Texts

THE DUAL SENSE OF WRITING

Since the ninth century the history of music has been characterized by a dual sense of writing: thinking about music, in an institutionally independent musical scholarship grounded in the *artes liberales;* and thinking through music, created through the invention of a system of musical writing, perhaps unintentionally but nevertheless consequential for the following millennium. This duality is not only a characteristic of music history but is its constitutive trait and its unique privilege. Aside from the question, in the broadest possible sense, of what relationship musical notation has to musical reality and what changes it was subjected to, this represents a central premise for engagement with music, and after the creation of de facto polyphony through the use of lines and *nota quadrata,* a double alphabetization. Anyone who wished to engage with music needed not only general literacy but a particular, specialized knowledge. From the start, thinking about and thinking through music were closely related: one of the earliest uses of neumes is found in a manuscript from the ninth century containing the musical treatise of Aurelianus Reomensis. Thus, thanks to music's definition as an *ars liberalis,* thinking about music had great theoretical potential, and the same was true of thinking through music to an even greater degree.

The history of this dual sense of writing is riddled with difficulties and contradictions, since the practice of polyphony (or composition) and the treatment of musical questions in connection with the *artes liberales* presented quite different challenges, whether technical, epistemological, or social. Thinking about music was of necessity far removed from the requirements of a somewhat craft-oriented definition of composition. Only with the

notational changes of the late thirteenth century, about which more will be said below, the relations changed insofar as notation came to be understood as a theoretical problem in and of itself, and thanks to its mental matrix a new category of music came to be: "musica mensurabilis." At least this is how one of its founders, Franco of Cologne, defined it in 1280 with authoritative ambitions, and it was astoundingly accepted by contemporaries and subsequent generations almost without objection. Musical scholarship took up this new challenge, and questions regarding the technical use of notation comprise the earliest concrete discussions (i.e., illustrated with examples) of music theory. Even the similarly anonymous English theoretician, who at the same time reported on music in Paris from two or even three generations prior, developed his nominalistic encryption (i.e., focused on differentiation) of different musical procedures (using the "names" Leoninus and Perotinus Magnus) through questions of notation and not, as previous research has claimed, through compositional differences.

This new testimony on the reality of composition changed musical scholarship, since compositional practice was granted an even higher degree of attention through the use of musical examples, even if they were always used as somewhat technical illustrations. Only in the fifteenth century did scholarship fundamentally broaden its scope, when this treatment of empirical evidence drawn from composed music was connected with critical judgments that went beyond technical matters. Questions about musical effect and beauty were first raised, astonishingly at first glance, in the context of monophony in the *Cantuagium* (ca. 1380) by the Carthusian monk Heinrich Eger von Kalkar (1328–1408). Upon closer inspection it becomes clear that the sensuous effect of chant, considered holy and instituted by God, whom Eger regards as a composer, was a subject that had been already examined by Augustine. (It was not known to fourteenth- and fifteenth-century witnesses that Gregorian chant was not the music that had occasioned Augustine's ideas.) This new turn toward the question of effect is thus a sign of increasing interest in the effects of music in general, which in the end was directed toward the musical work. The most important step in this process was the orientation of Johannes Tinctoris in 1477 toward the rhetorical concept of *varietas,* notably made in Naples, the intellectual environment of early Neoplatonism. From this point forward thinking about music—sometimes in increasingly complicated ways—was disseminated along with thinking through music.

Glarean's 1547 *Dodekachordon* can serve as a milestone in this regard even though it was written by a scholar and not a musician. The extravagantly reproduced examples that it discusses provide the first insights into the process of musical judgment that had existed since the fourteenth century, but was mostly evident not in scholarship but rather in social practices such as the fostering and recruitment of elites, institutionalization, and the development of repertoire. Nevertheless Glarean's writings were enormously consequential, not only for famous theoreticians such as Gioseffo Zarlino (1527–1590), but also for the teaching practices at universities and the musical debates at the Council of Trent (1545–63). Glarean's dedicatee was Otto Truchseß von Waldburg, a staunch Roman Catholic and one of the most influential church officials of the mid-sixteenth century, and a central figure in the deliberations of the council, musical matters included. Zarlino's *Istitutioni Harmoniche* (1558), which did not take up the discussion of musical examples in Glarean's sense, uses the neo-Artistotelian environment of Venice to bring theory and compositional reality into a new relationship, as explicitly stated in the *Proemio* of the second edition (1573). Its four books are divided among two on *materia,* or "musica speculativa," and two on *forma,* or "musica prattica." Within the discussion of "musica prattica" is a further iteration of the *materia-forma* dichotomy: while counterpoint is *materia,* modal theory is considered *forma.*[1]

It is strange that musical scholarship in the Renaissance was increasingly focused on and largely determined by musical works—even if the decisive (and fundamentally unacceptable) step was not made by a musical scholar, strictly speaking—even as it maintained a certain amount of distance from them. An unconventional and pragmatic connoisseur such as Giovanni Spataro placed his detailed engagement with musical works within his voluminous but private correspondence with Marc' Antonio Cavazzoni, Giovanni del Lago, and Pietro Aaron.[2] But he is not concerned with aesthetic problems in a narrow sense, but rather with technical questions regarding settings and notes, which are nonetheless discussed and answered related to the larger issue of artistic beauty. Only at the end of the Renaissance did this form of engagement become an outlet for a radical new perspective in the sense of aesthetic debate. This was concerned in the first place with the unexpected irruption of supposedly ancient categories into arguments, already a central subtext in Glarean and subsequently of great import for the opposition between ancient and modern posited by Nicola Vincentino or

Vincenzo Galilei (father of the astronomer).[3] But in the end it was concerned mostly with the status of debates over compositional technique. When the Salvatorian monk Giovanni Maria Artusi (ca. 1540–1613) leveled harsh critique at technical mistakes in the as-yet-unpublished madrigals of Claudio Monteverdi, the composer responded not with a technical but rather an aesthetic argument, and notably not in a stand-alone piece of writing, but in the prologue to his fifth book of madrigals—that is, through compositions: technical violations were necessary in an elementary sense when the concern was the appropriate musical representation of a text.[4] With this new valuation of rules and rule-breaking with respect to the persuasive powers of music, a paradigm shift took place that also had consequences for these kinds of discussions. The book that Monteverdi announced in his response never appeared, since a musical poetics of norm violation could evidently not be formulated in a normative manner. This too is an indication of the fundamental changes in these relationships.

Musical scholarship, similar to music itself and the realities to which it was tied, had undergone an astounding differentiation. Above all but not exclusively within the context of the Lutheran Reformation there appeared the comparatively simple elementary musical textbook intended for use in the Latin schools. As rector of the Martineum of Braunschweig (affiliated with the church of St. Martin), which had been originally founded in 1419 but newly constituted during the Reformation, Johann Faber (d. 1552) created three texts, including one with especially simple and modest lessons.[5] The book of a mere thirty-two pages, which first addresses Horace's poetics but otherwise displays an utter pragmatism toward musical matters—in the form of simple questions and answers such as "Quid est Musica?—Est bene canendi scientia"—met with constant success in Lutheran regions. By 1617 it had apparently been reprinted forty-five times, and there has yet to be any study of the ways that it transformed musical instruction itself. In 1597 Thomas Morley (1557/58–1602) published a general introduction to music (in the sense of composed polyphony). In his book, explicitly labeled as an "easy introduction," the demands and monumentality of performance clash in curious ways.[6] Aside from these examples there were significant compendia in which music was discussed in the context of the humanistically oriented *artes* that comprised the basic canon of universities, such as the work of the Lorraine-born scholar Nikolaus Wollick (d. 1541), who focuses explicitly on "compositio."[7] Writings dedicated to chant contributed to this diversification.[8] But an important aspect of this differentiation appears to be their

FIGURE 14. Title page, Sylvestro di Ganassi, *Opera Intitulata Fontegara. Laquale insegna asonare di flauto chon tutta l'arte opportune a eßo instrumento massime il diminuire il quale sara utile adogni instrumento di fiato et chorde: et anchora a chi si dileta di canto* (Venice: self-published, 1535), 15.5 × 21.5 cm. The flute method of Sylvestro di Ganassi points to the changes in musical writing in the woodcut illustration on its title page, in which three flutists and two additional musicians are in front of three part(?) books of notation. It thus becomes possible to theorize instrumental playing, and Ganassi claims the term "composition" for instrumental diminution.

completely pragmatic suitability for the demands of a true *ars mechanica,* instrumental playing. In 1535 in Venice, not coincidentally a city with special interest in the empirical perception of nature, there appeared the flute method of Sylvestro di Ganassi dal Fontego (1492–ca. 1550), an instrumental-ist at San Marco and court musician at the Doge's Palace. The noble flour-ishes added to his name point pragmatically to the Palazzo, which he lived close to, and the book bears the name of its author: *Fontegara.*[9] Here music very successfully became a craft, recognizable in a series of practically ori-ented discontinuities: on the drastic woodcut on the title page, in the craft-oriented definition of the term "ars," and in the leveling of differences between voices and instruments (fig. 14). Ganassi, who explicitly understood his practice of diminution (or the ornamentation of a phrase or model) as an act of composition, followed up the apparently quite successful book with a

violin method. This radical step, in which Ganassi equated diminution procedures with a kind of compositional foundation, was preceded by especially developed organ music. In 1511 the blind court organist at Heidelberg Arnolt Schlick (d. after 1521) published an organ method premised upon the use of examples.[10] Nevertheless this practical turn in musical writing took place years and even decades after the appearance of the first instrumental tablatures.

Another factor played an important role in the fifteenth century and even more so in the sixteenth: the infiltration of debates about music into contexts outside the discipline. Among these were Baldassare Castiglione's discussions of courtly behaviors, which offer revealing insights into musical judgment and the differentiation between good and bad music. Music could also be embedded in overviews of the *studia humanitatis*—for example, in the especially successful *Margarita Philosophica* of Gregor Reisch.[11] These kinds of contextualization can be very helpful. The great fascination that a thinker like Marsilio Ficino had for music rests in large part on the relationships that defined it. The creative explosion of music in Florence that he experienced firsthand evidently prompted questions about what this activity had to do with humanity and what it had to say about reality. But his observation of this context led him not to an "analysis" of the phenomenon but to ponder its irrationality. What he describes as the magical and numinous, especially in regard to music, represents an attempt to metaphysically transcend its craft-like qualities. Alongside the technical descriptions of the treatise there is an attempt to grant music and above all the musical work a new spiritual dimension. This path begun here is clearly but not exclusively linked with Neoplatonism, and continued through the late fifteenth and sixteenth centuries well into the early modern era (for example, in Athanasius Kircher), and it is always marked, when engaged in this subject, by a thematization of the sensuous experience of music. In general this played out in disciplinary writings either not at all or in a limited sense, such that the written accounts appear to diverge. Alongside musical writings in a narrow sense there now stood writings about music (paradoxically with Glarean as one if its prime witnesses), and this process of differentiation affected the modern era as well.

The other side of this "dual sense of writing" is much more complex, since it concerns not differentiation and careful paradigmatic changes but their invention in the first place. The composed polyphony of the twelfth and thirteenth centuries is mostly transmitted in manuscripts that were clearly

created later than the music they contain. This makes it difficult to evaluate the relationship of these codices to musical reality. For mensural music from around 1300 and after the findings are different and present other limitations. The vast majority of surviving music is transmitted in manuscripts that were actually poetic in nature, foremost among them the works of Machaut and the *Roman de Fauvel*.[12] The number of actual musical manuscripts is comparatively small, and spectacular examples such as those located today in Bamberg and Montpellier—collections created around 1300 with contemporary music in their own codices—are such an extreme exception that it would be unwise not to bring them into dialogue with the lost sources that were no doubt present and can in part be verified.[13] In the fourteenth century, musical manuscripts with polyphonic works remained the exception, including the compositions of the Italian *signorie* of the *trecento,* whose works were almost without exception transmitted later.

Around 1400 the situation changed in a serious manner. The number of surviving musical codices grew explosively, and so abruptly that one might speak of a writing boom. This applies not only to the immense and in a sense later repertoire manuscripts of *trecento* music (such as the Codex Reina)[14] or of French music (such as the Codex Chantilly, created in Italy),[15] but also to music of the times. The well-known collection of manuscripts created between ca. 1410 and 1440/50 (above all the codices located today in Bologna, Oxford, Modena, Rome, Padua, and Trent)[16] represent the first genuine boom in musical transmission. Here for the first time one can find repertoire assembled that can be considered contemporaneous in a literal sense. The significance of this evidence cannot be underestimated. The new contemporaneity of music is reflected in the desire for music to hold on to the present, to record it in writing and preserve it. The result of this process points to a paradox, since through this method of preserving its presence, the history of music first began to unfold in a decisive manner.

This new and sudden interest in the collection of music of the recent past and also of the immediate present—at first with Ciconia at the center, and then also with Dufay, Dunstable, and Binchois—can be clearly located. Almost all of the manuscripts in question, including later collections of older music, came from the northern Italian–Paduan region—that is, with no immediate connection to the place of their creation or where their composers were active (with the exception of Ciconia). The few surviving and spectacular exceptions betray either an entirely different interest—the compositionally oriented Squarcialupi Codex in Florence, focused on past music, is in this

respect a singularity—or have more or less clearer ties to northern Italy, such as a manuscript originally from the northern Rhine region destroyed in 1871 in Strasbourg; the collection of Hermann Poetzlinger (d. 1496), rector of the cloister school of St. Emmeram in Regensburg, today located in Munich; or a few fragments located in Poland.[17] Evidently the spiritual atmosphere that pervaded the University of Padua in the fourteenth century favored the production of such manuscripts. Thanks to renewed interest in the writings of Aristotle, in Padua (in contrast to Paris), interest in empirical and perceptible reality was never extinguished. On the contrary, it received a significant boost in the later fourteenth century, evident at the university itself in the form of the first anatomical dissections of cadavers as well as other documents relating to a new perception of nature, such as the comprehensive *Erbario carrarese,* created around 1400 and based not on schematization but rather observation.[18] This new interest in externally perceptible natural phenomena, which continues through the fourteenth century, evidently had an effect on musical perception, recognizable not only in the special qualities of Ciconia's compositions, but above all in the impulse to record them in dedicated manuscripts.

The "invention" of the musical manuscript as a new type of transmission appears to have been closely tied to these spiritual contexts and connections. In them the composed musical work was materialized in its own way, and this is reflected by some of the surviving contemporary indices associated with these manuscripts. Many classified pieces of music according to the incipits of their texts, but in the 1430s there begin to appear new musical characteristics (among others the names of composers), with the result that the musical rather than textual incipit became a means of identification, first clearly evident in the fragmentary codex that is today located in Modena (fig. 15). It was perhaps written in the 1440s in Ferrara, and was possibly connected to the papal court of Eugene IV. The index, which has only partially survived, records textual incipits, the names of composers, as well as the incipit of the uppermost voice. Barely a half century after the creation of the modern musical manuscript, the materialization and contemporanization of the musical work (including categorization by genre, of which more will be said later) had come to an end, and with a clarity that would not change for almost five hundred years.

This northern Italian process of the first decades of the fifteenth century was both successful and consequential. In these manuscripts interest in the musical work is made evident for the first time, and musical writing is from

FIGURE 15. Modena, Biblioteca universitaria, MS [alpha].X.I.11, f. 1r, paper, ca. 41.2 × 28.5 cm. The index of this manuscript, surviving only in fragments, is unique: it records the pieces according to the author's name and also includes an incipit from the uppermost voice as an identifying characteristic. The genre divisions of the manuscript are also evident in the (red) title: "Hic Incipiunt. Motteti."

this point forward a central element of cultural transmission. In the orbit of the University of Vienna this model was also adopted for monophonic secular music. But these codices at the same time raise numerous questions about the status of such writing. The music is recorded in single voices placed next to one another, the method of notating parts in the thirteenth century, and one that went by the wayside following the introduction of mensural notation in the fourteenth century.[19] What this meant for the compositional process will be discussed later. But this phenomenon was tied to several special features of musical manuscripts. What was written down was vocal music—that is, music with texts. From the late fourteenth century one encounters as part of this shift toward writing the recording of instrumental music in its own written form, tablature, at first for keyboard instruments, comprised of a kind of adapted vocal music. Only around 1500 does one encounter the recording of multiple voices without text, and in conjunction with printing practices there eventually emerges a whole series of instrumental musics, often specially written for specific instruments (keyboard, lute, viola, even flute).

In vocal music, by contrast, what is recorded was limited to the notated text in the narrow sense—that is, the single musical line and the text being set. Musical writing is thus somewhat reductionist, since many things that would later be considered important are not considered worthy of writing down, among them dynamics, instrumental accompaniment, and tempo variation. All of this is first introduced around 1600 with Giovanni Gabrieli or Claudio Monteverdi—that is, during a time when the score as the primary written form of music had claimed new durability. By contrast, the astounding shift in the decades after 1400 does not betray any interest in these accidental details, and during the Renaissance little changed on this account. In a letter previously mentioned that Thomas Stoltzer wrote in 1526 to Albrecht von Brandenburg, the composer explains that he has arranged his compositions, which were likely quite demanding, to be continually accompanied by crumhorns. This consideration affected the composition in a direct way, although one cannot find any evidence of it in its written traces. This quality must have led to enormous uncertainties in performance practice that even editions from the early twenty-first century have not been able to mitigate, whether regarding the size of the vocal ensemble, the precise placement of text, or instrumental accompaniment. The approaches of these editions have included reducing the singing to a clean four-voice setting (which is undoubt-

edly false) to the colorful addition of instruments, ornamentation, or new voice parts (which similarly leads to error).

Thinking through music thus demonstrably affected a transmission form that was nevertheless emphatically focused on musical texts themselves, and often not focused on performance in the modern sense of the word. The changes that took place after 1600 show that such possibilities were very much present, in part thanks to the conditions of mensural notation, but they had not previously been of special interest. The method of recording was thus the result of a conscious decision related to the mechanisms of courtly patronage. This decision had yet another side to it. The turn toward writing in the first decades of the fifteenth century as a rule brought forth manuscripts that were not intended for "performance" in the way the word is understood today. There were manuscripts in which music was collected and organized, and manuscripts that were interested in "text" and thus had the function of an archive. When one becomes aware of this fact the consequences are unsettling. Our musical historical knowledge rests in large part on such archives, although these same sources had at least a somewhat distant relationship to musical reality and its protagonists, who in general had nothing to do with the composers represented in them. Put simply, our entire knowledge of Dufay's work before 1450 is based on codices that with perhaps one exception had nothing to do with him or the places he worked, were not influenced by him, from which he never made music, but are nevertheless contemporaneous in the best sense of the word.

Only around 1450 are there increased indications and in a certain sense a second step leading to a more pragmatic sense of writing, including for music. There are manuscripts from the decades after 1450 that closely mirror the repertoire of institutions and were used by the organizations themselves. The 1470s marks the beginning of a series of surviving codices from the Sistine Chapel, and a great deal of evidence suggests they were also used for performances even if they provide no further clues about the character of these performances themselves. Both types exist side by side: manuscripts with collections of texts for the purposes of archiving, representation, or memory, and manuscripts that participated in the musical reality of an institution. This also can be described as a new process of differentiation and represents another marker of the era. Through the first printing of polyphonic music in 1501 this process acquired additional dynamics and qualities. A precondition for the so-called anonymous reproduction of music through print was the

"objectification" of the musical work, but this had been achieved already by the 1440s. The considerable half-century delay when compared to "normal" book printing can thus be described as above all a technical problem, which was solved by Ottaviano Petrucci in a spectacular manner with astounding technical efforts: a three-part printing process for bar lines, notes, and text. The first printings ultimately served to show the separation of compositional simultaneity in individual voices, since the unity of the manuscript gave way to the ordered multiplicity of individual part books. But this was not an invention of musical printing, as it had already existed previously—for example, in the "Glogau Songbook" of the 1470s.

Musical printing itself suddenly experienced a considerable development with the production of a series of independent types of transmission, from printed choir books to small songbooks, from part books to even handbills. Print and manuscript transmission existed simultaneously in the sixteenth century, with either overlapping or completely different intentions. Songs from the Reformation period were distributed in part as printed pamphlets but were also circulated in manuscript. Part of this differentiation was the songbook as a vehicle for both music and publicity, connected to the creation of a musical marketplace, in which musical writing had its own material value. Musically supported careers could be based on this print business, whether publishers such as Georg Rhau in Wittenberg, musicians such as Ganassi, or composers such as Lasso, who published a series of eighty-three individual printings of his own, and in the process became the musical market leader of the entire sixteenth century.

The linkage of musical reality to the medium of writing was not without consequences, with "variations" now possible in vocal music, and instrumental music existing in a close relationship to free realization or "diminution." In Basel Italian madrigal books were evidently used, but using texts in German if one so desired. Once they left their place of production, printed texts could take on lives of their own, through changes, corrections, or by being used as authoritative sources. Nevertheless, writing certainly became a marker of the era, a new means of taking stock of musical reality to which people had recourse whether they participated in it directly or not. (Thus the "illiterate" city pipers of Münster, after their statutory Cecilia-fraternity failed in 1583, represented their status by carrying a silver coat of arms and wire cage.) The meaning of writing for music history did not change significantly up to the end of the twentieth century. The exchange of roles within the dual sense of writing remained fixed: thinking about music had a com-

pletely immediate way of thinking through music by means of contemporaneous records. Both processes were dynamic, since writing developed, separately and together, a history of its own.

GENRE AND WORK

As Augustine well knew, music is inevitably linked with time, the passage of time, and time-bound occurrences. The difficulties that this raises for the continuation of this time-bound quality into the permanence of memory entered a new phase thanks to music's dual sense of writing and especially with the advent of mensural notation. Through the invention of this notation in the late thirteenth century and its differentiation around and after 1300, musical writing, which originally had served to fix pitches only in relation to one another, in one spectacular step was enriched by the ability to fix the duration of pitches as well. As the scholar Johannes de Muris noted at the beginning of the fourteenth century, this graphical method had a dual legibility, in regard to both the pitch and the duration of notes.[20] Although these innovations were at first tied to the genre of the motet—and these include the group of individual mass settings, especially those adapted from mass propers that are compositionally identical—they were almost at once applied to secular genres as well, and thus for the first time the ballade, virelai, and rondeau all began to be composed polyphonically. This expansion was tied to a notable compositional differentiation: secular songs were different not only from the habitus of the motet, but even as they were based on its poetic norms were delineated from them. A ballade stood as something different from a virelai. But this was neither obvious nor self-evident, since this sort of subtle compositional difference, which in the end points to the stylistic definition of a musical genre, presumed upon a high level of technical and self-reflexive ability and was thus a fundamentally new phenomenon. Nevertheless this differentiation still appears in the spectrum of genres as systematic, although it is tied to clear external conditions, above all the difference between Latin (motet) and French or Italian (secular genres). As a result it forms only a precondition for the subtle ramifications of the system, which emerged around and after 1400 in as explosive a manner as its written methods. The distant effects of this process can be observed for the duration of the newly beginning modern era, and it was not even undone by the much later signs of disintegration in modernism and postmodernism.

After 1400, musical writing—that is, thinking through music via the musical work—came to be fundamentally tied to genre, and compositional imagination came to be realized entirely through genres. Genre thus stands at once as an exceedingly complex and self-imposed normative form of thinking through which a compositional language could be articulated. Without this mode of thought the concept of the musical work is unimaginable. And conversely, the sudden and finely tuned differentiation of musical genres in the first decades of the fifteenth century is apparently closely tied to the diffusion of a concept of music and musical works attuned to sensuous perception. Genre was not an entirely new phenomenon, as there had been genres in the monophonic music of the troubadors and also in chant. But its incursion into polyphony had an entirely different quality. Thus the relationship between genre and musical works did not proceed in a linear manner, but in confusing and protean refractions, even as genres made it possible to place different levels of musical complexity into categories and thus create different levels of works. This kind of clear delineation of levels of demand was entirely foreign to musicians of the fourteenth century and began to change only after 1400. One example of this shift has already been mentioned briefly in this context. It is possible that Guillaume Dufay composed his cycle of hymns for the court of Pope Eugene IV. This was undoubtedly tied to the systematic development of the liturgies of the office in the competing papal courts around 1400, evident among other places in a hymn that is already present in the second fascicle of the Apt manuscript in ten anonymous examples.[21] The status of hymn composition for Dufay can be clearly determined: they were to be sung with simple, declamatory fauxbourdon and alternatim, and as schematic settings their authoritative identity was a matter of indifference. And yet through both their demands and clear normalization as a genre the hymns had a complex work-like character. This normalization occurred in the context of the generally developing network of "small" liturgical genres that in the middle of the fifteenth century was already branching out and in any case had resulted in a compositional habitus below masses, motets, or chansons: antiphons, hymns, Magnificats, sequences, and many others. But in Dufay's hymns—that is, in the earliest phase of this process—one can recognize that this procedure is already reflected compositionally. For insofar as the composer collected some two dozen hymn compositions into a single unit—the imprecise number is owing to the fact that transmission sources are difficult to evaluate—the work character resides in the unprecedented formation of a compositional cycle. In the hymn a "simple" compositional

habitus was created beyond the musical work, but the hymn cycle brought this form a status that had not previously existed.

This example shows that the connection between genre and work can be understood as paradoxical from the very start. The standardization of a genre under explicit pressure of work character could conversely result in its establishment as a genre. An important precondition for this lies in the fact that at the very earliest phases of this differentiation, in the first decades of the fifteenth century, genres were marked by a wide-ranging and prescriptive compositional habitus, to a degree that is far removed from the hierarchization in the *Terminorum musicae diffinitiorum* of Johannes Tinctoris; for in his lexicon, which was printed in 1494 but created almost two decades earlier, the first disciplinary lexicon of any sort, he designated the mass, motet, and chanson as, respectively, cantus magnus, mediocris, and parvus, according to their length and their stylistic level.[22] But this means at the same time that generic norms were implicitly present in works and series of works themselves, not in an explicit system of rules. This circumstance points to the potential of a new self-referentiality for music but also makes it difficult to determine the precise relationship between genre and work in the early fifteenth century. It cannot be easily identified in which manner, using the terminology of Ernst Gombrich, "norm" and "form" relate to each other concretely in individual cases.[23] One such example is the isorhythmic motet, whose norms were relatively strict but could be realized in quite different ways. From the general compositional norms John Dunstable created a variant mode that was still identical in its fundamentals, since it relied on the same proportional models. In contrast, Guillaume Dufay, inspired by the breadth of the underlying concept, wanted to newly define norms in the individual work, with new proportions and structures, resulting in especially heterogeneous and contrasting work defined by oppositions. Both procedures stand as complementary, since apart from them there is nothing comparable in the first half of the fifteenth century, and both point to an exceptionally differentiated but implicitly defined genre, as well as displaying the compositional will to exploit the possibilities of such a system.

When generic norms and engagement with them are located explicitly in works themselves, the works can achieve something normative, which raises the issue of the role of musical writing as the locus of musical memory. In reality both the dramatic differentiation and the creation of the system of musical genres were connected to the boom in writing around 1400 that has been previously discussed. In this context manuscripts created in the first

decades of the fifteenth century reveal themselves as a reflection of this awareness of genre, and this particular function of written records was fundamentally new, as it was present in fourteenth-century manuscripts only in a formative way and only afterward became closely tied to print practices. This new awareness thus also belongs to the development of the concept of genre in the period between ca. 1400 and 1440—that is, the newly conceived and dominant type of specifically musical manuscript served as a means of engagement with genre, albeit in starkly different ways. A heightened awareness of this question is equally present in all manuscripts.

Thus manuscripts should be considered not just as receptacles for musical works but as places in which norms were implicitly packaged, and thus stand as a mode of compositional thinking in and of themselves, which significantly affected the work of composition itself. Just how complex this context was for contemporaries is revealed by the different methods of codices, which have no discernible norms in this respect. Because it contains a preponderance of mass settings the Aosta manuscript is organized according to movement (Kyrie, Gloria, etc.) and not by mass cycle.[24] In the Venetian manuscript Oxford 213 no genre order is discernible, and upon first glance no such order is found in its contemporaneous index.[25] But at least in the case of its mass settings additional indications have survived, among which the most spectacular are mensural signs (such as "Et in terra pax. Binchois. O. ¢"). The compositional procedure of the choice of measures could thus be used within the genre of the mass setting as a decisive mark of difference. Especially revelatory in this context are manuscripts whose repertoire was actually ordered according to genre. A northern Italian manuscript, located today in Florence and for the most part created around 1400, holds the astounding distinction of being ordered according to genre and in turn ordered by composer.[26] Even the Squarcialupi Codex is relevant here, since it contains exclusively secular repertoire, presented in an especially startling order by its composers that includes stylized portraits. Created in the 1440s, the Codex Modena B offers perhaps the most highly differentiated genre categories,[27] which are represented and named in its index, with headings such as "Hic incipient motteti." The surviving parts of what was likely a larger manuscript reveal a subtlety of differentiation for which there is otherwise no documentation. Among its divisions are hymns, smaller liturgical pieces, Magnificats, and antiphons as well as an especially striking and sensitive distinction between isorhythmic and nonisorhythmic motets (for whose compositional differences plausible nomenclature does not even exist in modern terminol-

ogy). The separation of these genres assumes a pronounced compositional familiarity with them, and the quandaries of denomination that they later presented (in the case of the motets) show that these levels of differentiation were operative even if they could not be conceptually extracted (and remain obscure to this day).

The individual responsible for a manuscript such as the Modena Codex was exceptionally aware of musical genres. He went so far as to elevate them to subtle criteria of order. This does not reveal anything about the underlying motivations that led to such an order, but it does say something fundamental about the relationship between musical writing and compositional reality, since the manuscript itself shows the state of reflection upon questions of genre. From this point forward the wider history of musical writing cannot be separated from the conception of genre. This is already evident in the immediate spread of new types of manuscripts. The period shortly after the middle of the century saw in the orbit of the French royal court, although certainly thanks to Italian influence, the creation of the chansonnier, a form of manuscript whose distinctive appearance is oriented to the spectrum of genres that it contains.

The further differentiation of manuscripts around 1500 shows the sustainability of the model. There are motet and mass manuscripts, manuscripts with chansons and frottole, settings of propers and psalms, and many others. And in print transmission awareness of genre was absolute, and genre was discovered to be an instrument of not just order but commerce, especially in the wake of Petrucci's heterogeneous *Odhecaton A* (1501), which reflected the repertoire of an institution. Petrucci first published masses in dedicated volumes, then motets, and soon after new "genres" such as lute pieces, hymns, and lamentations, and thus provided direction for the publishing practices of the sixteenth century. Whether chansons, madrigals, or masses, print practice remained fixated on genres, since they made it possible to represent comparable compositional attitudes and social realities. Discourse about genres unfolded implicitly in these publications, and the "composition" of their contents was granted a certain unity. Intentional mixing remained a characteristic of manuscript practice, especially in outlying regions (such as the Codex of Jodocus Schalreuter from central Germany, containing mostly psalms and responsories).[28] When genre designations were abandoned, such as in Willaert's *Musica Nova* (1559), which combined motets and madrigals, this was evidently a conscious act and the transgression of boundaries had programmatic intent. Even genre-like changes such as Lasso's new definition of the German song were based on the

MUSICAL EXAMPLE 5. Guillaume Dufay, *Bien veignés vous,* measures 1–4 (ed. David Fallows). Dufay's rondeau, transmitted with an incomplete text in the manuscript Oxford 213, likely dates from his Italian years. The tenor and upper voice proceed in strict canon in which both voices sound simultaneously, the tenor a fifth below and with note values that are twice as long. This complex technique would be more suited to a mass or motet. In the surviving version the third voice, the countertenor, presents harmonic problems, which calls into question the status of this part.

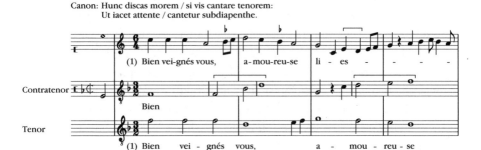

Canon: Hunc discas morem / si vis cantare tenorem:
Ut iacet attente / cantetur subdiapenthe.

deliberate accommodation of the *Tenorlied* to the requirements of the villanella and madrigal.

Consciousness of musical genres and their norms led to a differentiation of musical languages that had not and could not have previously existed. By this means music was connected with the other arts, as the relationship between norm and form comprises a central concern of painting, architecture, or poetry. The special significance of genre emerges clearly in instances when its boundaries were thematized, transgressed, or called into question. In the first decades of the fifteenth century there were already a variety of examples of this, which have not been previously discussed in a systematic manner, in part because it is enormously difficult to draw any coherent meanings from them. A few works by Guillaume Dufay provide a good illustration of these difficulties. His motet *Supremum est mortalibus,* likely composed for the 1433 coronation of Emperor Sigismund in Rome, is surprising not only owing to its apparent retreat from normative four-part writing in favor of a three-part texture, but through the insertion of irritating excerpts of fauxbourdon—irritating because they undermine the more elevated standards of the isorhythmic motet. Whatever the basis of this decision, and explanations have been posited from the structural to the semantic, what is astounding is the way the work consciously plays with generic norms. The

rondeau *Bien veignés vous,* with its canon in the outer voices, is compatible with the insertion of the nongeneric element, strict canon, albeit in a cantilena setting whose essential characteristics do not include contrapuntal writing (musical example 5). The virelai *Helas mon dueil* at first discloses a spectacular harmonic progression (much discussed in scholarship), which no doubt serves to illustrate the text—that is, to depict sorrow. In this instance no generic boundaries were crossed, but the possibilities of the genre of the virelai have been considerably elevated and thematized in an unmatched instance of harmonic boldness. In particular, the affective interpretation of text emerges for consideration as a compositional possibility in a drastic way, even if it is one of many such possibilities. All three examples, and these are but a sampling of them, show how the encounter with genres and generic norms was a productive challenge for composers and could be approached in many different ways.[29]

If one understands the first decades of the fifteenth century as a time in which a new awareness of musical genre arose, it is evident that playing with such norms, as well as their conscious thematization and transgression, was one of the central aspects of the period from the very beginning. Without these conditions the compositional history of the fifteenth century is unimaginable. Josquin's experiments around 1500 and after provide a good illustration of this—for example, the expansion of the *Stabat Mater* sequence, a "smaller" liturgical genre that had been in existence for only five decades, into a large-scale motet, which in its use of a French tenor (*Comme femme desconfortée*) itself transgresses generic norms. In a similar manner Josquin's later expansion of the chanson into elaborate and canonic five- and six-part polyphony shows his productive engagement with such norms. At the same time this reveals the importance of the *formes fixes,* text-based strophic forms. It is further notable that the resulting work, as evident in its broad reception history, itself became a normative point of reference. It was the model for numerous compositions, including works by Heinrich Isaac and Ludwig Senfl. The network of norms that a genre provided was best reflected in contributions to a genre, and the result could itself attain a normative character (or not).

Concepts of musical genre suddenly established themselves, after a brief prehistory, quite implicitly and successfully with a high degree of differentiation. This took place amid a complex network of other processes in the early fifteenth century: the turn toward writing, the emergence of the musical

work, the emergence of the composer in a modern sense, and institutionalization. The ephemeral character of the musical work had evidently made possible the creation of a mode of thought with which one could observe the functions of remembrance. *Memoria* as a mode of this remembrance and visualization was directed not only at individuals but toward processes and facts, making it possible to describe a wider social reality that was meaningful for everyone who existed within it. *Memoria* inaugurated, by holding the remembrances of the present, a continuity that at the same time represented an elevation. It appears that in the music of the first decades of the fifteenth century genre was discovered as a possibility of grounding *memoria* in composed music, with the astounding result that each new contribution to a genre implicitly or explicitly carried within it earlier contributions, in a way that can be at least provisionally described as intertextuality. The cantus firmus mass, perhaps the most astonishing and diverse generic innovation of the century, offers the best example of this, not least because its goal was functional, comparable to an altarpiece, and had everything to do with lived *memoria*.[30] The cantus firmus mass gave rise to a complex network of signification, but the use of "foreign" material and the technique of permanent relegation and remembrance created perhaps the most complex musical form of memory in the Renaissance. But the process itself, especially in its connection with the acting individual, became one of the most emblematic practices of the Renaissance.

Genre delivered memory into the ephemeral art of music, and with its help music was able to secure permanent presence and thus a sense of immediate contemporaneity. Composition within genres accordingly inaugurated a history of its own. Every work engaged with certain generic norms, and sometimes with other contributions to the genre. These took on explicit or implicit presence in concrete works. The series of isorhythmic motets by Dufay previously mentioned contain a deeper compositional sense when the hidden series of generic contributions behind them is known to the reader or listener. Every cantus firmus mass assumes a certain understanding of the context to which it reacts. The new perception of reality that affected the first decades of the fifteenth century in so many areas is evident most clearly in the new hierarchies of space created by single-point perspective, but is also evident in music, since composed music, by means of genre, was able to attain a new sense of contemporaneity and the durability of a mode of thought.

The connections between the musical work, writing, and genre awareness made it possible to view the compositional effort of an individual as unchanging and its result as unique and unrepeatable. This in turn prompted explicit reflection on the subject, above all but not exclusively through a rapprochement with Aristotle's concept of *ingenium* (which connects assessment to the ability to use it mentally). In the sixteenth century this concept was also taken up in musical writing, making it possible to describe the "creatio" of a composer as the result of human imagination. This was a delicate matter, however, since it placed the creator in competition with the divine Creator. As a result a mode of thinking prevailed, especially in Neoplatonic discourse, that the creation of an artist (which now included composers as well) was the result of a dichotomous disposition that bridged the jovial productivity of the sign of Jupiter and the darker melancholy of the sign of Saturn. An observation by the Ferrarese singer and agent Gian de Artiganova, who was tasked with recruiting Josquin in 1502 (as an alternative to Isaac, whom another agent was pursuing), noted how he was a better composer, but only when he felt like it ("fa quando li piace").[31] This points to the effectiveness of this idea in the self-conception of those concerned (and shows that Gian expressly considered composition to be an art).[32] In the unique series of letters that Lasso wrote to his employer this sensibility resonates throughout, and at the end of his creative life, cut short by a severe health incident in 1591 (likely a stroke), this disposition seemed almost to literally overcome him. In a certain sense this conception received a compositional response, in the form of the severe mysticism of the late spiritual madrigal *Lagrime di San Pietro,* dedicated to Pope Clement VIII, a setting of poems by Luigi Tansillo (1594). And the three masses of William Byrd composed around 1593–95 as a covert testament to the Catholic faith display *ingenium* with respect to the stress of their heterodox context; *ingenium* serves as a means of self-preservation in a literal sense.

When one considers the dual sense of writing as well as the fact that generic norms were formulated implicitly rather than explicitly, it is easier to understand compositional individuality less as an act of explicit reflection and more as the result of compositional practice, or thinking through music. The most remarkable and at once obvious indication of this is the fact that composers could interact with one another in an explicit manner—a relationship that could be expressed through the works themselves. Beginning

in the fourteenth century this was taking place in a tangible way, and in the fifteenth century it changed and became more pointed. The creation of elaborate polyphony was from the very start music about music, at first the normative doubling of a voice based on the foundation of a chant. Polyphony served already in its origins as a means of making music present, whether for purposes of legitimation or persuasion, since music could not be made from nothing, but required material to be at hand. For the duration of the Middle Ages, the history of polyphony was thus a history of commentary or the glossing of available monophony. Composed music was thus a trusted procedure through which one could derive multileveled senses of textual meaning—the literal, moral, allegorical, and eschatological—by opening up and revealing such commentary and making it more present. This conception of polyphony, thoroughly in accord with the principles of the *artes liberales*, held sway well into the thirteenth century, including the great polyphonic forms of Parisian scholasticism, leading to equally monumental four-part organum. In this mode, if it was syllabized, chant could, so to speak, unfold into eternity, insofar as each tone of a syllable, at once the fundamental tone of the four-part setting, was extended and elaborated as widely as possible. Of course in this procedure one can recognize the dangers of its internal dynamics, since if a tone could be extended for so long in the end it would have only an idealized presence and was thus somewhat expendable. The practice of conductus shows that people were aware of this possibility, and thus created an organum setting without fundamental tones.

With the mensural notation of the late thirteenth century, however, the practice of polyphony as music about music entered a new phase, since chant as a preexisting, fixed song had to be changed in a specific way to become cantus firmus: with new technical possibilities it was rhythmicized, and not in the sense of a model that was available for repetition at any time, but a model specific to an individual work. In this respect motets of the early fourteenth century were given a radical new approach, since through rhythmicized notation the chant excerpt became something unchangeable that worked for only the single work in which it was used. This meant conversely that this very same excerpt could be used in different works in entirely different ways. It is nevertheless notable that in the demanding field of motet composition, as much as it is possible to extrapolate from the challenging state of transmitted sources, the use of identical excerpts remained an exception and not the rule. This was also due to the fact that the excerpt itself was not considered the musical source of a composition, but rather a semantic

source. In motets from the fourteenth century, beginning with the pieces in the *Roman de Fauvel,* cantus firmus and upper voices enter into a subtle dialogue that is meaningful at the level of the texts. The poetry of the upper voices stands in an immediate relationship of exchange with the text of the chant excerpt in the tenor, sometimes through only a single word. This form of interaction of musical, liturgical, and poetic texts can be understood as intertextuality, and, like the extension of the dual sense of writing in the works themselves, is an intertextuality between the spoken and musical components of a composition. This new procedure differs, on the one hand, from the collective model of memory, the mere presence of a text, and, on the other hand, from the idea that the newly created voice was merely a commentary on the other. Much more, all of the structural and semantic parameters of a composition congealed into a new, meaningful, unrepeatable unity; the text was newly created in an emphatic sense, and the fact that the context of its "performance" also played a part must still be considered as well.

This procedure was not only taken up into secular genres, in which polyphonic compositions also were developed through the use of a tenor, which was not always liturgical in origin. Even more important, in the fifteenth century it formed the basis for a new conception of composition. At the center of this stands what is arguably the most important event of compositional history: the development of the cyclical setting of the ordinary of the mass, which began around 1400 with the setting of individual movements and by 1440 had achieved a normative status. Settings of individual movements are encountered already in the fourteenth century, but the appearance of a cyclical work is the isolated instance of Guillaume de Machaut's *Messe de Nostre Dame.* Beginning in the middle of the fifteenth century until around 1600, at first in the early Reformation musical cultures in Lutheran and English contexts, mass composition was a central compositional duty, even if in the course of the sixteenth century it would lose its position atop the imaginary hierarchy of genres. The bringing together of individual parts of the ordinary into coherent masses already stood as a central component of choral practice (including the special place of the later canonized Credo), but they comprised part of a liturgical rather than a musical unity. Cyclical mass composition changed this, since now the individual settings (revealing the special place of the Credo) were actually compositionally unified. A series of procedures served to achieve this (the spread of "head motives," mensural architecture, etc.), but from the start the connection of a single cantus firmus represented an important feature and in later decades became dominant.

The model of the cantus firmus mass inaugurated a new conception of composition, since the individual movements now appeared as music composed upon the music of an identical tenor, with liturgical concerns put into the background if not entirely ignored. This form of intertextuality was compounded, since very early on, some northern Italian works from the beginning of the fifteenth century experimented with the replacement of the melody of a (preexisting) chant by a (new or contemporary) secular song. Although this process was neither self-evident nor closely related, and it is all too easily accepted by existing research with its meaning rarely called into question, it made intertextuality into a central mode of compositional thought and stands as a defining feature of the Renaissance. Each cyclical mass composition reveals either five different or five similar forms of engagement with a single cantus firmus, which should be not only musically effective but semantically meaningful as well. This was true in a self-evident way for works based on chants and even more so for masses based on secular songs. The use of such songs opened up a new individual realm of meaning for each individual mass composition that stretched far beyond the liturgical. And even more so: the songs engendered memory or *memoria* in the deepest and most productive sense. Each mass written with the same cantus firmus developed not only a realm of meaning in its own internal play with the material, but with the other existing works that had already been written by another or even the same composer. In this expansive space changes and displacements in meaning were possible. The famous series of masses using the secular war song of the armed man, *L'homme armé,* perhaps composed by Guillaume Dufay, begins with a work of his and was continued by Ockeghem as well as six anonymous compositions, which were evidently connected to Philip the Good, the fall of Constantinople in 1453, the pheasant festival in Lille, the Order of the Golden Fleece, Charles the Bold, and the declaration of war against the Ottomans. The works react to the semantic and structural cosmos in which they developed, most clearly in the six cyclically ordered anonymous compositions (anonymous because the first pages of each mass, which likely contained the name of the composer, were removed). In the subsequent works—for example, in Josquin's two masses, which display quite different methods—this aspect recedes to the background in favor of more logical moves. The *L'homme armé* mass has been stripped of its original sense and has become a genre in its own right. The meaning of each generic contribution now lay, possibly owing to the desire of

the person who commissioned it, in its imaginary competition with other masses using the same song. The space of meaning thus attained a different breadth: the number of masses using *L'homme armé* is very high, while those using *Fors seulement* is low, in addition to the large number of singular works, in which the model was newly explored at the level of an individual work (for example, with Ockeghem).

Intertextuality thus created something like the compositional-technical glue with which individual compositional efforts could be defined and brought together. The compositional processes of the fifteenth and sixteenth centuries consist essentially of a permanent development and elaboration of this fundamental idea, in the sense of a plural sense of music. For finally it was possible not to limit attention to a tenor, but to take up entire parts of other existing polyphonic settings and put them into a new work. This new model of mass composition, based on either the melody or a complete setting of a secular song, was already so established in the generation of Johannes Ockeghem that the type began to develop in an almost incalculable number of variations— with *varietas* as a structural principle for creating individuality, comparable to variations of types in painting. While during the first half of the century a considerable number of these masses and movement-pairings (Gloria-Credo, Sanctus-Agnus) were created for specific occasions, in the second half of the century the quantity of surviving works leads to the conclusion that mass composition existed as an artistic endeavor that was not necessarily indebted to an occasion, but rather wanted to ensure ritual continuity and thus continual presence. The work of art thus became, working together with liturgy, a kind of ritualistic everyday experience, comparable to the status of an altarpiece. Almost all important composers were also composers of masses, and insofar as they wanted to create new variations in the spirit of intertextuality they elevated the demands of unchanging compositional individuality. Around 1500, undoubtedly the most "dense" period in the history of this genre, this new demand had an immediate effect on written sources. The large format and expensively outfitted representational and memorial manuscripts created for popes and dukes consist almost exclusively of mass manuscripts, just as Petrucci had dedicated his first individual printings to masses. An essential characteristic of this form of intertextuality is thus the historical dynamic that it reignited. The history of mass composition proceeded not statically, but as the result of an exceedingly large quantity of consecutive events that related to one another, dynamic in a modern sense of the word.

The cognitive mode of intertextuality was responsible for a quite diverse set of phenomena. But all of these were concerned with tradition building, normatization, and thus a dynamic sense of history—for example, in the large projects of Josquin and Obrecht. Even the most eccentric composer of the fifteenth century, the influential French court musician Johannes Ockeghem, is no exception to this rule. His paradoxical status represents an especially thoughtful engagement with these preconditions. His views of intertextuality led him to fundamentally doubt all norms, with the result that each composition (and especially each mass composition) reveals an unconditional individuality. They dispense with everything that might give schematic form to a composition (imitation, creation of excerpts, textual interpretation, and much more), and are realized with a limited and idiosyncratic counterpoint that appears to eschew all typical forms of orderly control. In Ockeghem's work intertextuality is manifest through perhaps the most radical compositional individuation that the Renaissance would ever witness, more radical than even the most ambitious works of Willaert or Gesualdo. Through their singular qualities his compositions possess a sense of absolute currency and presence.

Perhaps it is no coincidence that in Ockeghem one can observe an expansion of the principle of the musical text. For interextuality is comprised foremost of a series of processes concentrated on the cantus firmus—namely, in its valorization as a purely artificial object and in the substitution of secular templates for chant forms. But this procedure was also conceivable and possible outside of cantus firmus technique, and it had the capacity to influence publication practices and forms of representation. In the previously mentioned Chigi Codex, an especially early example, Ockeghem's mass *Au travel suy* is presented with miniatures, including depictions of a farmer at work and another man relieving himself, such that the links between image and text give the possible intertextual readings a specific visual angle, in this case in a somewhat obscene manner (fig. 16).

In the third decade of the sixteenth century a further dimension was added to this form of compositional intertextuality when the secular song was replaced by a motet, in part thanks to the influence of the Reformation. Thus the spheres of the sacred and secular were for the first time clearly separated— part of the wider process of musical differentiation. The effect of this new perspective was contradictory, and the purported clarification led for the most part to an overdetermination of intertextual practices. The somewhat unfortunately named parody mass (although not without contemporary

FIGURE 16. Johannes Ockeghem, Missa *Au travel suy,* parchment, 36.3 × 27.8 cm, 1500?, Vatican City, Biblioteca Apostolica Vaticana, MS Chigi. C.VIII.234, f. 89v. The page shows the beginning of Ockeghem's mass *Au travail suis,* whose cantus firmus is a rondeau by either Barbingant or Ockeghem himself. Perhaps created at the Hapsburg-Dutch court around 1500, the manuscript includes a whole series of fantastical and in part grotestque combinations of text and image.

evidence)—that is, a mass in which an existing polyphonic work was integrated—had by the end of the sixteenth century, in which it had not lost its status,[33] assumed the form of a compositional oddity. Masses were not just music about music, but music about music about music. The results often assume a character of monumental ambition. In 1610 Monteverdi combined his *Marian Vespers,* an exemplar of new composition, with a mass written on a motet by Gombert, which was to create an intertextual paradigm by offering an example of older composition. Created in Vienna by the imperial court kapellmeister Jacobus Vaet, the mass *Vitam quae faciunt beatiorum* was composed upon a motet, but was indebted to a previous work by Orlando di Lasso, *Tityre, tu patule.* The mass was thus music about its own music, which itself was music about other music that was a transgression of generic boundaries. This new nested identity, in the sense of an all-compassing artistic character with a signature totality—which at the same time Arcimboldo, also at the imperial court, was pursuing in his figures of fruits, flowers, and other objects—was by no means an isolated example. The Bavarian minister at the imperial court George Sigmund Seld reported in 1559 to Munich, not without pride, that upon hearing Vaet's mass in the imperial palace, it had "fürwar zimblich wol gefallen" (had pleased him somewhat) and its "Subiectum" had "in den oren geklungen" (rung in his ears), in a way that the Bavarian imperial kapellmeister could "so bald nitt ertkhennen" (not have recognized). But he had discovered that Vaet's motet had "wellen Imitiren" (somewhat imitated) Lasso's, and the mass had been made of "beide die selben Moteten" (both of the same motets).[34] In the era of Tridentine reform such kinds of intertextuality were exposed to the critiques of the nascent Counter-Reformation in which compositional individuality and ritual demands had entered into a precarious and contradictory relationship. But exactly this debate provides further evidence of how consciously people perceived and were reflecting upon the implicit realization of compositional individuality.

It is evident from Vaet's work that the cognitive mode of intertextuality was favored in the mass, but was not an especially significant mark of the genre. The use of intertextual processes and compositional inviolability is found in other genres, including the motet, smaller liturgical pieces, chanson, and especially the madrigal. The thoroughly eccentric intensification of an unchangeable physiognomy in Dufay's Roman motets in the 1430s is based on a radical intertextuality. In his work *Ecclesie militantis,* for the coronation of Pope Eugene IV on March 11, 1431, the composer not only used a previously rare five-part structure, but also combined five different Latin texts. The two

tenor parts bring together two liturgical texts, specifically the antiphon for Vespers of the first Sunday of Advent and the Magnificat Vespers for the Annunciation. Both texts contain concrete details ("Ecce nomen domini: Gabriel") that relate to the new pope (whose civilian name was Gabriel Condulmer), likening the start of a new pontificate to the start of the church year and also alluding to the feast of the Annunciation. The dense intertextual network in all five voices creates a unique work of art with a distinctive physiognomy, and all of the texts together—the five verbal texts and the five musical texts (with all of the possible implications)—represent the texts of the artwork. Josquin's setting of the penitential psalm *Miserere,* created in 1503 for Ercole I d'Este, is one of the most monumental motets of the Renaissance. Its unique structure of twenty-one (three by seven) parts separated by the intermittent cry of "Miserere" was inspired by a psalm meditation of Girolamo Savonarola that played a central role at the Este court in Ferrara even after his execution in 1498.[35] Insofar as Josquin's motet follows Savonarola's explication it represents a very specific form of intertextuality. Much more, it is recognizable that the composition has changed its status and does not want to be a mere setting; it takes on the status of a psalm meditation in and of itself. Josquin's composed music, an unparalleled musical artwork, thus participates in an act of interpretation and grants it a special urgency and presence. Like the case of the mass, the motet genre displays through these forms of intertextual processes a compositional pluralization that—in their most ambitious manifestations—affected music as a whole, and was immediately taken up by Thomas Stoltzer in his four monumental German psalm motets.

Fifteenth-century chansons similarly participated in intertextuality, even after the changes around 1500 that saw the abandonment of the *formes fixes* or poetically determined structures in favor of free forms. This cognitive mode was also the compositional nucleus for the madrigal, which, beginning in the late 1530s, became dominant throughout Europe, from Costanzo Festa up to the work of Carlo Gesualdo da Venosa. One of its early practitioners, the northern-born Jacobus Arcadelt was active in Florence and Rome, and his first book of madrigals (in four parts) appeared in 1539 in Venice.[36] The form of numbered books was borrowed from the model used for masses and motets, and thus intertextuality was evident even in methods of publication. Thus while in the first half of the sixteenth century it was still customary to offer as one's first anonymous publication a book of motets, by the second half of the century it was far more common to produce a book of madrigals as "opus primum," a tradition that endured until the Venetian students of Gabrieli around

1600 (among them Heinrich Schütz) and then suddenly was abandoned. One of the most famous madrigals from Arcadelt's first book is *Il bianco e dolce cigno,* the song of a lonely dying swan, which evidently enjoyed unrelenting popularity in the sixteenth century. Arcadelt's first book of madrigals was the most successful in history, and was reprinted as late as 1654 and appeared in a total of thirty-six editions. Fifty years after its first publication, in 1589 Orazio Vecchi expanded the dying swan madrigal with the addition of a fifth part, and thus showed how adaptation could help mitigate historical distance. As late as 1629 it was used as the basis of a parody mass (belated in every sense). Arcadelt's madrigal thus became a permanent compositional point of reference, and its presence represented a constant and unstinting challenge.

Through the methods of this wider intertextuality, music entered into a dialogue with itself, explicitly in the case of parody compositions, and implicitly through generic considerations. This new discursive potential was a quite literal phenomenon, and in the fifteenth century this exact procedure developed as a further characteristic of the era. The canonic imitation of one voice by another was well known since the fourteenth century. But its meaning as a procedure that created structure in a compositional continuum first appeared in the fifteenth century in a normative sense, at the latest in Josquin's circles. Around 1500 imitative structuring of settings became a momentous procedure, since it appealed to the perception of listeners and was thus a model for a genuine technique of musical recognition. This led, referring to Aby Warburg, to the creation of sound with a gestural quality, a certain form of musical "pathos formula." Such a process is at its core nothing other than the most densely imaginable form of intertextuality, and, since this self-referentiality is tied to chronological duration, reveals itself as a genuine privilege of music. Even the demonstrative abandonment of imitation in Ockeghem is spectacular only in relation to an unused availability, an intentional decision against using a certain procedure used by everyone else. Imitation reflects the desire for a genuine musical intertextuality especially clearly, and here at last it reveals the overarching context. Music in a complicated sense had become self-referential, and this possibility was systematically, structurally, and characteristically introduced. This required not only an even greater professionalization of the work of its actors, that is, composers, but also a special sensibility for the new forms of perception with which it was connected. This granted music a new form of contemporaneity, which conversely first made possible the development of its own musical history in later generations. As much as intertextuality required in all its manifestations technical requirements for

composition, it had made possible the realization of an unchanging compositional physiognomy. In the related diffusion, refinement, and very soon breaking of these preconditions lies a central quality of the era, whose effects were felt far outside the confines of the musical work.

MUSIC'S SIGNS

Since the ninth century music possessed its own system of signs, its own writing, in the form of neumes. During the High Middle Ages, based on the thought of Guido of Arezzo, neumes were changed in a characteristic manner into a new quadratic form of sign. They could be arranged in four-, five-, or six-line systems, and with the help of these lines intervallic relationships could be represented, which thus made pitch relations clearly legible. In the late thirteenth century this relational legibility was opened up, so to speak, foremost by Franco of Cologne and his *Ars cantus mensurabilis* (ca. 1280). The exact form of an individual sign provided guidance as to its relational duration as well. It was doubly legible, in relation to pitch and duration. Up to this point rhythmic preparation of parts followed an existing pattern, selected among a theoretical supply of at least six different forms and imposed on the proceedings, and thus it was able, according to tendency, to be individualized from piece to piece—so broadly that already around 1300, above all in Petrus de Cruce, rhythmic diversification of this type had become so convoluted that in the following two decades a new systematization followed, oriented toward a clear hierarchical division of note values. But Franco of Cologne defined "musica mensurabilis," measured music, not only as a new technical possibility, but also as a new type of music that encompassed both kinds: the theoretical expression and the written music itself—that is, in the dual sense of writing, thinking about and through music. "Musica mensurabilis" reveals itself as a complex and intricate theoretical matrix that was consequential for musical writing as well. The notation treatise offered a new genre for this purpose, and until around 1600 it had a secure place in general musical scholarship whereupon it vanished again.

The opening up of the temporal dimension of music—the possibility of ordering the course of individual musical works—stands as a determinative quality of fourteenth-century music and became an overriding compositional interest. It came to the fore most clearly in a manner of composition that since the early twentieth century has been labeled with the complex and ultimately

bewildering term "isorhythmic." By this is understood the process of allowing a tenor comprised of a chant excerpt, as was already the case with thirteenth-century motets, to repeat multiple times, but to add an individual rhythmic model to it. With the repetition of the excerpt the same model is heard, although mostly changed relationally—within certain internal proportions and by the shortening of its absolute values. Other procedures were also possible, in the most complicated case even the separation of the rhythmic model and the melodic excerpt (through the creation of a rhythmic model that, for example, was half as long as the melodic excerpt), but proportional shortening remained the favored method. In a rhythmic sense the composition no longer participated in an existing *ordo*, but this order was remade. This also meant that the tenor—the chant excerpt—could no longer be commented upon or glossed by additional voices. The tenor had to be constructed and rhythmicized anew from case to case. Chant was thus, in a decisive step, turned into a material available for composition. Its authority was reduced to being only the point of departure for composition. It was for the most part dispensable and replaceable, a possibility that was immediately exploited.

The dynamic of the dual legibility of musical signs not only extended to the idealized changes to the concept of composition tied to the tenor, but influenced compositions habitually. The new possibility of determined temporal structure encompassed all parts, but the tenor in a special way. The possibility of instituting an individual compositional order, for example, in the proportions of 3:2:1, gave the tenor not only a special influence, but also a specific direction. The phenomenon of the fourteenth-century isorhythmic motet was the discovery of a defined compositional course, which was most recognizable as a rule in the tenor. For the first time newly composed music had clear direction: a beginning, an ending—and a clear course from one pole to the other. This conscious change in the perception of musical time corresponds with a general change in the concept of time, which can be seen in a range of sources. Among the clearest of these (which include the use of Arabic numerals) was the invention of the mechanical clock, which measured time independent of external conditions and emerged around 1270 parallel with *musica mensurabilis*. Under the influence of a new reality-oriented Aristotelianism, time moved from being a metaphysical category to a physical and subjectively perceptible phenomenon, what Anneliese Maier has aptly described as the "subjectification of time."[37]

The compositional practices of the fourteenth century could have been somewhat schematic in this respect. But from the beginning they were

imbued with a new fascination with temporal structure. Original temporal standards represent the essential precondition for composing in a modern sense, and on the other side, in the realm of writing, the possibilities of temporal structure were met with great excitement, and ever more unrealistic proportional structures (such as 9:8) were discussed. The new notational possibilities made it possible for composition to order itself based on the perception of a recipient, and composition became part of the active world of experience and participated in this "subjectification." As a result, at the level of musical signs many differences can be observed owing to different worlds of perception. For the first time further graphical indications were added to written signs, specifically ones that designated the mode of the hierarchical distribution of notes (foremost being the main value of the breve); the designation of the main values as "longa" and "brevis" points not only to their origins in prosodic (metrical) theory, but also to an interest in the accentuation of temporal difference. The "mensural" signs that were created as a result (such as o or � or ¢) thus regulated on another level the compositional events, alongside the lines and the dual legibility of the signs positioned within them. A musical record thus had become much more complex: lines, and temporally and spatially legible graphical (square) signs, further directions in other kinds of signs (that could be augmented by verbal text), as well as the sung text itself, since for the most part only vocal music was recorded. Until around 1600 nothing about this structure changed fundamentally, and the stability of the graphical overdetermination that resulted is all the more astonishing when one considers the instability of the individual parameters. Even Petrucci in his 1501 musical publications maintained these different levels, in that he printed lines, notes, and texts in separate phases. (The process was likely abandoned because of its cost.) Only after 1600 with the fundamental changes and simplification of new score formats, in what appears to be an almost compensatory move, were further signs added. These were concerned with what we would today call "performance": instrumentation, dynamics, and so forth.

In this way musical writing separated itself in a distinct manner from other musical practices. But even nonliterate forms were affected by this overdetermination and began to abide by its standards whether intentionally or not. Reliant upon improvisational models, beginning in the fifteenth century the practices of instrumental musicians, above all organists, maintained the systematically developed concept that a sufficiently great virtue, *virtus,* could provide stable structures to musical activity if one intentionally

dispensed with written sources. And only in a second phase would written forms of this music be developed. This was part of the diversification of the musical and is manifest in the extrapolation of more and more possibilities for written records.

The addition of proportional signs and verbal instructions (so-called canon instructions) were not the only accommodation to habits of perception that had been brought forth in the fourteenth century. Within the system itself differences were introduced, above all in France and Italy but also in England, with other models for musical temporality brought to bear. In the scholastically minded French theory the procedure was deductive, assuming that note values could be hierarchically divided into smaller ones. In the more pragmatically minded Italian (and this means above all Paduan) theory the process was inductive, drawing on the smallest possible unit, which was grouped together to form larger note values. In this practice one also used, owing to pragmatism, a six-line staff. In the early fifteenth century the Paduan scholar Prosdocimus de Beldemandis contrasted these as "ars scilicet Italica" and "ars Gallica."[38] The systems of musical signs thus oriented themselves according to the cognitive and experiential worlds of their protagonists.

In the fifteenth century people grasped the principal complexity of musical records, on the one hand, but they did so, on the other hand, on their own terms. Above all but not exclusively in the early fourteenth century there was considerable interest in the compositional structuring of time—in an anonymous motet from late in the century (*Inter densas / Imbribus irriguis*) all possibilities of musical temporal structures are systematically used—and in the fifteenth century this interest abated. It was interesting as a problem only in spectacular exceptional cases—for instance, *In hydraulis* by Antoine Busnois, written in honor of Ockeghem—which once again explored the possibility of bringing pitch and duration into a systematic and compatible relationship. In the explicitly developing musical work the possibility of the individual structuring of time evidently stood no longer as a genuine challenge but rather as a necessary premise. Around 1500 mensural indications are more systematic and in the sixteenth century were reduced, slowly but surely, to the norm of a two-part *tempus imperfectum* (*diminutum*), the least problematic meter. The fact that this mirrored an orientation of people's perception shows that in the fifteenth century there is evidence for the first time of the idea that the structure of temporal process could be connected with the human pulse.

In the fifteenth century further refining tendencies stand alongside the disavowal of the active, demonstrative possibilities of temporal structure. The opposition of different models of comprehension, above all the Italian and French, was abandoned around 1420/30 in favor of a single method of recording that was adopted throughout Europe. All special modes of writing were based on these methods, above all instrumental writing. Curiously it was not the empirical Paduan notation but rather the scholastic French notation that attained the status of dominant norm. Upon closer inspection, however, the result appears not so paradoxical. Compositional decisions would not be oriented toward results, since they did not proceed inductively, but rather deductively through complex planning. Even the new sonic realms explored in Ciconia's compositions around 1400 were not the product of an additive procedure, but rather—with a certain conscious simplicity—a reduced partitive process that assumed a draft. The term "artwork" assumes a formal plan based on thoughtful procedures that cannot be understood as additive—much like a painting forges ahead from draft to execution and not the opposite. Connected to this was the eventual adoption of the five-line staff, which stood clearly differentiated from the four-line staff of nonrhythmically notated chant. The fact that differences in tonal systems (harmonic as opposed to modal tonality) were noted should be understood not as a point of departure for the Renaissance, but one of its "results."

The simplification of the system of musical writing was connected to another change around 1420/30. Throughout the entire fourteenth century mensural signs were black notes, which could occasionally be rubricized, or made red, to note special things such as a change in meter. Beginning in the first third of the fifteenth century the technique changed, and notes were only "white," since they were bounded by lines and blank within, and the reddening was as a rule replaced by blackening. In previous research this change is most often discussed, when it is treated at all, as part of the change in writing materials from parchment to paper. But in records from the fifteenth century parchment did not disappear so suddenly. For this reason underneath this change, which coincided with the numerous other changes previously discussed, above all the boom in writing and the adoption of the French notational model, one can presume a change in perception took place as well. The single note appears no more as a black area, but rather as a body bound by lines. The new valorization of the line as one such boundary of creative production, which played a large role in painting and is explicitly discussed in

Alberti, reveals another understanding of the graphical signs. Cennini and Ghiberti discussed the line as the foundation of "disegno," of drawing, and Alberti viewed the line as the bearer of structure.[39] The activity of the composer now consisted of the ordering of these linearly bound signs, which had a new function as bodies in sonic space. Notational signs acquired boundaries like the figures in a painting. Thus written notation was a new materialization that was important not just for the musical work of art. Much more, musical writing contained a quality that in the end differed markedly from written speech, contravening the intentions of its ninth-century inventors.

Musica mensurabilis was connected to an individual voice that during the entire fifteenth and sixteenth centuries remained unchanged as a method of recording and transmission. The musical work was put together from the fragmentary components of the individual parts, which thus possessed a great deal of autonomy. It was based on this consequence that a compositional procedure would come to be based on the idea that the combination of multiple parts proceeded *punctus contra punctum,* as counterpoint. Thus the musical work participates in a realm of experience also present at the same time in single-point perspective. The components of the representation were now focused on and centered on an imaginary observer. In the case of music this observer was a listener, who as a figure is first encountered around 1400 and was for the most part the singer himself. He puts the separated voices together again and creates the end goal of the musical event, which in the end—and especially in the preparation and resolution of dissonances—is oriented toward his expectations. The technique of the choir book, which brought all the voices of a piece together on two pages in separate notation, places this before the eyes with physical clarity. The written score, in which simultaneously sounding parts are written underneath each other and first encountered in the late sixteenth century, signaled the end of polyphonic settings in which—at least in theory—there was no hierarchy of meaning.

For this reason in existing research there has always been much discussion about whether the composed work was notated in score or was begun in individual parts, a thesis that has been put forth by Jesse Ann Owens. The embedding of composition in the process of the *artes,* however, rules out the divided conception of voices. Controlled planning characterizes the work of art, especially the musical work. This means exact control over the compositional process is unthinkable without a score, especially given the new organization of consonance and dissonance. The fact that the score as a compositional form was not also a form of recording, archiving, and transmission does not repre-

sent a contradiction. Alberti also explicitly articulated the structure of pictorial space through the structural work of the line, but this structure vanishes in the eventual final work. For the new representation of the musical work it would be similarly self-evident that the efforts of construction evident in the planning phase would disappear. The illusion of the free interplay of individual voices was preserved as a cognitive concept as well. The tiny compositional elite did not include the conceptual forms of the musical work in transmission and apparently had no desire to do so. For this would be comparable to a painting or a sculpture that intentionally revealed its principles of construction (and thus would fail as a work of art). The most successful model of recording music in single voices, closely tied to the signifying system of *musica mensurabilis,* obscures the circumstances of its creation—and points to the immediate contemporaneity of music in a process termed "performance" since modern times. It does this even when music is recorded in manuscripts that were not intended to be used for singing (above all in the first decades of the fifteenth century, and also somewhat later).

The separation between the modes of compositional cognition and musical transmission continued in the process of performance itself. Beginning in the later fifteenth century there are manuscripts that were systematically used for music making. But these very examples were an archive to be used only in case of need. Music is, after it is composed, of necessity performed for a first time, or premiered if you will. For this first performance there typically was no choir book or part book, and certainly no printed version. And yet the composer's manuscript was not considered especially valuable, with music focused on the result not the traces that led to it, the "single-handedness" that is discussed in painting at the latest in Vasari. In this fact remain perhaps the reactionary traces of the *ars liberalis,* of music as an immaterial free activity. Between the act of composition, the first transmission, and archival conservation, which took place after one or multiple performances, there lies a gap that is difficult to fill, and cannot be ameliorated by a surviving autograph or "performance materials." In order to fill it Charles Hamm proposed the "Fascicle Manuscript" thesis: double pages prepared for the purposes of performance and perhaps prepared by the composer himself.[40] It is not impossible that in some manuscripts, in particular codicological oddities, such single sheets were preserved through whatever happenstance. Thus Guillaume Dufay's motet for the 1431 coronation of Pope Eugene IV *Ecclesie militantis,* preserved in a manuscript located today in Trent, could owe its transmission to the inclusion and (incorrect) binding of two separate pages

FIGURE 17. Detail, Gentile Bellini, *Procession in St. Mark's Square,* oil on canvas, 367 × 745 cm, 1496, Venice, Galleria dell'Accademia. The large-format picture by Gentile Bellini provides insights into an important church festival in Venice. Abundant evidence makes it clear that the city was continually busy with processions of all kinds. The number of singers depicted cannot be determined for certain, and a boy singer is also present. It is similarly unclear what role the violin player had. But one can see two double-sided manuscripts, which evidently were not preserved like the music necessary for the procession itself.

originally intended for performance.[41] The value that such facsicle manu-scripts would have had for a "performance," for which instruments were also engaged, still remains unclear. In the *Procession in St. Mark's Square* (1496) by Gentile Bellini (ca. 1430–1507) there are chapel singers on the lower left side of the picture singing from this kind of facsicle manuscript, while the similarly engaged instrumentalist, apparently also a cleric, has no need of a text (fig. 17).

The system of musical signs was evidently ordered such that the traces of composition intentionally disappeared. These kinds of traces are present in meaningful numbers only beginning in the seventeenth and eighteenth centuries, because, among other reasons, the concept of composition and along with it the system of musical signs had decisively changed once again.

Forms of Perception

TIME AND SPACE

The awareness of time as a definitive quality of music, indeed one defining its transmission and composition, first became evident in the late thirteenth and fourteenth centuries, and shortly after 1400 its importance to music became so clear that it was no longer an explicit goal of composition. The few examples to the contrary had either symbolic motivations—such as the previously mentioned motet *In hydraulis* in praise of Ockeghem by Antoine Busnois, active at the Burgundian court and in Bruges—or an interest in technical experiments—such as the nine proportional pieces recorded by John Baldwin (d. 1615), a member of the Chapel Royal, in his *Commonplace Book* prior to 1591.[1] But both impulses—the use of technique as a means of reference or an end in and of itself—are characteristic markers of the era. This independent availability of technical means assumed a certain separation from craftsmanlike concerns, evident, for example, in the paintings of Jan van Eyck. Musical arrangement of time emerged around 1400 at the latest as a compositional technique in and of itself, elevated from its original function of providing a linear structure for compositional procedures. Thus already in the works of Ciconia there is evidence of a diminishing interest in a certain kind of engagement with time. Relatively speaking, the temporal structure of his works is quite simple compared to levels that had previously been reached. With the new demands that the musical work presented, similarly evident in Ciconia, an interest in a differentiated organization of the horizontal (compositional time) was displaced by a more subtle development of the vertical (compositional space).

Obviously both aspects are connected—the planned unfolding of the composition in time and space—but one was dependent upon the other. In

the realization of compositional linearity, which was not present in the successive rhythmical models of the thirteenth century, a fundamental condition of the musical work was not only created, but with the level of differentiation reached around 1400 it could be considered complete, and thus was brought out only in certain significant exceptional cases in which it was introduced as a technique. This modern push toward stable temporal structures, represented by clear mensural notation and finally in (modern) tactus, persisted well into the twentieth century, when time again became a compositional interest. It is no accident that the work of composers such as Charles Ives and Edgard Varèse took place in an era in which both philosophy (Henri Bergson and Martin Heidegger) and physics (Ernst Mach and Albert Einstein) exposed fundamental instabilities regarding time. Different from temporal structure, the spatial organization of voices, which arose as a compositional concern of comparable necessity shortly after 1400, was evidently understood as a matter of ongoing concern. It was never considered a settled or finished matter. Accordingly this concern affected the era with decreasing intensity and developed with its own dynamics. The desired solutions that had been pursued for over two centuries were once again subjected to changes, revisions, and upheavals, and would remain in effect until the completely new organization of verticality in monody, the use of a solo voice and basso continuo, around 1600. The significance of the northern Italian *signorie* must once again be noted regarding the earliest stages of this process, since the music connected with them for the first time fostered an immediate engagement with the spatial organization of voices. This is evident in the by no means small number of pieces that limited themselves to elaborate two-part structures, above all an astounding number of madrigals.[2] The artful combination of only two voices in secular pieces of the fourteenth century—and in the following two centuries limited to the specialized (and mostly pedagogical) sense revealed in the experiment of *bicinium*—evidently coincided with the discovery of a new sonic space through a system that did not nor could not have existed in two-part organum. These methods of composition took place in political and economic centers in which a new relationship to space was an important and even vital precondition for economic prosperity. A new consciousness of the experience and perception of space is seen not only in the representative and also idealized organization of civic space, but also in musical works whose sonic structures are oriented toward a new (and newly perceptible) contemporaneity, fundamentally connected with the comprehensible representation of a poetic text. This special context made the category of space a central and

even metaphorically effective dimension of music. The dynamic process set in motion by these concerns had effects well into the following centuries, including in contexts that were quite distant from the reality of musical works—for instance, the signaling of civic musicians.

As previously discussed, the fact that around 1400 the temporal organization of music lost its dynamic potential and at the same time the spatial dimension began to be developed can be understood as an essential hallmark of an era in which spatial explorations played a central role, whether internally, in Leonardo da Vinci's subtle experimentation with proportion, or externally, through the exploration of new trade routes and even continents by Christopher Columbus. Interest in the spatial structure of music, in the narrow technical sense of sonic space and in the larger and related sense of acoustics, continued throughout the fifteenth and sixteenth centuries and went in a new direction only with the advent of monody and the related theatrical form of opera—that is, with the assumption that music was structured as a staged, affective language oriented to an audience. Music thus in its own way witnessed its own share of fundamental changes in perception and was if not a cause of these new general concepts of space then at least an index of them. The place of polyphonic music in the new public sphere of fourteenth-century northern Italian urban centers should be understood in this sense—namely, as the desire to make music perceptible as a public statement, not as a signal or sonic ceremonial representation, but as composed polyphony itself. Even if concrete details about performance practice are based on conjecture the fact of the performances themselves assumes great significance. It represents the premise for the most important compositional changes in the fifteenth and sixteenth centuries. The compositional shift in the first decades of the fifteenth century, which saw the experience of music as an acoustical event, should be understood in this sense. The essence of this change lies in a completely new relationship between consonance and dissonance, as evident in the contrasting motets by Guillaume Dufay previously discussed. But the compositional procedures of the fourteenth century, including two-part madrigals, were based on a technique of additive sonic development: the process of music was marked by consonances, with dissonances freely placed between them or at least not introduced in goal-oriented succession. A vertical temporal process existed only at the level of duration, not as sonic progression. Dissonance was thus not, especially in the lead-up to clausulae, correlated with consonance. This changed in the early fifteenth century, again through the initiative of Ciconia and his circle as well as

English musicians active in continental Europe. Dissonances were now prepared before they were introduced and had to be systematically resolved.

Suddenly compositional processes are determined by expectations. These expectations could be met and fulfilled, or not. This new orientation of musical settings required a regulated compositional linearity without which this kind of sonic organization would not be possible. In scholarly circles there has been endless discussion, and even bitter debates, over whether this should be considered the advent of harmonic tonality or not. In a technical sense it was absolutely such a moment, since tonality takes as its central characteristic the structural connections between and the related organization of consonance and dissonance. This holds true regardless of the functional differentiation of various components—that is, the question of whether something is "still" modal or "already" in a major or minor key. If the engagement with compositional space is generally considered to be dynamic to a large degree, this holds true for this situation. The change from modal to harmonic tonality proceeded not in fits and starts but as a process, and this process was extended within harmonic tonality itself, which for its entire existence and despite all kinds of normative rules has itself never been a stable object, and astoundingly such stability was never anyone's stated goal. This internal dynamic thus also reveals itself in music as a characteristic of nascent modernity.

The Renaissance is marked by the start of this process, driven by the awareness that sonic space had acquired a new quality. When ideas of expectation (consonant and dissonant relationships) were to be defined in musical works and when the formal encounter with them was revealed as the internal motor of the work, then such works were now oriented toward a listener in a previously unseen manner. The composer dealt with this in a calculated sense, and in short, the work presented itself to him as a counterpart. The previously discussed qualities of a few compositions from the 1420s played an important role in this process. The incorporation of fauxbourdon in the *Communio* of Dufay's *Missa Sancti Jacobi* (likely created in 1426) shows just such an interest in the listener—that is, it shows a kind of perception similar to the spectacular highlighting of the words "in sede beata" in Dunstable's motet *Sancta Dei genitrix,* created for the liturgy of hours for All Saints[3] (musical example 6). As previously mentioned, the musical work's new orientation toward the listener corresponds with the reorientation of painting toward the viewer in the technique of single-point perspective, which points to a change in perception regarding the organization of depicted space rather than standing as that change in and of itself. These changes are as evident in

MUSICAL EXAMPLE 6. John Dunstable, *Sancta Dei genetrix,* measures 140–47 (ed. Manfred Bukofzer). John Dunstable's three-part motet for All Saints, *Sancta Dei genetrix,* preserved in the Modena manuscript whose index was reproduced in figure 15, is doubly layered at the end. Before the weighty "Amen" the words "in sede beata" are sung in homophonic block chords, set apart by pauses and a change in measure and elongated by *coronae* (fermatas). This technique is found occasionally in the fifteenth century and is labeled as "noema."

the more than twenty surviving two-part madrigals of Jacopo da Bologna as in the explorations of space by Giotto and his circle, and in the first decades of the fifteenth century they became a controlled and controllable mode of representation in the mathematical models of Filippo Brunelleschi (ca. 1413) and Leon Battista Alberti (1436). This new elevation of the subject as the focus of perception (and with it the work of art) was evident simultaneously in different contexts, in Alberti's treatise on painting (*Della pittura,* 1435) with its rhetorical foundations or in Lorenzo Valla's linguistic philosophy (*Dialecticae disputationes,* 1439), in which the perceiving individual stands as the center, elevated by the all-powerful claim of the author to replace Aristotle. The new regulation of consonance and dissonance, which very early and (only at first glance) surprisingly led to the spread of norms and types of cadences, can be understood thus as part of changes articulated in many ways, but in which music, thanks to its immediate and sensuously perceptible connection to space and time, played an especially significant role. This circumstance is connected with the previously mentioned attempts to fix if not music itself but the perception of certain kinds of music in verbal form. A passage from the 1441/42 epic poem *Le Champion des dames* of Martin Le Franc, previously mentioned briefly in a discussion of historicity, is once again relevant, since the author describes not just a specific music, but also the technical transformation (in Dufay and Binchois) as a habitual

change of composition that has an immediate effect on the perception of a listener:

> Car ilz ont nouvelle pratique
> De faire frisque concordance
> En haulte et en basse musique,
> En fainte, en pause et en muance.
> Et ont prins de la contenance
> Angloise et ensuÿ Dunstable
> Pour quoy merveilleuse plaisance
> Rend leur chant joyeux et notable.[4]

The author describes a new technique as differing from older methods in a positive way. He reclaims the advantages of the "moderni" compared to the "antiqui." For this he uses the characteristic term "pratique" (or "prattica"), and by this indicates that it is the result of "making" in the sense of craft. In this way composition has become, in a poetic text, semantically likened to the sort of handiwork that Monteverdi at the beginning of the seventeenth century could designate as "prima" and "seconda prattica" with utter self-evidence. The new structure of the experiential realm thus lies in a technical matter, an understanding that was applied to the perspectival structure of a painting in similar ways at the same time. The emphasis on "making" in a workmanlike sense, in fact a well-known cognitive figure in antiquity, represents a *novum* in the engagement with composed music, and this points to the newly emergent quality of orientation toward a listener. The listener was able to see the result as unusual, to feel it as "frisque." This changed experience must have in turn had an effect on composition itself, in that now technical possibilities, "pratique," and aesthetically effective calculus, "plaisance," were to be directly combined for the first time in the history of music.

The spatial exploration of compositional structure was indebted to changing interests. While in Dufay's generation the newly available compositional possibilities—of which more will be said—were certainly tried out, in the succeeding generation—similar to cadential techniques—these matters were already so fixed that attention could be turned to other aspects. The hierarchization of voices that took place in the middle of the century is one such aspect. While linkage of tenor and discantus still represented the central axis of compositional activity as had previously been the case, the tenor lost its privileged position, setting aside a few notable exceptions. By the end of the century four- or five-part settings had for the most part dispensed with a

center, and polyphonic texture was no longer dependent upon internal hierarchies. When such hierarchies are present—such as in Josquin's *Miserere* or Pierre de La Rue's *Delicta juventutis*—they should be understood as intentional deviations from the norm. As a rule musical space was premised on a new sonic order in which all elements were treated equally. Temporal structure could thus recede even further into the background. This is revealed not just by the increasing normatization of mensural possibilities. Much more, one encounters in the later fifteenth century, in Ramos de Pareja (1482), the first systematic efforts to understand musical time "corporeally," through the previously mentioned connection to the human pulse.[5] Temporal structure in a network of simultaneously sounding voices is exclusively indebted to interaction with the text, which now reproduced the underlying structure in a perceptible sense. And in places where this text itself was normalized, such as in mass composition, mensural relations were completely regulated.

As already indicated, given this background it is likely that the score or the complete musical setting must be understood as the actual mode of compositional thought, as the real medium. In the moment in which interest turned to modes of expectation and thus the exploration of musical space, composition in separate voices appears unlikely. Any control over these results would be impossible without the cognitive mode of the score. The difference that was thus created between the forms of compositional thought and practical modes of representation—that is, between the "thinking" of the score and the "doing" of the individual voice parts—can be understood as a productive challenge of the era, only overcome by the (re)introduction of the score under the auspices of monody. The new organization of sound assumes the simultaneous conception of all voices, an occurrence that can be observed on many levels, in Ockeghem's masses as well as Josquin's motets and the frottole of Bartolomeo Trromboncino. The lowering of the level of difficulty does not indicate a difference in the techniques of creation. This is especially evident in the over sixty monumental motets created between 1497 and 1502 for the great choir book of the college chapel in Eton, whose sonic organization and profile stand in singular contrast to continental works owing to their different techniques for grouping sounds.[6] The idea of newly conceptualizing space and thus being conscious of it also affected painting. From the 1470s there are efforts to combine the different chronological layers of a story in a single simultaneous pictorial space using perspective. Such attempts at making the conception of space available for immediate sensuous perception were not just brought to bear upon the simultaneous conception of voices in a broad

manner. Johannes Ockeghem's *Missa prolationum,* which was long mistakenly considered a "medieval puzzle," can be understood in this modern sense as an attempt to simultaneously blend all of the musical parameters in a complex sonic space and thus make perception accessible. The development of polyphonic texture from a double canon at the level of interval and measure is also an indication of a new compositional plasticity. In a similar way entire spaces, such as the *studiolo* of Federico da Montefeltro in the ducal palace in Urbino (1476), could be projected into two dimensions in order to make them newly perceptible.

Music as a compositional event participated in these discoveries and this creation of new spaces of perception. This was embodied in a compositional technique, often connected to Josquin but not limited to him, but which he used in a particularly incisive manner. This is the systematic structuring of the text that is to be set. The individual excerpts are marked with a musical-melodic unity, a "motive," that is imitatively "realized" in all voices. Afterward, at the start of a new textual excerpt, a new motive follows, and so on. Josquin's six-voice motet *O virgo prudentissima,* composed using a text by Angelo Poliziano, is an especially eloquent example of this. In earlier research this technique was understood as rhetorical representation, but it is in fact far removed from rhetoric in the humanistic sense. Much more, it is interested in the systematic sounding out of a sonic space with the text as its tectonic framework. The text is not linguistically "represented" (in the humanistic sense), but it rather structures and illustrates a musical process. The procedure in early madrigals (such as Arcadelt's) in which excerpted text declamation was treated quantitatively and not qualitatively was evidently attractive and fascinated composers of the first half of the century, including Adrian Willaert. The tension between a tectonic function of the text and the increasing desire to "illustrate" this sensuously (in the sense of rhetorical *evidentia*) stands as a characteristic of the sixteenth century. It was first resolved in the clear turn to the presentation by a singer in monody.

In contrast to interest in time, interest in musical space was not, however, limited to composed musical works. The position of music in space gained increased attention and eventually became a central premise and condition. In Dufay's isorhythmic motets one can already discern efforts through which composition could react to its spatial context in a provisional manner. The fauxbourdon excerpts in the motet *Supremum est mortalibus* demonstrate a new technique not just symbolically. They appear to be a reaction to the place of their performance, outside on the steps of St. Peter's in Rome. In the end

too little is known about such places of performance, but there are nevertheless certain connections that can be grasped. There are large-format liturgical manuscripts from the Este court from around 1480 that included two choir books intended for parallel use. They thus suggest that two different groups performed music simultaneously from different places in a room.[7] This "multichoir" format, which is evident in other liturgical sources, was later developed systematically at San Marco in Venice from the middle of the sixteenth century and was responsible for the European renown of Andrea and Giovanni Gabrieli. The reason for this was not necessarily the number of lofts in San Marco, as these conditions existed in other places and could have been easily reproduced. Nor was it the extremely problematic acoustical properties of the church, which was ill-suited for different techniques of perception. Perhaps this testing of the spatial dimensions of music was linked to a place in which for a long while—and especially in the sixteenth century—civic, republican, and ecclesiastical representation could be combined. The large-scale pictures and frescoes by Tintoretto, Titian, or Veronese disclosed the collective effects of real and fictional space in a dramatic way, in the persuasive sense of a rhetorical technique—in a way that is not far removed from the large double- and multichorus works of Giovanni Gabrieli. Pietro Aretino has stressed one quality of perception unique to the Venetian environment that might explain why more freedom with tradition was possible compared to other places. It is at least somewhat plausible that the pragmatic exploration of spaces had an effect on music owing to the economic interests of this oligarchical-republican environment. The discovery that a subject, by contrast, could experience space not only in an architectural sense but in an acoustically determined manner must have had an effect on music throughout the city, not the least on the rich practices of instrumental music.

Empirical experimentation and the sonic exploration of a defined space also have an opposing trend, a limitation that was especially influential in Venice, among other places, by which a new mode of musical experience became a special interest. Music not only could be experienced in different kinds of internal spaces and used for representative occasions in public, but could be found in the organized and controlled separation of nature. Abundant evidence from painting and literature shows that music, both composed and improvised, could be heard in gardens or other semienclosed contexts (or at least it was imagined that it could). The boundaries between composition and improvisation thus become more porous, since in paintings one cannot always discern notation or notes. But music appears, like a sculp-

ture in a park, as an artistic product in the natural realm, and the experiences of art and nature complemented one another. The new reality that music could achieve in the "realm" of nature in turn had an effect on musical practices. Instrumental methods such as Ganassi's *Fontegara* assume an isolated working subject in a place (including natural settings) in which he can use his instrument to fill the space with music.

In the sixteenth century this new relationship to space led to spaces being architecturally conceived of specifically for music, creating a designated space for music itself. A result of the dynamic relationship between music and space lay in the creation of a sonic space in an elemental, physical sense—a room in which sound could be preserved. This began with the singer chancels and lofts in the fifteenth century up to the musical lofts in festal chambers such as the music tribune of the *Festsaal* (the antiquarium) of the Munich Residenz completed in 1578 and its dedicated theater, as well as Palladio's Teatro Olimpico in Vicenza (1585). The process that led to this separation unfolded throughout the Renaissance and can be understood only in connection to the compositional exploration of sonic space. The separation that occurred is at once a "result" of the Renaissance, and in subsequent centuries, well into the twenty-first, it developed in a dynamic way that has never remained static.

TEXT AND CONTEXT

One attribute of the musical work is the tension between its written form, its text, and its status as a sonic event, its "performance." With the sudden proliferation of the musical manuscript as an independent type of written transmission around and after 1400, which for the first time created a relatively stable textual status for music, between the creation of a work and its conservation there nevertheless stood a considerable temporal and spatial distance, which was by no means impossible to overcome. Every text has a context. But it is not easy to differentiate between text and context, and the problems that arise surrounding this issue are constitutive of the era as a whole. As difficult as it is to determine the fundamental ontological status of the musical work, these difficulties are all the more productive in this early phase. For the difference between text and context not only concerns the larger disparity between notation and performance but can be encountered on various other levels. On these different levels a wide variety of findings arise, and beginning

around 1600 a significant change appears to have taken place, which can be understood as both a reduction and a systematization of this variety. With the comparably stable textual form that the musical work had attained by around 1400 the tension between a "text" and its "context" in fact arose for the very first time. This tension was not just a novelty of the Renaissance, but was rather one of its constitutive characteristics and the source of a great deal of productive energy.

Mensural notation granted music a comparably dense texture. This took place in special circumstances, above all the recording of individual voices. This density was limited to the system of signs, that is, of multivoice settings—the indispensable structure created by actual compositional effort in the narrow sense of the word. The text accordingly reveals fundamental information about the relationships between voices, even though this is not precisely depicted in the graphic system. The motivation of written notation (the textual stability of the score) and its optical materialization (the preservation of the autonomy of individual voices in part books and choir books) thus similarly represents a field of tension in which other central elements did not participate or did so only in isolated cases. This area of tension is a condition unique to music and is foreign to all other modes of writing. Only the musical work had to solve the problem of how to depict the simultaneity of voices in successive or side-by-side texts, especially evident in part books. An initial context of the texts reveals itself as the recording of an imaginary vanishing point of polyphonic coordination.

Music of the Renaissance that was preserved in written records is for the most part bound to texts. The ways that texts were placed below notes display a great level of variation, and the character of the underlay was evidently completely dependent upon the interests of the party responsible for compilation. In a manuscript such as Modena B, created in the 1440s and connected to the repertoire of the papal chapel, there is evidence that great care was taken in the recording of text, down to the smallest details.[8] In a later codex created in the middle of the 1470s for the chapel at St. Peter's in Rome, also intended for the use of an august institution, the exact opposite strategy can be observed—that is, an astounding lack of interest in the words themselves.[9] Even if such findings might not be seen as significant in a chronological sense, since in the course of the sixteenth century interest in a "secure" placement of text increased markedly, in fact for this same reason they show how these contrasts did not entirely disappear even as the ordering of text and music in general became subject to a stricter regulation. At the Munich

court in 1558 the miniature painter Hans Mielich outfitted a monumental choir book containing four- to eight-voice motets by Cipriano de Rore, under the supervision of the composer himself with special attention to text underlay.[10] In the six part books prepared by the Zwickau cantor Jodocus Schalreuter beginning in 1536, by contrast, completely different and in the end not entirely harmonious interests are evident, setting aside the disciplinary knowledge of its owner. Here the text is at times carefully positioned and at other times not at all.[11] There thus arises the question of whether the distribution of the text under the notes contains textual or contextual qualities, and perhaps it is wrong to even expect that there might be an unambiguous answer to such a question.

The cantor of San Marco, Johannes de Quadris (d. after 1455), can with a reasonable amount of certainty be identified as the collector of the remarkable collection of music that is today housed at Oxford. As a specialist he was concerned with creating the most precise records possible and favored the inclusion of composers' names (by no means a self-evident decision in the 1430s), as well as additional information (often somewhat isolated) such as dates and affiliations—for example, "Hugo de Lantins ad honorem santci Nicholaj confessoris et episcopi conposuit."[12] One of his principal passions was the collection of French chansons. But the records of the poetic texts show that the collector had little or no fluency in French. What does this mean for the real-life context of these compositions in Venice? The uncertainty only increases. The first printed polyphonic music, Ottaviano Petrucci's 1501 *Harmonice musices Odhecaton A*, also created in Venice, contains almost one hundred (ninety-six) songs, almost all of them French. Its publisher, Petrus Castellanus (d. 1506), was kapellmeister at the Dominican Convent of SS. Giovanni e Paolo, and it might thus be assumed that the collection reflected in part the musical practices of this institution. But it remains entirely unclear what this reveals about the presence and comprehension of French texts and their devotees around 1500, much less about the proclivities of learned Venetian Dominican monks for French love songs. This question will be taken up at greater length later. There are thus collections of texts whose context is quite difficult to define, and in this respect manuscripts and print sources do not differ markedly.

Even more difficult to ponder are manuscripts (and print sources) that do away with textual underlay altogether. Here there are also variations, from the insertion of an incipit, which evidently served to identify the respective piece (as occurs in the *Odhecaton*), to the recording of a "naked" musical text

with no additional information. In some research these examples have been perhaps rashly interpreted as "instrumental" transmission without venturing other explanations. But when one can observe a passion for French music in environments with limited knowledge of the French language, an interest in "pure" music seems to lie entirely within the realm of possibility. And there is at any rate no reason to interpret these as pragmatic notation for instrumental music. On the contrary, there is also evidence of a lack of interest in the underlay of "original" text. In sixteenth-century Basel there is evidence of both French chansons and Italian madrigals. But in fact a twenty-eight-page manuscript (containing only poetry) belonging to the doctor Felix Platter (1536–1614) shows that these pieces were not sung in French or Italian but in German translation; for example, Arcadelt's famous *Il bianco e dolce cigno* was sung with the text "In allem Sterben singt der Schwan."[13] The stability of the musical text was confined to the notation, and the relationship to the text was not necessarily taken into account. This difference is even more evident as the Renaissance was the age in which the beginnings of philology—that is, critical concern with secure textual sources—came to be. Ancient texts were the primary focus, initially Latin and later Greek, after the exodus of scholars following the fall of Constantinople in 1453. Soon the Bible gained renewed attention, evident in the centralized editions planned around 1500, the revision of the Vulgate in the multilingual six-volume *Complutensian Polyglot Bible* (1514–17) championed by Cardinal Francisco Ximénez de Cisneros as well as the new edition of the New Testament by Erasmus of Rotterdam, who explained his process in a self-reflexive manner in the very title of his translation.[14] Such activities were at the very least meaningful for music theory, since they concerned not only the textual restitution of ancient authorities—for example, in Boethius—but also the idea that the purportedly mute repertoire of eight modes might be broadened to include the twelve modes of antiquity—for example, in Glarean. In polyphonic music, by contrast, such philosophical concerns were the exception rather than the rule—for example, in the monumental sixteenth-century edition dedicated to Josquin, Johann Ott's 1537 *Novum et insigne opus musicum*. The restoration of texts had special meaning in the context of liturgical music, specifically chant. The many efforts at reform in the fifteenth and sixteenth centuries were concerned with having a single binding text, culminating in the great reforms of the Council of Trent. Through these reforms not only were numerous local variants eliminated, but there also arose an edition that purified the repertoire philologically, the 1614 *Editio Medicaea,*

which as already noted, turned chant from a practice that had been periodically made new into a historical object, evident in the very use of the term "reform."[15] It is notable that concern with purified musical texts arose within a repertoire that had been continually expanded well into the sixteenth century, but which in contrast to polyphonic works had no sense of authorship.

Up to this point the relationship between text and context is already quite complicated. But if one looks deeper into musical writing in a more narrow sense, then new uncertainties arise. What do these writings reveal, and what do they not? They are normative regarding the organization of voices with respect to one another, but other contrasts recede in importance, if one sets aside the special case of instrumental manuscripts. They offer no insight into the arrangement of singers and instruments, and they lack additional markings that might reveal the precise way in which they were performed. As a result these contexts are not explicitly legible in the written sources. This does not mean that a high level of capriciousness was the norm. Much more, it appears that performance was governed by a complex of implicit norms that were employed in different ways. Such norms had wide regional variations, but, generally speaking, they were not considered worthy of noting. As a result, text and context cannot be separated on this level. Among the representations of the seven virtues that Pieter Brueghel prepared for copperplate reproduction in 1559, a "portrait" of a clerical chapel is found on *Temperantia,* made by Pieter van der Heyden, with five boys and three men with a master behind them, all assembled in front of a choir book (fig. 18). The accompanying organist, who is not a cleric, also plays from notation. But the same does not hold true for the substantial complement of instrumentalists in the background. Thus on a certain level writing reveals itself as a necessary precondition for some but not all performance, and yet both types of performance remain inextricably connected. But even this kind of evidence must be differentiated. In 1511 the wedding of Duke Ulrich took place in Stuttgart. During the mass the six-voice mass setting *In Summis* by Heinrich Finck was heard. A Saxon chronicler notes that it was sung "von der wirtenbergischen Cappelln" (by the chapel of Württemberg) and "ist ain laut gut wolgestimbt Regal darzow geschlagen wordenn" (and a well-tuned regal was played loudly as well).[16] A manuscript of the music has survived, however, with no mention of the use of an organ or regal in this context.

The fact that notation could itself be "open" at least in exceptional cases is attested by the practice of musica ficta, which can be understood as nothing

FIGURE 18. Pieter van der Heyden, *Temperantia,* copperplate after Pieter Brueghel the Elder, excerpt, 22.6 × 29.2 cm (Pl.), 1559/60. The representation of the chapel on the copperplate evidently contains realistic aspects, and one can see beside the boys and singers in front of the choir book an organist and at least four instrumentalists, who do not play using notation.

more than normative alteration in cases in which the modal system makes this necessary (for example, in order to avoid a tritone). As its name suggests, musica ficta is not an explicit component of notation, but was at least implied, or in other words defined by contemporary theory. Nevertheless here textual boundaries are revealed quite clearly, since there are no general norms regarding the process of making these alterations, which has led to considerable conflict among researchers. Even if concrete decisions for a particular performance are in evidence, these are not part of the notation. At the time there must have been some consciousness of these boundaries with respect to written notation.

Such problems of text and context go even farther. Even in the fifteenth century the transmission of numerous works leads back to geographic and chronological contexts far removed from the place of the music's creation. A large portion of the compositions of Johannes Ciconia is transmitted in manuscripts created shortly after his death in 1412. If these records were to be used for performance, and this is more than doubtful, then they would have

not been used under the supervision of the composer. These problems have not just historiographical consequences, since there are almost no records that trace back to the immediate vicinity of the composer—a problem that was solved only in the course of the later fifteenth and sixteenth centuries. This had wide-ranging consequences for the status of written records, since the performance context itself was not considered worthy of note, but was only a kind of substrate. Already mentioned on several occasions, the Chigi Codex is of utmost importance with respect to the transmission of the works of Johannes Regis and especially Johannes Ockeghem. But it was created in an entirely different geographic context, far removed from the French court chapel and long after the deaths of both composers. Without this manuscript, Ockeghem's oeuvre would be dramatically reduced (especially concerning his masses), and yet it reveals nothing about the reality of these works in their place of origin. This context is entirely concealed by the text. Even the extravagant musical manuscript production undertaken under the name Petrus Alamire in Antwerp reveals much about the status that costly manuscripts (and the repertoire they contained) had for their customers, but almost nothing about the actual context of the pieces themselves. The same holds true for the manuscript of polyphonic music prepared by the Nuremberg doctor Hartman Schedel (1440–1514) around 1460 for his own use: it is entirely focused on the collector, and with respect to the works reproduced it is merely a document of their reception. This difficulty did not fundamentally change in print contexts, and in fact was heightened, for the purchaser of a collection was for the most part anonymous, apart from individuals addressed in dedications. Nevertheless from this point on musical works could be created for an "anonymous" context—that is, created for the context of publication. This is true of early Reformation songbooks, which offer an ideal context not because of the individual significance they might have. In the exemplar of the *Enchiridion Geistlicher leder vnde Psalmen* located today at Emory University (Pitts Theology Library), only handwritten notes offer insights into the user, and these concern only the texts and not the melodies.[17]

Other aspects determine contextual meaning aside from moments of performance and reception. These concern a different type of external condition—for instance, the way a composition fits within a simple or complex ceremony. At the same time they are also concerned with internal considerations. A monumental work such as Adrian Willaert's six-voice mass *Mittit ad virginem* is only comprehensible in the context of the genre's wider history. It is based on one of the composer's own six-voice motets, published

in 1559 and immediately directed to its dedicatee, Alfonso II d'Este, who is explicitly praised in the Agnus Dei. The mass thus reacts subtly to the historical contexts of genre and patronage, despite the fact that these traits are stripped away in the process of transmission. The consequences are intriguing: in performance, text and context could be inextricably melded together, but the manuscript in which the work is preserved[18] presents only the text and thus the structure of the musical work. These structural demands of the musical work are in evidence throughout. In a manuscript created in the 1470s and today housed in Naples, six masses using the military song *L'homme armé* are recorded. Since the first page of each mass has been removed, nothing is known about their respective composers. In these six works text and context create a network of meaning that is quite dense and difficult to understand but at the same time indispensable for an understanding of the composers. And yet at the end of the manuscript there is a remarkable verse excerpted from a poem, which notes how Duke Charles the Bold admired these masses above all other musical works and had taken much delight in them: "Charolus hoc princeps quondam gaudere solebat."[19]

Text and context play a central role in all modes of art. But in music their boundaries are defined quite imprecisely, despite (or precisely because of) the fact that there is evidence of the effort expended to give the work of art a fixed and stable textual form. Two aspects of this are significant. On the one hand, the performance conditions of music are generally unstable and subject to constant change. These often depended upon the conditions of the location of the performance, which was explicitly discussed in the previously mentioned letter written by Thomas Stoltzer to Albrecht von Brandenburg in 1526. But the use of instruments in and of itself does not differentiate the status of the performance site, as evident in the use of the organ at the 1511 wedding in Stuttgart, in which a notable court chapel also participated. As a result written records represent an attempt to separate the essential from the accidental, evidently with the awareness that one does not exclude the other. But the stable text and the changing conditions of its sonic realization were not understood to be contradictory. The further separation of writing and performance is actually a product of the changes associated with monody. On the other hand, throughout the entire Renaissance there was a great awareness of this problem in and of itself. This is shown clearly in cyclical masses, an "invention" of the fifteenth century. The compilation of settings of the ordinary in choral records was at least an indirect model for order but not an indication of compositional connection and unification. The complex

cantus firmus masses of Josquin Desprez or Pierre de La Rue reveal this intention toward compositional unity, which can also been seen in manuscript and print transmission. This was possible only through familiarity with the actual liturgical function that can be explicitly identified in areas outside of a sacred context—for example, the court of Ercole d'Este in Ferrara. Each liturgical "performance" of this kind of mass—and this kind of liturgical presence must have been the norm in the sixteenth century as well—recreates the actual functional context, but at the cost of the musical work. It appears that this field of tension was not understood to be a dilemma or a flaw, but an essential element of the creative demand. Different from an altarpiece, a palace's architecture, a statue, or a poem, only music was characterized by the continuing contemporaneity of this field of tension. The musical work of the fifteenth and sixteenth centuries is unimaginable without this quality, and through its productive energy and power had wide-ranging effects, even on musical practices with no written apparatus.

LANGUAGE AND MUSIC

The dual sense of writing continued to be dominated by Latin during the Renaissance. And when the prominence of Latin came to be challenged in the sixteenth century, above all in the madrigal's triumphant march through Europe, this had little effect on the language of music. This was true above all for music theory, which only in pragmatic contexts (that is, in instrumental methods) relied on vernacular languages, and otherwise remained bound to Latin, with a few exceptions. In a manuscript containing an elementary lesson in musical modulation, created around 1500 in the Convent of St. Catharine in Nuremberg, the vernacular is included only as a translation: "Quot sunt cantüs in manu / Wie vil sein gesang in der hant?"[20] The use of the vernacular in discussions of serious polyphonic music is limited to a few notable exceptions. The Florentine-born singer Pietro Aaron (d. after 1545), possibly a convert from Judaism, began his series of writings in Latin in 1516 and continued them in Italian in 1523, taking into consideration the previous Latin works.[21] It is nevertheless notable that this change occurred after his relocation to Venice. The pragmatism that led to the unqualified interest in the implementation of a single written language, Tuscan, for the Serenissima and its sphere of influence—with completely different conceptions of it stylistic normalization, for example, in Bembo or Aretino—was accompanied

by an empirical interest in composed music itself. This interest that by 1400 had already led to the creation of musical texts in the environs of the University of Padua, after 1500 made it possible for the demanding fundamentals of music to be discussed in the vernacular. This was connected through no small coincidence with the explosive spread of musical printing, whose mercantile center was also Venice, beginning with Petrucci, who received a papal privilege in 1513 at a time when Pietro Bembo served as apostolic protonotar, a high position in the curial administration.

The conflict between the demands of a differentiated musical practice and the Latin scholarly apparatus that accompanied it and made it possible was at least partially resolved in Venice in part thanks to a vernacular music theory, leading to Zarlino's landmark writings and the controversy between Artusi and Monteverdi around 1600, all published in Venice. This rapprochement represented an exception, however, and elsewhere it was reserved for only "mechanical" contexts, that is, instrumental writings and elementary methods. This exception was consequential, since it ultimately revealed the supplanting of the international lingua franca Latin by Italian, facilitated by the economic significance of Venice and its cultural exports, foremost among them music itself. But in the sixteenth century this exception remained, aside from the dynamics that it unleashed, an isolated example. As a rule this duplicity between an increasingly differentiated musical work and a writing that did not reflect the details of these works (with the exception of Glarean) was connected to the continued adherence to Latin. In France, for example, the number of vernacular musical writings is small. A special case is the master of the *maîtrise* of Saint-Maur des Fossés, Michel de Menehou, whose French music teachings were somewhat widely distributed.[22] In German-speaking regions Latin remained the language of choice for important works, and the vernacular was limited to confessional and pedagogical writings. In England prior to Thomas Morley (1597) there are only a few publications in the vernacular, exclusively short elementary methods for use in schools. Aside from efforts in the Italian and especially the Venetian context, the prominence of Latin remained undisputed.

This conflict had consequences for music and its perception. Composed music was for the most part vocal music, while instrumental music played a growing but still subordinate role in written transmission. Apart from settings of the ordinary and proper of the mass, Latin texts used for musical settings were both new and old, and, except for hymns and sequences, were for the most part new poems often written for specific occasions. The great

reluctance to engage with ancient texts has already been discussed extensively, but the circumstance is nevertheless astounding in this context. The acceptance of the musical language through the setting of an ancient text played a role only in cases when one might rely upon the recognized norms of this language—for example, in the composition of odes. When one considers the breadth of ancient themes found in fifteenth-century painting and sculpture or the orientation of poetry and architecture toward ancient models (by figures such as Alberti), the distance here at first seems somewhat irritating. Nothing could have been easier than to set ancient poetry to music. But this occurred only in a few exceptional cases. Apparently at the Munich court Virgil and Horace were briefly made the focus of motet composition, in the large-scale motets by Cipriano de Rore (*Dissimulare etiam sperasti,* seven-voice, after Virgil, and *Donec gratus tibi,* eight-voice, after Horace) as well as their companion pieces by Lasso (*Dulces exuviae,* after Virgil, and *Beatus ille qui procul,* after Horace, both five-voice), but these remain exceptions. The setting of ancient texts was not broadly pursued and undertaken only in extremely circumscribed special cases. Latin texts that were set, however, developed their own literary world insofar as they were newly written, a parallel world without its own modes of literary transmission. Only one text used by Guillaume Dufay in his motets, *Nuper rosarum flores* for the consecration of the Florentine cathedral, was also transmitted as a poem without music. Latin motet texts as a rule represented a genre in and of itself that existed only with and within music. Even if motet production increasingly approximated liturgical texts to a large degree, this finding remains astonishing. An attribute of Latin music thus was that the text—which could make allusions to ancient texts without deriving from them directly—could at best be newly made in the same way as music. But one important and essential characteristic of composition, authorship, was withheld from these texts. In a few cases this duplicity was recognized as such. In a singular motet attributed to the singer Nicolaus Frangens de Leodio (d. 1433) active in Cividale, the doubling of creation is highlighted at the end of the poem in an unconventional way: "Hec Guilhermus dictans fauit / Nicolao qui cantauit / ut sit opus consummatum," which can be translated as something like "This is what Wilhelm the poet created for Nikolaus the singer so that the work could be completed."[23] This had no direct bearing on authorship, for in the written source the name of the composer is lacking, and it is otherwise discernible only from these verses. Conversely the authorship of Angelo Poliziano related to the funerary motet composed by Heinrich

Isaac for the death of Lorenzo de' Medici, *Quis dabit capiti meo,* has no place in musical transmission and can be gleaned only from literary sources. Even in the large Latin festive motets of the late sixteenth century—for example, by Leonhard Lechner—the author of the text remains unknown. The poetic genre of "motet text" was thus only in effect within music in relation to composition, and the setting of prominent authorized lyrics remained the exception. This circumstance, which has been scarcely noted in most research, reflects back on the status of the musical work. In no other artistic mode did the creation of the work of art occasion such a doubling that nevertheless was clearly decided in favor of music. Herein lies another connection to the setting of liturgical texts, since these also lacked a form of recognizable authorship, like newly composed Gregorian chant.

As dominant as Latin was, the share of vernacular compositions was considerable around 1400, and this number rose significantly until around 1600. This phenomenon should be understood as a unique and specifically musical challenge. The one mode of musical writing, which was used throughout Europe at first by a highly mobile clerical elite, was based on the use not only of Latin but of various languages, ranging from wordless instrumental music up to the polyglot cosmopolitanism of Lasso, who displayed this habit in his multilingual correspondence. Multilingual qualities were thus manifest in music as a complex phenomenon, as a range of further languages stood in the service of musical language. Thus the use of the vernacular was not necessarily a way of overcoming distance, since the patterns of use were much more complex. The strong presence of French in northern Italy in the first decades of the fifteenth century is evident in the notable penchant for French secular songs. It is not entirely clear whether the texts sung were actually understood by the writers, singers, or listeners, and many errors in transmission justifiably raise doubts on this front. Latin scholarship in fifteenth-century Venice was interested not only in the reception of a Pan-European musical language but in the furtherance of the Tuscan dialect, in parallel to the preference for French songs. Petrus Castellanus, the person behind Petrucci's *Odhecaton,* was thus proficient not only in monophonic chant but in the language of mensural polyphony, in addition to Latin, the Venetian dialect, and in all likelihood Tuscan as well as rudimentary French. Whether the same was true of his imaginary intellectual circle can perhaps be doubted. In any case the point of unity amid this multiplicity was music.

Against this background the distance that music maintained from literary authorities is striking. Musically speaking, the early canonization of Petrarch

had almost no effect; through the end of the fifteenth century there have survived only four settings of his poetry, and one of these is in Latin translation. When Serafino de' Ciminelli dall'Aquila performed Petrarch's poetry with a lute, the result explicitly denied scripturality. Only with the onset of debates over Petrarchism, also centered in Venice, were the *Canzoniere* valorized and promoted as a principal poetic source for madrigal culture. And yet the spread of these madrigals throughout Europe, in contrast to what has long been assumed, does not necessarily mean that their enthusiasts were fluent in Italian. The Danish kapellmeister Melchior Borchgreving (ca. 1569–1632) stayed with Giovanni Gabrieli in Venice in 1599, as his patron hoped that the visit might provide a boost to their musical culture at court. But it is entirely unclear what level of Italian linguistic knowledge was tied to this experience, and whether any formal instruction in Italian took place during this time. As the fruits of this visit, and no doubt in an effort to please his patron, Borchgreving published a collection of Italian madrigals in Copenhagen in 1605.[24] Whether the purchaser of such a collection possessed knowledge of Italian appears questionable at best. This historical aporia goes back even farther. The Flemish-born Heinrich Isaac (d. 1517) spent most of his life in Italy, but during his tenure at the Hapsburg court chapel composed a whole series of German songs, at least in part at the behest of Maximilian I. In the history of the *Tenorlied* (that is, songs with the melody in the tenor rather than the discantus) these are especially significant. But there are good reasons to doubt whether this indicates that the composer was fluent in German. In the case of Orlando di Lasso, who in 1567 published a collection of German songs in a genre closely tied to the Italian madrigal, any active knowledge of German can be ruled out completely.

Thus the language of music was astoundingly independent from the various languages used in conjunction with it. Or perhaps the opposite was true, that this musical language made it possible to bring together and consolidate these many different languages, with Latin at the center. Thus the music of the Renaissance stands as distinctly international, and only toward the end of the sixteenth century can one observe the beginnings of a tendency toward music production with a national linguistic structure: Hans Leo Hassler's German madrigals (1596) were written for a German public, the English madrigals of Thomas Weelkes (1597) for the English, Cornelis Schuyts's *Hollandsche madrigalen* (1603) for the Dutch, and so forth. This tendency was limited to the madrigal, however, and even in this case Italian retained a leading role. Thus only in music was there a split between a mode of writing

not tied to the vernacular, for which literary texts in various languages (and from different chronological periods) were the rule. Insofar as music was tied to languages in this way, it received the status of a language in its own right. The subjugation of music to the mechanisms of rhetoric, which had led to the development of the system of the arts in the fifteenth century, contributed to this conception—that is, that music was a language in and of itself. The fact that music was produced by individuals for other individuals was the clearest way in which it revealed its similarity to language. Music's unique performative qualities corroborated such comparisons, along with the conviction not only that music could arouse the affections of human beings, but that the mechanisms of these affects could be regulated through the norms of rhetoric.

The similarity of music to language in overall conceptions of the musical and a differentiated understanding of poetic vocabulary are significant in another respect. The musical geography of the fifteenth century and above all the sixteenth century was characterized by an institutional profusion held together through modes of competition. These institutions brought together transregional repertoires of a more general character with works closely bound to their local context, which were preserved and performed in an unchanging manner. These musical institutions were staffed at the highest levels by mobile personnel who were active across Europe, alongside musicians who were more securely bound to their place and more directly embodied their respective institutions. In the fifteenth and especially the sixteenth centuries the chapel was foremost a courtly attribute, obligated to represent the individual in power—that is, concerned with political self-representation and its external manifestations. These external representations served dual purposes, meeting the needs of both the ruler and the musicians at the same time. Archduke Ferdinand of Tyrol explicitly noted this in his 1565 *Instruction und Ordnung auf die Capeln und Instrumentisten,* in which he explained that "a well-organized music should be maintained to preserve the renown and honor of the sovereign as well as the musicians" (ain wol zusammengestimbte Music ir fürstl. Durchlaucht und inen [den Musikern] selbst zu Rumb und Ehern erzeugt auch darbey erhalten werde).[25]

The functional limitation of courtly representation at the same time gave rise to a focused demand that this representation be something unique and irreplaceable in musical terms. The growing network of courtly competition—which was similar to the competition among cathedrals and their cities, or even the competition between cities and courts—meant that the most

important practitioners of this music—that is, the kapellmeisters—were highly sought-after throughout Europe. Ensconced in nominally clerical positions but soon constituted as a distinct social group defined by their compositional, singing, or instrumental *exercitatio* and the *virtus* that lay behind it, these individuals stood in a productive rivalry with one another, part of a market system based on competition. On a social level this connected them with other artists, whether painters, architects, sculptors, and to a certain extent poets as well. Each court chapel was not simply a component of a developed practice of external and internal representation, but their musicians found themselves in competition with one another and were conscious of their own interests. Only a few were truly unassailable—Dufay or Josquin in the fifteenth century, and Willaert or Lasso in the sixteenth. In order to navigate this divide between international prestige and local identification, the language of music developed on different levels and with changing idioms. These had to fulfill the different local demands, and at least in principle arose out of institutional and social practices. Music as a language was not understood by everyone, but it could nevertheless exist in multiple dialects that could be in demand everywhere or be relevant for only a certain region or location.

Even in a document calling for drastic cost reductions, such as the memo written between 1603 and 1605 by the chancellor of Gottorf to Duke Johann Adolf regarding the court chapel, it is clearly articulated that "music is a Godly work, and a foretaste or *praegustus* of eternal life, and thus pleasing to all noble persons" (daß es mit der lieben music ein gottlich werck, und das sie ein Vorsmack oder praegustus des ewigen lebens, und dahero allen furstlichen persohnen pillig angenehmb sei).[26] For this reason the language of music possesses a general relevance. But music's place in representative mechanisms that straddled transregional and local demands had consequences. The independent position of the musicians was strengthened considerably, and they were no longer so closely bound to their clerical duties. The creation of a culture of musical representation tailored to local conditions connected the highly sought-after creative elite with a larger panorama that was to be as comprehensive and self-evident as possible. For, on the one hand, it was the intent of this representation to make their creators desired in other places, but, on the other hand, everything was structured to render their own place distinctive and somewhat incompatible in order to tie the creator to the place itself. The court chapel invariably served at the pleasure of the sovereign. At the founding of the chapel of the Margrave of Brandenburg in 1572, it was stipulated that Johann Wesalius (d. 1582) "as our senior kapellmeister should

be true and loyal to our cantors and instrumentalists and youngsters and be present for the fulfillment of his service as often as need or occasion demands at our court in the castle's chapel, within which we are in the habit of meeting at table or hosting foreign lords, and perform diligently at whatever time he is requested" (als unser Oberst Capellmeister und gedachte Cantores und Instrumentisten sampt den Jungen Vns gehorsam getrew und gewärtig sei und hinfüro Zeit ihres Dienstes, oder so offt es von Noten und die Gelegenheit erfordert, zu unserm Hoflager in der Schloss-Capelle und wohin wir sie sonsten zu gebrauchen, vornehmblick auch wenn wir Taffel halten oder frembde Herren bei Vns sein und sonsten zu jeder Zeit, wenn und wohin sie erfordert werden, fleißig aufzuwarten).[27] In other words, unlimited availability at one location categorically prohibited work anywhere else.

Such examples abound throughout Europe. They show how the musical language of an institution should be a distinctive local idiom. Music was a means not only of representation but of self-assurance. When it was understood elsewhere this was regarded as quite flattering. On July 14, 1573, Duke Albrecht V wrote from Munich to his son Wilhelm to warn him of the politics of musical recruitment with the Duke of Württemberg: "Orlando will inform you and give you a good report, to which I refer, and for this reason I write you this letter, whether the Duke of Württemberg would headhunt him because he is looking for such good musicians, that you have to reject with all your power, so that he does not get him" (Der Orlando wirtt dir khünden | guetten bericht geben, darauff refferir ich mich | Guethe halben, vnd dises alles schreib ich dir darumben, | ob der Herzog von Wirtemberg In mir wolt | absetzen, weil er so fast nach sölchen gueten | Musicis tracht, das du mitt handt | und fuessen | wöllest abweren, damitt er In nitt Uberkhumb).[28] On the other hand, when a regional profile and the regional language were not particularly beloved, no comparison could be made. When Thomas Mancinus was installed as kapellmeister in Wolfenbüttel in 1587 it was noted that all music "should conform to our church order and doctrine" (vnser Kirchen Ordnung vnd Corporj doctrinae gemes sein), that he should come out with "new songs" (mit newen gesengen), but that they should never circulate in print without permission (nicht ohne vnser Vorwissen Jn offentlichen Druck).[29] Such differentiation is not only of sociological significance, but had an immediate effect on the compositions themselves. Numerous dedications of musical publications mirror these diverging demands, in that the music reveals the actual practices of the institution where it originated, or that there is a desire to bring the compositions to another patron.

The development of different idioms of the single language of music owing to institutionalization is tied to another quality. On the one hand, this meant that certain stylistic levels were assigned to certain compositional genres, as articulated by Tinctoris in 1494. On the other hand, the development of a personal and individual musical language, a "maniera" or "mode of writing," became a distinct characteristic for composers. The creation of the musical work created the conditions for this, and as early as 1500 a diverse range of habits are in evidence in Josquin Desprez, Heinrich Isaac, Pierre de La Rue, or Jacob Obrecht. This individualization was bolstered by the creative concept of *ingenium,* the virtuous exercise of composition in terms of handiwork. But in the end, and already beginning around 1400, it was also indebted to the increasingly complex network of institutional demands and expectations that accompanied the social practice of professionalized composition. This social practice brought considerable prestige to all of those involved (and those dependent on it). This pressure was for its part indebted to the spread of individual idioms. Thus the language of music, independent from the texts to which it owed its being, was comprehensible in a general manner. But now attention was directed at the details of structure, at the unique and distinctive aspects of this general canon of norms. This is apparent in composers, and then increasingly for performers and instrumentalists as well. Against this background it is clear why in the sixteenth century the language of music without language (that is, without text) could experience such growth. In instrumental music, distinctive manual skill was melded with the performative act. But here around 1600, under quite different conditions, the connection to rhetoric once again was of utmost importance.

VIRTUS AND THE POWER OF THE MECHANICAL

Music is of necessity connected with manual labor. This is true not only for reproduction but also for production and composition. As previously discussed, the tension between the status of music as an *ars liberalis* and its actual reality as an *ars mechanica* permeated the entirety of the Renaissance in a way that cannot be underestimated. This difficulty is especially evident in the way that instrumental playing was undervalued as a musical activity. At the start this activity was almost of no significance whatsoever, whether in scholarly discussions or in comparison to the social status of singers. But instrumental playing was also capable of bringing forth powerful effects, and

also participated in a somewhat murky way in the *ars musica,* whose classifications included *musica instrumentalis* (however one made sense of it). In order to ennoble the mechanism of playing and to valorize the effects that it produced, the term "virtus" (virtue) was brought to bear upon it. This occurred around the same time that the term was taken up by Alberti to describe the activity of the architect, and it was also applied to the work of painters, as evident in the early example of Giotto. The connection between handiwork and virtue could mitigate an underlying flaw of this activity, which was not free or "liberal," and prove that the effects of this work were not objectionable. Lorenzo Valla defined *virtus* pragmatically, as a love of good and a hatred of evil. The virtue of those engaged in art must therefore reflect back on the products themselves. Lorenzo Ghiberti (1378–1455), both a goldsmith and an architect, defined *virtus* as the determinative characteristic of architects and painters in his fragmentary collection of *Commentarii,* indebted to Vitruvius. For him virtue encompasses *ingegno, arte, doctrina,* and *disciplina* and thus becomes a master concept that unites the science of the arts and the technique of manual effort.[30] Aside from the fact that painting—in contrast to music—was considered one of the *artes liberales* in the first place, this correlation indicates a close relationship between ethics and aesthetics that was widely recognized throughout the Renaissance and beyond. Tying creative production to the good made it possible to remove the stigma of "dirty hands" and to remove any questions about the objectionable qualities of its effects, visible in the immense quantity of musical angels. This gave rise to the wider prevalence of the term "virtus" in the Renaissance.

The mechanisms of instrumental music were similar to those of painting, for at the center of both was the concern with featuring and ennobling an activity that was not highly esteemed among the *artes.* In a 1430 lawsuit the *signoria* of Florence testified on behalf of the organist Antonio Squarcialupi to vouch for his innocence: "sed virtus ejus talis est."[31] The virtuousness of his musical being could thus immediately reflect back on his social and even juridical existence. The fame of Pietro Bono de Burzellis (d. 1497), a celebrated lutenist at the Este court, is revealed in a series of unusual literary witnesses and in the astounding array of no fewer than four surviving medallion portraits. The Augustinian Aurelio Brandolini (ca. 1454–1497), author of *De laudibus musicae et Petri Boni Ferrariensis,* praised his virtuousness, which allowed him to miraculously master his materials, such that it sounded as if a thousand hands were playing on a thousand lutes. Blind from birth, organist Conrad Paumann (ca. 1410–1473) was lauded as "meyster ob allen

meystern" by Hans Rosenplüt in 1447, with explicit reference to his lack of sight, and was eventually knighted;[32] and in 1470 in Ferrara he was called a "cieco miracoloso," an attribute that Cristoforo Landino had already brought to bear upon Alberti. The virtue of instrumentalists, especially organists or lutenists, made it possible to envision the discipline of music in the moment of playing, and this presence allowed the stain of manual labor to disappear. Aside from these players, court musicians as well as members of civic instrumental groups saw their undertakings newly valorized. Finally, many mythological figures in paintings, above all Orpheus and Apollo, came to be depicted as instrumentalists, a role previously embodied only by the exceptional figure of King David.

One special way in which music differed from the other arts was the fact that one could not correlate it directly with external nature. Different from painting as well as poetry, this nature was neither a guiding principle nor a corrective. Virtus was confined exclusively to manual labor and the effects that it produced. The significant role that the figure of Orpheus acquired beginning in the fifteenth century, not only in Neoplatonic environments, reveals this theoretical stance. Through instrumental music and song Orpheus is able to beguile Eurydice, tame wild beasts, and even soften the wills of Charon and Pluto. The special role that blindness played in relationship to the *virtus* of instrumental playing relates back to Orpheus as well, and Martin Le Franc notes it as a feature of the musicians at the Burgundian court. Blindness as an attribute of instrumental playing is present in antiquity, but beginning in the fifteenth century assumed a more prominent role. There is an astounding succession of blind organists beginning with Francesco Landini, and in addition to Paumann, Arnold Schlick (d. after 1521), Antonio de Cabezón (d. 1566), Francisco de Salinas (1513–1590), and Antonio Valente (d. after 1601); there are other blind instrumentalists, including lutenist Giacomo de Gorzanis (d. 1576/78) and vihuela player Miguel de Fuenllana (d. after 1590). These instrumentalists were placed in an imaginary relationship with Homer the blind poet, who himself is often depicted in Renaissance iconography with a fiddle. The corporeal defect was understood in favorable terms, insofar as it caused their vision to turn inward and be represented in the sound of instrumental playing, which was thus infused with an incomparable virtue. The ambivalent potential of such a conception of music did not go unnoticed, for the lack of a correlation with nature also had its perils. In 1472 in Bologna Roberto da Sanseverino (ca. 1430–1474), prince of Salerno, was amazed upon hearing the Greek organist

Isaac Argyropoulos (d. 1508) and reported on the experience in a letter to Galeazzo Maria Sforza: "chi lo aveva udito sembrava impazzito."[33] His mechanical ability was so great that his reason and sense were threatened. Giorgio Vasari criticized Tintoretto, whose work he did not admire, in a similar manner. The painter was "dilettato di tutte le virtù e particolarmente di sonare di musica e diversi stromenti"; that is, he was virtuous in his musical and instrumental abilities. But this did not excuse the extravagance of his paintings.[34] In this mode, where it was possible to have an obligation to nature (for Vasari the priority of *disegno*), Tintoretto was regarded as entirely lacking in *virtù*. The ethical dimension of the concept of virtue needed at best a certain amount of control.

Such concerns aside, instrumentalists were elevated to the status of virtuosos owing to their excess of virtue. This uneasy legitimation created a new structure for instrumental music that began to exert a powerful influence in the course of the sixteenth century. Even when it is concerned with a courtly or patrician practice—the city musicians of Kiel, in somewhat questionable circumstances, were said to be engaged in "quite honest work" (an sich ganz ehrliche Arbeit) by authorities even in 1726[35]—this should be understood as the mark of a fundamental change in meaning. This can be observed externally in the many instrumental methods, which were for the most part in the vernacular and elaborated on the ethos of the virtuoso in a pedagogical idiom. Even as such instructional materials became increasingly pragmatic in their focus, they were characterized by a general commitment to *virtus*. Sebastian Virdung, part of the clerical elite as a singer, maintained in his pathbreaking vernacular *Musica getutscht* (1511) that instrumental music had "many similarities with regulated music" (vil vergleichnuß mit der regulirten Musica)—that is, mensural music—and thus the two should not be kept separate.[36] His writing is directed only at instrumentalists and appeared at a time when Ottaviano Petrucci had already discovered the commercial viability of tablature books. The technical term—"intavolare," "intabulieren"— was thus undisputed from the very start, and the term also designated the process of paneling or covering with wood. Initially focused in Venice, the mercantile and publishing hub, this process was quite dynamic and reached a turning point in 1540 with the publication of the first printings of instrumental ensemble music.[37]

The coincidence of Virdung's *Musica getuscht* (translated into Latin in 1536) and Petrucci's printing practice reveals two further consequences of the connection between *virtus* and instrumental practice. On the one hand, it

had become possible, above all in regions in the Venetian sphere of influence, for instrumentalists to be promoted to the position of kapellmeister. The *maestro di cappella* at the Cathedral of Cremona, Marc'Antonio Ingegneri (1535/36–1592), was educated as a choir boy but was also active as a violinist at the Scuola Grande di San Marco in Venice. His student Monteverdi began his professional career as a violist, and Vincenzo Galilei started his career as a lutenist. The careers of the organists Thomas Tallis and William Byrd and the lutenist John Dowland show the tendency toward similar valorization in other musical cultures. On the other hand, the concept of *virtus* assumed the participation of wider circles of instrumental music and thus enabled the separation between professional musicians and amateurs. Although their exact classification was anything but clear, both professionals and amateurs were united by the virtue of their undertakings. In his prefatory dedication Virdung speaks of this ethical aspect of instrumental playing, making reference to Psalm 150. For whoever would take from his book "something small, or at least a fundamental start" (ettwas cleins / oder wenigs zů einem fundament / oder anfang der instrument) at playing an instrument, could hope to achieve "the promise of eternal joy" (die verheissen ewig seligkeit mitzů erlangen).[38] This virtuousness was not evident in professional musicians alone, for anyone who was dedicated to music in an edified or civilized sense shared in this virtue, in the way that Castiglione describes in the *Book of the Courtier*. One chronologically later piece of evidence that was discovered quite early shows how these aspects flowed together. In 1608 the organist Girolamo Baglioni was not in a position to pursue the publication of his own work, since he had died thirty years earlier in Milan, and his works appeared instead in a memorial edition. At the end the publisher Filippo Lomazzo inserted an obituary with an expressive epigraph that united both of these aspects: "Alli amatori de virtuosi."[39] In painting, by contrast, there is much implicit evidence of this connection. In a painting from around 1580 that is likely a self-portrait of Marietta Robusti (d. 1590), the daughter of Tintoretto, the painter attests to the virtue of keyboard playing, and the subject is depicted with musical writings, including a part book with Philippe Verdelot's madrigal *Madonna per voi ardo*. The painting unites amateur interest and artistic demands as evidence of great virtue (fig. 19).

The representation of music and particularly instrumental music in numerous paintings, especially in the sixteenth century, shows the efficacy of this cognitive figure. Music was not just considered decorous, but playing an instrument, especially a lute or keyboard instrument, could enhance the

FIGURE 19. Marietta Robusti, *Self-Portrait with Madrigal,* oil on canvas, 93.5 × 91.5 cm, ca. 1580, Florence, Galleria degli Uffizi. Created around 1580, the painting was acquired by Leopoldo de' Medici through the efforts of Marco Boschini. On this occasion Boschini offered the painting, previously attributed to Tintoretto, as a self-portrait of his daughter Marietta Robusti. Her love of music is evident. Vocal and keyboard music are depicted in the representation as equally valid.

virtue of the person depicted. Here music differs fundamentally from painting, in which the status of active amateurs was only known to a much more limited degree. Only music, which existed on a performative level, allowed amateurs to have access to the virtue of this practice. Thus the instrumental methods of the sixteenth century favored techniques such as the alteration of existing compositions by making them smaller, through diminution. The musical work was thus subjected to the whims of the moment in order to give

it a new, unique, and unrepeatable sonic form. The amazing number of examples in Ganassi's *Fontegara* shows not the limitations but rather the inexhaustible possibilities of the procedure. The ability of amateurs to learn these possibilities, even with discrete limitations, made it possible for them to participate in the production of music itself. As the amateur genre par excellence, the madrigal provided another mode for such engagement. Alongside compositional engagement with the works of their predecessors and competition among composers themselves, performative engagement was pursued by these *amatori*.

The connection between *virtus* and the mechanics of instrumental playing had immense consequences for all areas of music. Thus the question arises of how the concept of *virtus* was meaningful for composition and musical works. It is not easy to answer this question, since the problem has not assumed great prominence in existing research. In any case the professionalization of composition must have been related to the mechanization of the occupation. Composition was previously defined as the combination of multiple methods of posing and solving problems. But the definition of a compositional problem is not just a cognitive activity, and the process of creating a work is something of a craftsmanlike process. This handicraft must first be acquired, and not in the sense of individual but rather generalized familiarity. Composition required not just knowledge of writing and rules, but a differentiated consciousness of the possibilities latent in the system of norms. Learning such possibilities was closely tied to "technical" or craftsmanlike abilities. It is no coincidence that this developed in an environment in which the manual dexterity of the instrumentalist had acquired new recognition.

Guillaume Dufay spent many years of his life in Italy. The vast majority of his surviving work was created there, almost all of it in French, and most of it recorded in a manuscript from the 1430s discussed above. The depth and breadth of this early transmission makes it possible to track how one became familiar with these compositional possibilities. In the 1420s Dufay was kapellmeister at the court of the Malatesta family. It is likely that he wrote the rondeau *Adieu ces bons vins de Lannoys* for this context (musical example 7).[40] This piece represents a very early phase of the musical work and arose amid significant compositional changes in the 1420s. Even the generic norms of the polyphonic rondeau were comparatively new. Through this work the twenty-something composer demonstrated that he had a thorough knowledge of the rules of the French rondeau and that he could thus fulfill the expectations of the commission. The work is written in two parts, and each

MUSICAL EXAMPLE 7. Guillaume Dufay, *Adieu ces bons vins de Lannoys* (ed. David Fallows). The rondeau is preserved in Oxford, Bodleian Library, MS Canonici misc. 213. In this source it is dated 1426. For this reason it was assumed that the composer had occasionally traveled to France. Given the prevalence of French music in northern Italy this is likely only a hypothesis, and there is no further evidence to corroborate it. It is more likely that the piece was created in Italy.

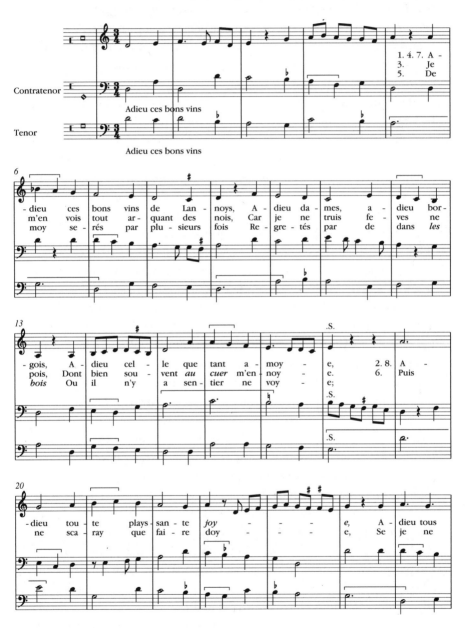

com - pai - gnons ga - lois.
crie a hau - te vois:

part corresponds to one of the strophic divisions of the rondeau. The setting is in three parts, also typical of the genre, with a sung upper part and two untexted lower parts. Aside from the fact that little is known about the circumstances or context of this work's performance, the surviving text nevertheless displays qualities that point to a mechanical quality for a composed work. The two musical parts are not texted throughout and are framed by textless passages. But in these passages the musical structure changes, from a cantabile to a style that can be understood as more instrumental in character. The work begins with one such framing part and between the first and second excerpts a brief transitional moment, and another framing part comes at the end. The framing parts are of a similar length and thus mark not just a change, but possess a proportional or tectonic character. The composer uses this structural method over and over again in his works. What is characteristic in this case is not only the tectonic function, but above all the different method of writing used. Texted and textless passages are typically different, since one must contend with singing and the other does not. For this reason the difference is limited to the upper voice. Only in this voice can this shift between "vocal" and "instrumental" setting be pursued in an effective manner. In the transitional moment, however, the countertenor voice briefly takes over this function, evidently so that the framing parts and the transitional moment can be differentiated.

As self-evident as this procedure might appear, it had to be developed in not just a cognitive but a technical sense and be invented from scratch. The systematic differentiation of vocal and instrumental settings is a new phenomenon that did not previously exist in this form. It had to be mastered in a mechanical sense. That the composer did not limit himself to this shows the organization of its use. In two places the instrumental habitus intrudes into

the vocal, in the fourth "adieu" and on the word "joye." Thus a new compositional change is not only pursued, but is given the possibility of divergent functions. The first instance has a "framing" function that is a structural measure, to mark the word "adieu" after two-thirds of the strophe of the refrain. In the second instance the change creates a sculptural interpretation of the word "joy," which is held out at the end over the word "doye." The separation of vocal and instrumental settings creates a structure in which the first technique can be combined with the second, resulting in another manner of text setting. This complex procedure required not only cognitive deliberation but technical and mechanical implementation.

This emphasis on habitual differences presents composition as a technique and makes it into the object of conscious perception, in the sense of *facilità* that should by no means betray any bodily effort. How little these decisions were determined is revealed by another significant detail. The interpretation of text through the changing of its musical setting, a technique that historically became the norm around and after 1500, appears in Dufay's rondeau as just one of several options. A working composer demonstrates such options in their profusion, and the functional differences that they betray represent in a significant and self-conscious way a new phase in the history of composition. Dufay's oeuvre is rife with such compositional decisions, in which problems are not just posed, but their solutions are pursued in a craftsmanlike way, and in a systematic manner that was previously present only provisionally.

Such explorations pervaded the era and varied in accordance with the general technical availability of certain solutions and the kind and quality of the problems posed. In March 1585 the Teatro Olimpico was opened in Venice with a performance of Sophocles's *Edipo Tiranno,* in an Italian translation by Orsatto Giustiniani.[41] It was the production's ambitious goal to mount a performance of an ancient tragedy in a theater, not through the intermediary of an accompanying festival, as had been done under other circumstances. The preparations were extensive. The expectations for the music were clearly defined, and above all aimed for a radical break with the polyphonic conventions of the time. The search for a composer for the four great choruses proved difficult after Philippe de Monte declined the commission. It was finally accepted by Andrea Gabrieli (d. 1585), the principal organist at San Marco in Venice.[42] Nothing was left to chance, with the number of singers determined in advance (twelve) as well as the quality of their voices and vocal style. The setting of the text would have a strict syllabic style so that the words would be understood with the utmost clarity. Different from the

humanistic odes of eighty years earlier, in this reconstruction of the chorus of ancient tragedy the focus was not metrical experimentation but the desire for a heightened expressivity deriving from text declamation. Gabrieli tackled this unusual assignment in a similarly unusual manner, exploring a quite new technique. Each of the choruses (with up to six parts each) was divided into a number of excerpts that were brought together through modes of contrast. Expressivity here is paired with the desire for an equally monumental form. The style of this astounding feat of craftsmanship lay beyond the structures of large-format motets as well as the small-scale madrigals, and yet had to rely on their central qualities, only in turn to render them vestigial or obsolete. The intensity of such a compositional solution is not entirely different from Dufay's efforts almost a century and a half prior, even though it was working toward a different goal.

Such compositional efforts were overlaid with the virtue of their agents. The development of composition in the sense of a professional craft could have been possible only in this context. As previously mentioned, when the agent Gian wrote to Ferrara in September 1502 that Josquin composed only when the spirit moved him, it carried this significance: compositional decisions could be fulfilled by virtue only when the conditions were right for it. Luther's dictum on Josquin's composition, as handed down by the Joachimsthal pastor Joachim Mathesius, is clear on this point: "Josquin is the master of the notes, and they must do as he says, while the other singing masters must do as the notes say" (Josquin ist der Noten Meister, die haben's müssen machen, wie er gewollt, die andern Sangmeister müssen's machen, wie es die Noten wollen).[43] In the wider context of the Lutheran Reformation the *virtus* of the composer was strongly emphasized. The Magdeburg cantor Martin Agricola, an early ally of Luther, explained the difference between "bad" and "good" music (meaning music composed well or poorly) in the introductory verses of his 1532 book, *Musica Figuralis Deudsch:* "Virtue and good habits are not instilled by bad music but rather whittled away" (Dadurch [durch die schlechte Musik] tugent vnd die guten sitten / Nicht auffgericht / sondern gantz zuschnitten).[44] The virtue of the composer thus stood as a mark of distinction, and when things proceeded differently the results were disastrous. The Heilsbronn school rector Caspar Othmayr (1515–1533) recommended his *Bicinia sacra,* or method of two-part writing, likely published in 1547 in Nuremberg for those eager for a "virtuous pastime" (dugentliche kurtzweil).[45] In 1556 Johann Jacob Fugger mentioned to Antoine Perrenot de Granvelle, the bishop of Arras, a young musician named Lasso, who was not only a "huomo verame[n]tee

cc[ellentissi]mo nell'arte sua" but because of "le virtu sue" would be a good fit for the Bavarian duke, who himself was an "amatore d[e]l arte."[46] When Archduke Ferdinand II of Tyrol reported to Francesco della Torre in Venice in 1564 that he should obtain from Cipriano de Rore "two or three good mass compositions and various motets, all of them new and something special" (zwey oder drey gute compositiones missae und etliche Muteten, die alle neu und etwas sonderliches weren)[47] novelty and uniqueness were claimed for the virtuous work, the "good" of the composer. The fact that virtue or goodness was concerned with spirit led to the use of the term "caprice" in conjunction with music beginning in the 1560s, first in the *Primo libro del capriccio* with madrigals by Jachet von Berchem (1561) and the three-part instrumental *Capricci in musica a commodo dei virtuosi* by Vincenzo Ruffo (1564), in which a direct connection is drawn to virtue. Here not only is a connection explicitly made with the rhetorical concept of *inventio,* but the handiwork of composition is stressed in a technical sense. For the fantastical quality that the term reclaims (which took place in art—for example, Arcimboldo) assumes the virtuousness of the deed, for only then can the unusual qualities of the results be justified. Against this backdrop it was possible to refract the long-standing unification of singer, kapellmeister, and composer into a new professional multiplicity. In the 1560s one encounters for the first time in Italian courts castrato singers, whose main duties were to perform, and the same period saw the first professional women singers, notably in similar contexts. The very figure of the singer (whether male or female) represents an undoing of some of the central premises of the era.

Memoria

REMEMBRANCE AND ENVIRONMENT

As a temporal art, music is the art of the ephemeral. Since the invention of mensural notation in the late thirteenth century, and especially since the writings of Johannes de Muris, there has been a growing awareness of music's fundamental condition as a time-bound art. This connection to temporality has shaped the musical work in an especially emphatic manner. Unlike a painting, statue, or building, music has no form that might lend it an enduring material existence. Many of the changes of the fifteenth century that have been described above were an effort to contravene this ephemerality and with it the possibility of forgetting: the desire to describe the concrete impression of sounding music in words and thus preserve it through other means, the creation of the musical text, the development of compositional individuality, the founding of musical institutions, and many others. Behind all these stand the demands of the musical work, which necessitated a new form of musical memory. The more developed or individual the artistic demands of a composition, the more emphatic were efforts to document the accomplishments of its composer, and the stronger the desire to have access to it in the future, even after the death of its creator. Thus a composer's works, which attempted to overcome this temporality, were connected with the idea that their fame (*fama*) could exist separately from the person of the composer. The creation of musical memory (*memoria*) is manifest especially in contexts in which this temporality was explicitly reflected upon.

It is likely that Guillaume Dufay wrote the four-part *Lamentatio Sanctae Matris Ecclesiae Constantinopolitanae* in 1456. It combines a Latin text with a lyrical song of two verses, in which a personification of the church of

Constantinople laments its fate after the Ottoman conquest of 1453. The foundation of this tenor is an excerpt from the Lamentations of Jeremiah ("non est qui consoletur eam ex omnibus caris ejus: omnis amici ejus spreverunt eam"; there is no one among his beloved who can be consoled: all his friends have been untrue), with alternating half phrases and using a melody derived from the liturgy for Good Friday. The liturgy, specifically the matins for Good Friday, is brought into an immediate relationship with an actual event. The compositional payoff lies in a complex liturgical interweaving: through Jeremiah's lamentations the conquest of Constantinople is likened to the fall of Jerusalem, and is elevated in eschatological terms through an association with Good Friday and Easter. What is most notable about this composition, however, is that it, itself so closely bound to temporality, is entrusted with a constant remembrance—that is, the overcoming of temporality through the use of the temporal medium of music. The church's lament over the loss of Constantinople, understood as a decisive change in the Christian world, is transmitted into a complex and highly individualized musical work that possesses a durability into the future.

The attempt to grant music a certain resilience is new. That it is connected with the origins of memory itself, the sacred mysteries of Good Friday, is hardly coincidental. The model created by Dufay was taken up in a remarkable series of memorial compositions in the later fifteenth century. These were no longer dedicated to institutions, however, but written in memory of musicians who had passed away. The composition becomes an artistic means of remembering a deceased composer. The earliest surviving example comes from Johannes Ockeghem, who wrote such a composition, *Mort tu as navré / Miserere pie,* for Gilles Binchois, who had been a member of the Burgundian court chapel and in the last years of his life a canon at the monastery of St. Vincent in Soignies. The piece is in four parts and uses a text that would be typical for a ballade. Binchois died on September 20, 1460, in Soignies, and the composition must have been written immediately afterward. In the poem of three stanzas, which could have been written by the composer himself, important cursory incidents in the life of Binchois are noted, and in the first stanza he is mentioned by name. But the work is by no means a true ballade, as it is based on a Latin tenor and in its dual textuality displays a decisive characteristic of the motet. The tenor derives from the Requiem mass, specifically a variation and expansion of the final verse of the *Dies irae* sequence: "Miserere, Miserere, pie Jhesu / Domine dona eis requiem / Quem in cruce redemisti / Precioso sanguine / Pie Jhesu domine dona eis requiem."[1]

The procedure recalls a technique used by Dufay in which a French poem is underlaid with a Latin text of mourning and memorial (along with the corresponding chant excerpt). The connection of the demands of the musical work with the continued memory of a composer in itself grants durability to the music.

For their part, compositions by Ockeghem modeled on the example of Dufay gave this concept a greater sense of permanence, in the form of a whole series of works indebted to his example. When Ockeghem himself passed away on February 6, 1497, he was remembered in numerous funerary poems. One was by Erasmus of Rotterdam, and two others (one in Latin and one in French) were written by Jean Molinet, in addition to an extensive lament by Guillaume Cretin. The poem by Erasmus was set to music by someone who went by the name of "Lupus," and Molinet's *Déploration* (identified as an "epitaph" in the verse) was musicalized by Josquin in 1497. The poem is in French, and at the end four musicians—not four singers, for the work is in five parts—create an imaginary funeral procession with Josquin himself as the leader. For this work the composer relies upon the model created by the deceased person being remembered. Like *Mort tu as navré / Miserere, Nymphes des bois / Requiem* is a mix of motet and chanson, containing a French text and a Latin tenor. As was the case with Ockeghem this tenor comes from the Requiem mass, specifically the introit: "Requiem aeternam dona eis Domine: et lux perpetua luceat eis." Pierre de La Rue also composed a similarly structured dirge, whose relationship to Ockeghem is not entirely clear (*Plorer, gemir / Requiem*), and Josquin for his part created a Latin dirge (*Absolve quaesumus / Requiem*), which was likely written in memory of Jacob Obrecht (d. 1505), and is also related to a work by Philippe Verdelot. Upon the death of Josquin there is evidence of six memorial compositions, by Benedictus Appenzeller, Nicolas Gombert, and Hieronymous Vinders, as well as three unknown composers, one of whom could have been Verdelot. After the death of Adrian Willaert, Cipriano de Rore in 1562 composed the motet *Concordes adhibete animos* as an homage to his illustrious role model and as a bid for the succession planning for his position in Venice, which Rore took up in the following year.

It is somewhat paradoxical that musical memory is evident in such works: they represent a remembrance that—different from a stone funerary monument or an epitaph—can offer enduring presence only in a secondary manner—that is, through the mode of scripture. This view of evanescence is related to the attempt to overcome this evanescence. With the advent of

polyphonic settings of the Requiem prior to 1500, with Dufay and Ockeghem as early practitioners, this process became perceptible: the festively appointed polyphonic Requiem mass and its artistic character recall evanescence, but different from memorial music the mass eschews explicit individualization. In Dufay's *Lamentatio* the musical demands are clearly present, but in the moment of performance they are to a large extent revealed as fleeting. The tension that is thus created, perhaps intentionally, betrays a consciousness of heightened temporality and thought, and this awareness evidently made it possible for temporality to be introduced into the enduring creation of genres and thus traditions. This form of remembered presence through the fleeting medium of music is nothing other than "memoria." *Memoria* as a culture of thought and remembrance has two motives that are intimately connected. It is a decisive moment of self-assurance. Only in remembering the dead could the exalted status of the present, and one's own place and people, be preserved. And for this reason *memoria* should be described as a comprehensive social phenomenon in which all areas of lived experience could be integrated in an orderly manner.

Memorial compositions make it especially clear that music in its capacity as a musical work participated in this culture of remembrance. It is a special quality of the Renaissance that music was granted this capability for remembrance and thus the ability to overcome the ephemeral. Musical dirges show that both of these aspects were important—that is, the elevation of one's own present moment and the ordering of the relationships in which one was embedded. In the desire to make the dead present in a musical work this participation in memorial culture is evident in the broadest possible sense. All of these works were composed with the explicit intention of elevating the musical nobility of the composer in question. And the works create a noble lineage: a memorial composition, especially one in which the composer is mentioned by name, such as Josquin in the case of Ockeghem, not only fosters an identity among the creative elite but also shows that one belongs to this elite. It draws a boundary in a positive sense and also creates an enduring social identity in an area in which this was new and difficult to construct. The culture of *memoria* is no doubt a culture of individuality. Different from pictures, buildings, or sculptures or even literary witnesses of memorial culture, the presence of the dead in works of musical memorialization is not exactly stable and endures only partially. Aside from the intentions of written records, performance is as ephemeral as the thoughts that lie beneath them, independent of the complex compositional structure or even *memoria* itself.

As if through a concave mirror these aspects are brought together in the four-voice motet *Ave regina celorum* written by Dufay likely in 1464 using the text of a Marian antiphon. Through interpolated Latin tropes (additions) the singer himself is able to intercede with the Blessed Mother by positing his own name. In his will the composer stipulated that this work was to be played at the hour of his death and should perhaps also be part of his memorial mass. Fully conscious of the ephemerality of the musical work, Dufay here reclaims the idea of *memoria* for music. Not only does the composition thus serve as memory, but the composer has combined evanescence, duration, and consciousness of his elevation in a unique way that had not been achieved before. For in the moment of performance the composer wanted to exchange temporality for eternity and to stand before his creator with his sonic belongings. And at the same time the additional performance of the music in the memorial mass would not only occasion remembrance of him but secure the presence of the work in the future. This set in motion musical *memoria* for the entirety of the Renaissance. Adriano Banchieri praised Luzzasco Luzzaschi two years after his death in 1607, saying that like Claudio Merulo he was worthy of "memoria eterna."[2] In 1613 Pietro Cerone recalled the "felice memoria del señor Domingo Phinoth,"[3] referring to Dominique Phinot, who was hanged in 1560 for engaging in homosexual acts and one of whose works was published in 1618.

Memory and remembrance were genuine privileges of poetry and eventually of pictorial art. The idea that music was capable of participating as well permeates both the manuscript and print culture and the creation of a perceptible compositional individuality. This is evident in the amazing series of works that are known only from sources written shortly after the death of their composers. These could be comprised of individual works—for Ciconia there is documented interest in individual compositions—or more comprehensive collections such as the case of Ockeghem's masses. In the sixteenth century there is evidence of the phenomenon of memorial printings, first with Josquin's five- and six-part chansons, which are mostly known thanks to two memorial editions, one from 1545 in Antwerp and another in 1549 in Paris—that is, a quarter century after his death. Such editions do not just function as monuments but were conceived of with this intent. The principle of honoring and remembering through a memorial was already articulated in Alberti's 1452 *De re aedificatoria*. The extravagant memorial musical edition gave music a form of enduring permanence. In the later sixteenth century there are many examples of this. Mateo Flecha d. J. (d. 1604), while

active at the court of Rudolph II in Prague, in 1581 published the idiosyn-cratic *Ensaladas* (similar to madrigals) written by his uncle of the same name who had died thirty years prior.[4] Fourteen madrigals by Paolo Bellasio, the *maestro di musica* of the Accademia Filarmonica of Verona who died in Rome in 1594, were published in his home city a year after his death in his memory.[5] In 1600 there appeared, with clear memorial intent, the great five-voice motet book of Giovanni Andrea Dragoni, kapellmeister of St. John Lateran, who had died two years earlier, in 1598.[6] Part of the sacred music of Luca Marenzio was published only after his death, also with clear memorial intent. The years between 1602 and 1605 saw the publication of four collec-tions of mass compositions by the imperial vice-kapellmeister Jacob Regnart (d. 1599), a series that began only a few years after his death. But two most notable cases are the large print editions that Giovanni Gabrieli created in memory of his uncle Andrea in Venice, as well as the editions undertaken by the sons of Orlando di Lasso in 1604.

These attempts to integrate remembrance of music into the environment are manifest in surviving funerary monuments (and descriptions of them) in which musicians were depicted as musicians. In these instances *memoria* was materialized as remembrance of both musical *virtus* and musical *fama,* with the intention of also remembering the work associated with them. The grave-stone that Guillaume Dufay prepared for himself presents him only second-arily as a canon and first and foremost as a musician and musical scholar. In contrast, the gravestone of Josquin Desprez—which was destroyed along with the entire Church of Notre Dame in Condé in 1793, but whose inscrip-tion was recorded elsewhere—makes no reference to his musical activities. Another pair of contrasting examples are Conrad Paumann's gravestone in Munich's Frauenkirche, on which he is depicted as an organist, and Antonio Squarcialupi's in the Florence Cathedral, which does not reference his status as organist. The organist Leonhard Waldeysen, laid to rest in 1546 in the Church of Our Dear Beloved Lady in Ingolstadt, is described as an "honor-able and richly artistic master" (erbar und khunstreich Meister),[7] while text on Caspar Othmayr's 1553 gravestone in Ansbach calls him an "honorable, learned, and renowned composer and musician" (Erwirdig wolgelert auch weitberumbt Componist vnd Musicus),[8] and Georg Slatkonia is identified as "pontifex" along with the title of "archimusicus" on his gravestone.[9]

The presence of deceased musicians in the present was secured through a series of mechanisms of *memoria,* and to the extent that these mechanisms were strengthened they appear to have caused the clerical status of musicians

to lose currency. This change took place in various forms, including manuscripts, printings, portraits, coins, medallions, and funeral monuments. But it could also be made present in music itself, whether implicitly in the relation of a work to the norms of its genre or explicitly in memorial compositions. This was accomplished in part by the process of canonization undertaken in musical writings, such as the retrospective canonization of Dunstable by Tinctoris, the lionizing of Josquin by Glarean, or the honoring of Willaert by Zarlino in Venice. Music was considered worthy of not just memory or remembrance, but this possibility fundamentally changed the place of music in lived experience. The remembrance of deceased musicians, their *fama,* meant remembering their works—as in the case of Ockeghem—or their service to music—as in the case of Pietro Bono. *Memoria* was comprised of both, and this discovery of musical *memoria* is one of the most astonishing qualities of the era. It decisively changed not only relationships with the musical past but relationships with the musical present.

THE CREATION OF MUSIC HISTORY

Music's memorable qualities and its place within the culture of *memoria* not only had effects on the present-ness of music from the past but helped spread a new and wider consciousness: not just painting, architecture, sculpture, poetry, and science had a past, but music did as well, in the form of the written and fixed musical work. This past was its genuine privilege. All other components of musical culture, from signal tones to the most elaborate performances by instruments or singers, were characterized by forgetting, since they existed only in the present moment. In the first decades of the sixteenth century Piero di Cosimo painted a portrait of Francesco Giamberti (1405–1480), father of the architects Giuliano and Antonio Sangallo (fig. 20). The portrait was created after his death and was a complementary piece for a portrait of Giuliano Sangallo. Through the presence of a sheet of music, a clear attribute, Giamberti is depicted as a musician, heightened by a tiny detail on the right side of the picture. There one can make out a church, in front of which an altar has been erected and a *Cappella* of singing boys is making music. Decades after his death Giamberti thus enters into history in an astounding act of *memoria*—and at the same time this image constitutes the only evidence of his musical activity, which at some point employed written notation. Similarly, the medallions of the lutenist Pietro Bono minted

FIGURE 20. Piero di Cosimo, *Portrait of Franceso Giamberti,* oil on wood, 47.5 × 33.5 cm, ca. 1500–20, Amsterdam, Rijksmuseum. It is not known how Francesco Giamberti was active as a musician, and it is not clear whether he was in fact a musician at all. This portrait by Piero di Cosimo depicts him as a musician in two ways—through the attribute of notated music and the chapel scene—but is the only available evidence of his musical activity.

during his lifetime are the only historical evidence of his celebrated skills. Occasionally the difference between presence and sounding reality is heightened—that is, when muted music becomes the object of painting. The battle between Phoebus and Pan, painted by Bartholomäus Spranger in 1587, shows in the right third of the painting a similarly mute music deprived of its context, with instruments and written notes placed outdoors. In the 1540s Lorenzo Lotto painted a sleeping Apollo, at whose feet lie the abandoned attributes of the Muses—that is, signs of a mute music. This insight not only sharpened consciousness of the absolute presence of music but showed the contrast between different modes of engagement and the strangeness of the past. Thus during the Renaissance—an epoch characterized by the rediscovery of the past—the musical past for the first time came into its own.

Beginning in the fifteenth century there is a significant series of indicators regarding active engagement with the musical past. It has already been noted how discussions of individual composed works were a rarity in musical scholarship. Mentions of the names of deceased composers, however, point to canonizing intentions and the creation of a wider historical context. This began with the names and newly connected historical boundaries noted by Johannes Tinctoris, who thereby connected the past with the present (Dunstable, Dufay, Caron, etc.). Motivated by many factors, this practice in turn came to be something of a topos. The honor that Gioseffo Zarlino bestows upon Adrian Willaert in his 1558 *Institutioni harmoniche* served to develop a music-historical continuum that would reflect well on Venice. The creation of a specifically musical memory in the system of genres also led to the result that this system could be elevated as a sphere of history in its own right. There are direct witnesses to this: there is evidence that Ciconia's compositions were present in Padua as late as 1472,[10] and that Petrucci printed the Lamentations of Johannes de Quadris a half century after his death. The cantus-firmus mass also serves as an illustrative example. When Giovanni Pierluigi da Palestrina published his mass *Nigra sum* in 1590 he had at his disposal a motet by Jean Lhéritier (d. 1552), a composer of a completely different generation. The motivations for this are obscure, but the composer must have been conscious of his historical distance from this work. This historical consciousness is also evident in the memorial compositions created by musicians for other musicians, for in these works the development of continuity among the generations is explicitly posited.

This newly discovered historical dimension relied upon many wider premises. As previously mentioned in another context, the change in

conceptions of time in the fourteenth century—that is, the replacement of the metaphysical category of time by a physical one under the auspices of renewed interest in Aristotle—was closely tied to a change in historical consciousness. This change led to a somewhat paradoxical result. The growing interest in the concrete and concretely measured temporal situation of mankind meant that engagement with the past could be not just a mode of rapprochement (that is, of continuity), but also a mode of separation (that is, of discontinuity), evident in the use of a rhetoric of new beginnings in Tinctoris. Involvement with the past thus meant at once the elevation of one's own present and its advantages. In this sense the turn to the past that is immediately evident in Tinctoris above all serves to demonstrate the excellence and uniqueness of the present.

Underpinning such evaluations is the idea that history existed not in a purely eschatological sense, as the tenets of scholasticism would maintain, but rather in a complex sense could be "made"—that is, indebted to a certain will of creation. Machiavelli captured this sense in the term "occasione": if it could be wrested from fate and used by man, then the individual could successfully place himself within the structures of history.[11] This was the belief of the heroic individual—that is, the ruling sovereign—but spread to other areas in which the concept of action held sway. Engagement with the past and the elevation of one's own present through the concept of "occasione" thus introduced a conflict that was not easily resolved. The increasingly differentiated turns to the past, leading to the schematic separation of history into centuries, for the first time in the *Magdeburger Zenturien* in 1574,[12] led to increasingly prevalent concerns with systematically organizing the present and thereby measuring one's place in history. The 1582 reform of the calendar undertaken by Pope Gregory XIII and the curia, an effort to bring calendrical time and astronomical time into accord, is only one of the more notable examples of this. Against the backdrop of such reevaluations, engagement with the past was not just an instrument of separation, but stood as something that could be valued and experienced in and of itself. A premise for this was an encounter with historical phenomena that was entirely comparable to the way in which scholars had engaged with the Latin and Greek texts of antiquity. Their distance had already been bridged by Petrarch, who brought them into the present and even granted them an immediate and lasting contemporaneity. The embedding of the story of salvation into scenes of everyday life, evident above all in fifteenth-century painting, had similar premises—that is, by making present incidents that had occurred long ago.

For the perception of and engagement with music, these processes were quite significant, since there was no other realm of culture in which owing to its special qualities a history was not as readily available, but must be deliberately reconstructed, with all the uncertainties that went along with it. One characteristic example is engagement with Josquin Desprez, which was already quite intense during his lifetime and after his death in 1521 took on a different quality. It was grounded in the concept that in the case of a deceased composer one was dealing with works that could live only in the *memoria* of the succeeding generations and were no longer under the sway of the "occasione" of the individual who composed them. In every instance of written engagement with Josquin it was evident that one was dealing with a composer of the past. The motivation for this remembrance, however, was not identical to what Glarean called "ostentatio ingenii," the witness of his genius.[13] Much more, the grounds appear to have been, also noted by Glarean, that the will to realize compositional individuality—which the composer again attested to—could relieve his musical works of the boundaries of their time. Each generation in the three eras defined by Glarean had transitory and transtemporal qualities. Only such a connection, entirely comparable to Petrarch's absolute contemporization of antiquity, could justify the continued *memoria* of composers.

Johannes Manlius (d. 1570?), a learned student of Melanchthon, described this area of tension in 1563. The composer continued in his endeavors until his works were completed: "Quoties nouam cantilenam composuerat, dedit eam cantoribus canendam, et interea ipse circumambulabat, attentè audiens, an harmonia congrueret. Si non placeret, ingressus: Tacete inquit, ego mutabo"—that is, whenever Josquin composed a new cantilena (a chanson), he gave it to the cantors to sing, and he walked around and listened attentively to discern whether the harmony worked. If it did not please him, he approached and said: 'Be silent, I will change it.'"[14] Regardless of the veracity of this anecdote, it shows the composer as the person who has the authority to create in the moment of sonic reality and acoustic perception. Only when his demands are met, as noted in corrections to the surviving written record (with consequences for further performances), is it considered worthy of later remembrance. This is especially evident in Glarean's somewhat earlier attempt to elevate the composer as a second Virgil.[15] This meant not only the creation of a certain authority, and not just the combination of poetry and music, but the attempt to loose the composer from his historicity and bring him in accord with a transtemporal exemplar. Such efforts are nevertheless

connected to the special difficulty in making music present, since in contrast to poetry or painting, it enjoys only a limited and mediated materiality. For this reason the poet Glarean—not only in the case of Josquin—relied upon extensive musical examples, which in their emphatic knowledge of the musical text could create the preconditions for *memoria*. This precondition is connected to a special quality of the reception of Josquin: the increasing use of concrete composers in concrete works, whose concrete biographical situations, evident in perceptible anecdotes (in the manner of Manlius). In the anecdote, a genre popularized foremost by Poggio Bracciolini and which provides a pointed biographical moment (for which there was no designation), the reader has immediate access to a tiny slice of the life of the person represented. Bringing the composer into the present in this manner does not return him to temporality, but takes him out of it. This practice holds validity in a comprehensive context, such as the numerous anecdotes that Glarean, in tandem with concrete compositions, relates about Josquin.

Martin Luther went the farthest in this respect and at least according to secondary sources made multiple observations about Josquin, articulating an explicit consciousness of the historicity of music. In a *Tischrede* from 1537 he noted, "Ach, wie feine musici sindt in 10 jharen gestorben!" (Alas, how many fine *musici* have died in the last ten years!).[16] The previously mentioned sentence handed down by Mathesius, that the composer was the "master of the notes" (der noten meister), in contrast to his colleagues who were dependent upon them, shows an inversion of the *materia-forma* distinction, from which only Josquin is able to liberate himself from the historicity of the laws of dictated *materia*. For this reason, in another *Tischrede* the temporality of the history-"making" composer is elevated to an expectation of salvation: "Was lex ist, gett nicht von stad; was euangelium ist, das gett von stadt. Sic Deus praedicavit euangelium etiam per musicam, ut videtur in Iosquin, des alles composition frohlich, willig, milde heraus fleust, ist nitt zwungen vnd gnedigt per [regulas], sicut des fincken gesang."[17] The assumption that Josquin is in a position to exemplify the antinomy between the law and the Gospel means the composer is akin to a soteriological figure. Insofar as the historical music of a working composer is compared to divine revelation, it paradoxically loses its historicity. In the sixteenth century the consciousness of temporal processes emerged only vaguely at first—namely, in the careful separation of eschatological expectation and concrete occurrences with whose help the individual could conceive of himself in history. It appears all the more obvious that Josquin would be denied this kind of historicity by being elevated to a soteri-

ological reality. Statements ascribed to Luther show a model of interpretation that was of enormous importance for the nascent historical consciousness of music. Almost all written discussions of the composer have this intention, noting his name and the reality he created and, in Luther's sense, tracing his eschatological status. The creation of a history of music took place through a juxtaposition of the activity of the present with the atemporality of earlier exemplars, and in this consciousness of the construction of history lie the roots of the canonization of individual works and composers.

The evidence for this mode of interpretation is astoundingly abundant. Johann Ott maintained in 1537 that the incomparable work of the heroic composer Josquin was akin to divinity: "habet enim vere divinum et inimta-bile quiddam";[18] and Giovanni del Lago, in a 1532 letter, similarly noted his divinity and spoke of the "stato divino del componere."[19] The Florentine diplomat Cosimo Bartoli noted in a 1657 publication parallels between "Ocghem musico" and "Donatello scultore" as well as between Josquin and Michelangelo, adding that both had opened the eyes of lovers of art in the present and the future,[20] and Hermann Finck maintained in 1556 that Josquin would also show the true way for musicians of the future.[21] All of these witnesses suggest that composers earned their significance because they had been able to transcend the conditions of temporality. Philipp Melanchthon thus maintained that this kind of composition could not be learned, but that it was a "res naturalis."[22] Such statements about Josquin abound in a broad array of musical writings, not just in music theory, but in prefaces, letters, and other genres. But music-theoretical writings are of special significance. For since at least the High Middle Ages these writings encompassed a genealogy of musical inventions, beginning mostly with the story of Jubal and leading to Guido, and in the case of Franco of Cologne effectively ending with himself. Thus music theory almost reveals itself as a disciplinary history of theory, in which the presence of the past had legiti-mating intentions. With the naming of living or deceased composers from the fifteenth century, however, this quality changed, since now concrete present and concrete past were equally present. Beginning in 1500 musical writing thus became "historical," and the most significant turning point is no doubt Glarean's *Dodekachordon,* since in it the exemplum was included. The book's underlying concept was explicitly laid out in its preface. Appealing to Boethius and Augustine, the rational fundamentals of music and their affective efficacy are to be reconciled, with the goal of recreating music's ancient golden age. The orientation toward the past, which for the author was

musically the time of an "ars perfecta," arises from the attempt to overcome this only diffusely perceived temporal distance. His musical thought is connected to his historical thought. His *Helvetiae Descriptio,* published in 1514, stands in the service of history, above all to secure and defend the incomparable superiority of the Swiss Confederation in relation to the empire. The procedure can be traced into the minutiae of musical mundanity up to Adrianus Petit Coclico (d. 1562), active in Copenhagen and famous as a student of Josquin.

This apparent shift in historicity must have in turn had an effect on the history of composition itself. The canonization of the Josquin paradigm, on the one hand, in France, for instance, is juxtaposed to a withdrawal from him in Willaert's Venice. Nevertheless the occupation with the example of another composer in one's own works is always an engagement with history in this sense, creating presence beyond the historical distance. Every cantus-firmus mass thus led to the creation of a new space of historical experience, which could also be seen in other areas. The numbering of works by book, a biblical and literary practice, was an enormously effective consequence of the work of the publisher Ottaviano Petrucci. The previously mentioned transfer of the unity of a "work" to a book not only created boundaries (and expansions) of the work concept, but also had chronological consequences. This is not at all dependent upon authorship. The three numbered books of Josquin's masses (1502, 1505, 1514) are juxtaposed to eleven numbered books of frottole by various composers, not all of whom are even named (between 1504 and 1514). The numbering of works, leading to the addition of opus numbers around 1600, serves as a means of historical separation of the work that did not previously exist, with the notable scholarly consequence that in earlier research many presumed that the three books of Josquin's masses were a chronological reflection of their creation.

This kind of historicization can be observed in other musical contexts. With the 1614 *Editio Medicaea* monophonic chant was finally removed from history, and the repertoire that had been continually expanded for centuries received practically no new additions. This task was motivated by a concern for archaeological purification and reconstruction. Here the consequences are also notable, although there is very little research on the composition of chant in the Renaissance. The mechanism that was applied to chant was evidently similar to the mechanism of polyphonic music, insofar as it had to do with past works that had been subjected to historical changes, and there was a desire to remove the repertoire from temporality and make it valid for

all time. Similar intentions can be seen in the production of church songs in the sixteenth century, but they were concerned with the renovation of song from a purported originary source, connected from the start with the widespread intentions of canonization evident in the abundance of printed songbooks. The insights regarding the historicity of music and the attempt to liberate music from it significantly shaped engagement with it. When Thomas Tallis died in Greenwich in November 1585 and was buried in the altar area of the Church of St. Alphege, William Byrd composed a song for voice and four instruments, *Ye sacred muses*. At the end the author of the text, perhaps Byrd himself, declares the end of music: "Tallis is dead, and music dies."[23] Tallis's falling silent reminds him of the end of music, and yet this meant that *memoria* occasioned the wide-ranging poem on the epitaph destroyed in the eighteenth century, that this music had not fallen silent, but had been given over to history and thus had been elevated.

THE "ONRUSH OF ANTIQUITY"

At the outset of this book it was mentioned how the fundamental relationship of the Renaissance with antiquity presents itself as an especially thorny problem for music. Engagement with antiquity is found in music-theoretical treatises, in poetry dedicated to music or written to be set to music, in paintings and sculptures, in architecture, but not—or in only a few notable exceptional cases—in compositional practice. These exceptions are isolated instances in which ancient poems were set to music. The attempt to get closer to antiquity through the musicalization of an ancient text always remained an exception, and it cannot be described as a widespread practice. Only in the last third of the sixteenth century did a new pathway for engaging with antiquity emerge. The reasons for this development have presented numerous puzzles to researchers, and in previous investigations this led to the unquestioned acceptance of Nietzsche's thesis of belatedness. In 1868 August Wilhelm Ambros wrote that at least in Italy "around that time [1500] music had to relent and follow the paths in which it found itself around 1600, striving to 'revive' ancient music ... under similar conditions and modifications as ancient architecture."[24] But in fact this abrupt turn to antiquity was by no means limited to genuinely musical contexts, and took place in debates in which music played an important but not exclusive role. Upon closer inspection other features become obvious. This was not a sporadic engagement with

a precisely delineated problem, specifically the effectiveness of tragedy, and this debate was entered into only in a few places by specialized interests. What is astounding about the process is thus less the subject itself and the fact that a small, specific group at a certain time was interested in a specific problem, but rather the enormous effects of the result (with opera as the most significant), which saw the musical landscape of Europe fundamentally reshaped in the course of only a few decades. The engagement should thus be understood as part of the intellectual discourse of the era, whose results were in part felt well beyond the era itself. This was of course not a discrete event but rather a process, albeit one with considerable energy and limited duration, which had not previously existed in music history and has not occurred since.

In all forms of perception of the fifteenth and sixteenth centuries music was always brought into a relationship with antiquity. This can be seen especially clearly in the large festivals and processions that took place throughout the era. The previously mentioned pheasant festival in Lille in February 1454, in which mostly contemporary music was heard in contexts that were determined and directed by ancient themes, stands as exemplary. The collision of completely new music with mythological or historical themes was by no means understood as contradictory. On May 27, 1475, Costanzo I Sforza (1447–83) and Camilla of Aragon were married in Pesaro. Their extravagant nuptial festivities were described several years later in a report created by the Neoplatonist Niccolò di Antonio degli Agli, preserved in a richly illuminated manuscript. It is unimportant whether the character of this report is idealized or merely following protocol. One detail in particular is significant. On the second day of the festivities there appeared in a procession alongside mythological figures, astonishingly enough, the Santa Poesia. Behind her were three girls, costumed as the arts of Grammar, Rhetoric, and Astronomy (fig. 21). This curious mixture represented a new interdisciplinary trivium. These personified arts carried a Mons Elicon, a Parnassus, fashioned out of sugar. Upon this were the Muses, albeit only six, and the stream of the Hippocrene. The stream is crowned by a strangely old, fiddle-playing Apollo. In order to carry the sugar-Parnassus Rhetoric had to set down her lute. This music-oriented scene was surely accompanied by specially composed music when it was presented, even if there are only vague records of the state of court music in Pesaro in the fifteenth century.

Such confrontations between representations related to antiquity and contemporary music abound in the era, and they were evidently not regarded as problematic. In Florence in the 1570s things went in a different and new

Vogliamo ancor de sitoi libretti ornate
Chesono de eloquentia larghi fiume
Riceue adunc sue sublime carte
Et fa che a nostri studij sia benigna
Cum opia & cum ingegni in omni parte
Accio che di maior ti facci degna

MONS· ·ELICON·

GRAMATICHA
EST SCIENTIA

RETTORICA·

ASTRONOMIA· GRAMATICA·

FIGURE 21. Vatican City, Bibliotheca Apostolica Vaticana, MS Urb. Lat. 899, f. 110v, 20.6 × 13.7 cm. The manuscript contains a richly illustrated report on the marriage of Costanzo I Sforza and Camilla of Aragon on May 27, 1475 in Pesaro. The codex contains a great deal of material regarding representative festivities in the later fifteenth century, including grand processions.

direction. As previously mentioned, solo singing accompanied by a lute or keyboard instrument was practiced throughout the fifteenth and sixteenth centuries. But this practice did not enjoy the stability of written transmission, which remained a privilege of polyphony and only slowly was expanded to include instrumental music. The debate that unfolded in the intellectual circles of the Florentine academies moved forward relatively quickly. The organizational background of this is striking. Relying on the example of Plato, places of learned exchange were formed in the fifteenth century in which members of the intellectual and creative elite came together. Both Poggio Bracciolini and Marsilio Ficino availed themselves of the term "academy." Setting aside the sovereign patronage they relied upon, the model of the institution lay in the relatively informal connection of urban elites, and the competition that resulted made them analogous to the norms of the institution of the university. The Accademia Platonica, founded in 1462 by Cosimo de' Medici under the influence of Ficino, was not an isolated case, but part of an extraordinarily dynamic process. By 1530 twelve academies had been founded in Italy, and by 1600 there were hundreds located in countless places throughout Europe. Discussions of education, language, poetry, painting, or music now had a dedicated place in which to occur.

The debates begun in Florence in the 1570s occurred in an expansive context in which academies were being founded and academic discussions took place. In the city were multiple locations of this sort: aside from the previously mentioned Platonica, there were the Accademia Fiorentina (1540), the Accademia degli Alterati (1569), and the Accademia della Crusca (1583). The association that according to the later witness of Giulio Caccini called itself the "Camerata" evidently borrowed freely from members of various academies, but was less formally organized and did not have statutory stability. It was called into being at the initiative of Giovanni Bardi de' Conti di Vernio in his Florentine palace, perhaps beginning in 1573. The apparently intentional instability makes it difficult to attain any clarity about the procedures and structure of the enterprise. Among its inner circle were, aside from Giovanni's brother Pietro de' Bardi, the singer Giulio Caccini, the musical scholar Vincenzo Galilei, and the poet Piero Strozzi. In addition there were associates such as Emilio de' Cavalieri and Ottavio Rinuccini as well as the musicians Jacopo Peri and Jacopo Corsi. The exact nature of their discussions can be discerned from traces in later sources, especially Caccini, who dedicated the 1600 publication of his opera *Euridice* to Bardi and reported there that the "nobili virtuosi" had spoken of the performance of Greek tragedy.[25]

Vincenzo Galilei wrote his previously mentioned *Dialogo* in the sphere of the Camerata, although whether it was the result of discussions there is a contested matter, in spite of the fact that Strozzi and Bardi served as interlocutors. Nevertheless the cognitive form Galilei introduced was entirely new: the competitive juxtaposition of "antica" and "moderna," of the ancient and modern, in music.[26] Galilei's comparison comprises three aspects: tuning, modes, and affective expression. Throughout his discussion he engages mostly with authors who possessed an understanding of history and who wanted to hold up the past at the same level as the present, above all Glarean and Zarlino. Galilei was, for the first time in musical scholarship, convinced of a clear music-historical break, and his conclusion was the restitution of ancient practices, which also plays a role in his final excerpt dealing with instrumental music.

The figure of a break was invoked through discussions of ancient tragedy and the question of whether it was staged using declamation or included singing throughout. Girolamo Mei (1519–1594), a Florentine who lived for many years in Rome and was a correspondent of Galilei around the time of the *Dialogo,* directed his studies of antiquity to include music and held forth in multiple writings, all of which remained unpublished, on the fundamental difference between antiquity and the present. Nevertheless he came to the conclusion that tragedy had been entirely sung, albeit monophonically and without instrumental accompaniment. Here it is notable that in this small circle of accomplished intellectuals interest in the music of antiquity was oriented above all to theatrical representation. All other aspects, including mode or the use of instruments, appeared to be secondary concerns. The discussions among the members of the Camerata focused on a special problem, and it appears that their discussions had come to a close in the 1580s. But these discussions did not lead to the actual performance of tragedy—quite different from the case of Vicenza, in which the Sophocles choruses by Andrea Gabrieli represented an isolated and perhaps more historically "accurate" solution. Aside from his single experiment the discussions of music in ancient tragedy did not produce results and remained an academic discussion, a deliberation, or a possibility. In this respect it was in principle no different from other scholarly discussions of antiquity, including those by Nicola Vicentino.

Thus the obvious next step, the performance of an "ancient" tragedy with "modern" music, was undertaken only as the exception. And yet Galilei himself, along with other musicians and scholars, pointed to a completely

different and intriguing conclusion. As previously mentioned, he was the kind of musician who had begun his career not as a singer but as an instrumentalist, specifically a lutenist. For him interest in the song of tragedy was not simply an antiquated passion, but arose from his interest in singing with instrumental accompaniment. Both of these interests were evidently closely related. While in the *Dialogo,* reflecting the discussions of the Camerata, affective solo singing was promoted as the model of antiquity, Galilei had also granted this kind of song a prominent role in his own musical activities. In 1582, a year after the *Dialogo* appeared, he demonstrated these principles not through ancient texts or tragedy but through an entirely different type of lamentation song. There is evidence that in Bardi's house, accompanying himself on the violin like the blind Homer, he performed parts of the Lamentations of Jeremiah as well as the responses from the liturgy for Good Friday, and, especially striking, Ugolino's lament from Dante's *Inferno.* The use of biblical texts as well as texts that were not exactly ancient was deliberate, even if the experiments were not deemed worthy of recording in writing. The composer Galilei was also concerned with tablature—that is, the reduction of polyphonic settings for voice and instrument to a fixed theoretical foundation. As early as 1568 he published an entirely different *Dialogo,* in which the procedures of vocal music were set out for the first time as a conscious practice.[27] Notably, a new and expanded edition appeared in 1584, after the writings on ancient music and the performances in Bardi's house. In this context Galilei introduced the term "imitare," an aesthetic terminus that had not previously played a role in music, although it is considered one of the central termini of the Renaissance: "Di maniera che io ho piu caro offender gl'orecchi di alcuni imitando questi tali [Lasso, Porta, Willaert and others], che dilettargli con imitare alcuno ignorante" (I would sooner violate the ears of some by imitating these than please them through the imitation of the ignorant). The handling of compositions is concerned with imitation not only of nature but of available works.[28] Additionally, in Galilei's own copy of the first edition of the *Fronimo,* located today in the National Library in Florence, are preserved handwritten tablatures for voice and instruments. The *Dialogo* is thus embedded in a completely different contextualized form of solo singing and instrumental playing.

The "onrush of antiquity" in music beginning in the 1570s thus reveals itself as a Janus-faced undertaking, not simply consisting of the reconstruction of ancient contexts, but rather of the intentional and subtle blending of antiquity with compositional demands of the present moment. This proce-

dure would subsequently be applied to Dante and biblical texts. The category of "imitatio," originating in the Aristotelian circles of Padua, was taken up from medical and legal contexts by painting, first by Cennino Cennini (d. ca. 1440), who in his *Trattato della pittura,* created shortly before 1400, defined the imitation of nature as a corrective to the imaginative faculties of painting. From this point there developed a rich debate focused on the arts regarding the function of nature as a role model, which applied to painting, sculpture, and poetry, and, as in the case of Leonardo da Vinci, painting stood before music. The flexibility with which Galilei adapts the term from its rhetorical-poetic context for music expands the term in the broadest possible manner. It did not just concern the imitation of nature, the *imitatio naturae,* but rather the imitation of great masters, the exemplum. Lodovico Agostini Ferrarese, an otherwise unknown composer, in 1583 published *Il nuovo echo à cinque voci,* which contained a *Fantasia da sonar con gli istromenti,* which he prefaced as "ad imitatione del Sig. Striggio."[29] A short time later but in the same context, the availability of the term "imitation" led Caccini not to limit it to nature, as was the case in painting, but to expand it to the imitation of words and affects. Here the intensive turn to antiquity also led not to a strict approximation of realities, however they were defined, but rather to the constitution of entirely new and different contexts of meaning.

As a consequence of the continued development of history in music there resulted not historical precision but a flexible availability within its own realm of historical experience. When in 1594 in the context of the Accademia degli Alterati it was attempted to present a drama with singing throughout, they chose not an ancient text but rather a new poem, and not a tragedy but rather mythological material, namely, *Dafne.* The librettist Alessandro Striggio and composer Jacopo Peri could build on certain experiences in Florence—namely, *La pellegrina,* a drama performed in the intermedi that were part of the marriage of Ferdinando de' Medici and Christine von Lothringen—and perhaps also on two lost Roman pastorals by Emilio de' Cavalieri with close ties to the Camerata. What was decisive was the use of a mythological antiquity, the turn away from ancient textual sources, and the abandonment of the idea of remaking ancient tragedy. While in the Venetian sphere, steeped in Aristotelian realities, one at least considered the recreation of ancient tragedy and otherwise sought other pragmatic means of dramatic presence, such as the madrigal-comedies of Orazio Vecchi and Adriano Banchieri, in the Neoplatonic environment of Florence and later also Rome the focus was on the "idea" of musical drama. Purportedly ancient techniques

flowed into its realization, but in the end the result was the genesis of an entirely new form, like Galilei's tablature. Before this genre was pragmatically named "dramma per musica," notably in Venice upon the opening of the first commercial opera houses in 1637, the preferred term in Neoplatonic Florence and its sphere of influence was "favola." In poetical theories of the late sixteenth century the *favola* stood as an index of the pastoral world, as realized in an exemplary manner in Torquato Tasso's *Aminta* (1572, printed in 1580). This connection to the tradition of the eclogue provided music a space of possibility that did not exist in tragedy.

The musical form that was developed for this new mode was instrumentally accompanied solo singing. No doubt a result of the intensive discussions of the 1570s in Florence, this practice nevertheless remained nameless at first, existing in circumlocution and euphemism. A normative term first became widespread in the seventeenth century, a word borrowed from Greek. μονῳδία (*monōdia*) derived from μόνος (*monos*, alone) and ᾠδή (*ōdē*, song) and was first used by the papal diplomat Giovanni Battista Doni (1595–1647) in the circle of Urban VIII in Rome.[30] Thus only in 1635, clearly after its creation, it was labeled as bass-accompanied solo singing and contrary to historical evidence was identified as a Roman invention. The attempt to "antiquate" this practice retrospectively through the application of this name shows the strange amalgamation of forces at play. The goal of this new form of singing was clear. The success of modern text representation in the madrigal was undisputed, but was accomplished at the expense of textual comprehension. Interest thus turned to making a literary text as musically expressive as possible while still being comprehensible, through the *imitatio* of a purportedly ancient technique. It was always clear to these innovators that this could be possible only by building upon the accomplishments of polyphony. The lutenist Galilei indicated this in his *Fronimo,* just as the singer Caccini later stressed that these changes were thoroughly indebted to contrapuntal study. Recitative singing was thus not, to use Schiller's terminology, a naive retreat to antiquity, but a fully conscious and sentimental move. This is evident in the terminology that Monteverdi would use shortly thereafter. The separation of the polyphonic style as "prima pratica" from the recitative and monodic style as "seconda pratica" would be nonsensical in a historical sense if one was in fact convinced that in monody one had rediscovered an ancient practice that now should be given primacy.

This new engagement with antiquity was thus astonishingly pragmatic, including the products of the theatrical representational form of opera.

Pythagoras and Orpheus now joined Jubal and David. The innovations that soon became necessary—the new duties of the singer, scenic representation, new modes of writing for song, the practice of figured bass, and many others—were pragmatically mastered within a shockingly short period of time. The solutions that were found were evidently resilient and essentially did not change in the following decades. Perhaps this contributed to the unparalleled success of the new concept, for within only a few decades it had spread throughout Europe. At the center of this development stood the theater and stage performances, but their point of departure was not ancient tragedy. The new engagement with antiquity in the sphere of the Florentine Camerata was fundamentally a consequence of the new crafstmanlike conception of composition, the new systems of the arts, a new professionalization, and a new sense of historicity. This mixture owed much to the pragmatism of these decisions, as their pragmatism led to a dynamic that in the end produced one of the few and conclusive paradigm shifts in music history.

THE "END OF THE RENAISSANCE"

The new availability of imitation in music eventually led to this term being used to describe the relationship between word and sound, popularized by the concept of a composed "musica poetica." In this term the canonical norms of prosody, under the influence of rhetoricization, came to be used for composed music and for the understanding of music as a whole, not without certain difficulties and points of friction, evident above all in German writings at the time—for example, in Nicolaus Listenius. At the center of musical *imitatio* stood not the reproduction of external nature but rather of its affect. The "affectus," the counterpart of "effectus" in Neoplatonist philosophy, was present throughout the fifteenth century. The astounding rise of the term and related concepts in the second half of the sixteenth century was based on the fact that with the rapprochement of the arts to rhetoric a new area of engagement was created, which was also evident in the other arts. Giorgio Vasari identified this area as the artwork's oscillation between *grazia* (grace) and *terribilità* (the use of pathos), both of which could be called forth by painting at various levels and in different combinations. Thus the concern was not only with abstract, linear effects but rather with a variety of possibilities to produce them, which were mutually exclusive but each justifiable in their own right. In 1559 Francesco Viola contributed a preface to Adrian

Willaert's *Musica Nova* in which he praised precisely this quality: the multiplicity of affective representations that were coupled with the considerable ability of the composer to unleash them, "ad ogni sua richiesta fa sentir nell'animo tutti gli affetti che si propone di muouere."[31] With the invention of recitative, monodic song pushed the affective representation of words through music into the foreground.

The Roman-born Giulio Caccini (1551–1618) lived in Florence beginning in 1566 and was a member of the circle of Bardi's Camerata. But in contrast to the other members he was not a scholar, and in contrast to Piero Strozzi and Vincenzo Galilei he was not a music theorist either, but rather a singer. And yet his musical livelihood was not based in a chapel—that is, an institution; rather he worked exclusively at the behest of the Florentine oligarchy and especially the Medici family. After returning from an intermediate stay in Ferrara, he sang in Jacopo Peri's *Euridice,* which was performed on October 6, 1600 (including his own completions), upon the occasion of the marriage of Maria de' Medici and Henry IV in Florence. Caccini promoted himself as the "inventor" of the new art of sung speech, or at least was the first to publish it. Especially compared to Peri and Emilio de' Cavalieri these accomplishments are revealed not only in Caccini's additions to Peri's opera, which were clearly done in the service of virtuosic self-representation. Much more, his publicity program was intended to be pursued externally, with the publication of his own setting of *Euridice,* to compete with Peri's and published two years prior to its 1600 premiere, and his ambitious collection *Le nuove musiche,* published in 1602 albeit dated 1601.[32] The title of this publication had the same programmatic intentions as its contents, twelve solo madrigals, ten *arie,* and the concluding scene of the opera *Il rapimento di Cefalo,* performed in Florence in 1600 and whose intended publication did not come to pass. The unusual format in which it was printed displays the remarkable self-consciousness of its author, along with its dedication to Lorenzo di Jacopo Salviati as well as the notice that the works would be performed in his palace, today the Palazzo Aldobrandini-Borghese. But the most important component of the publication is its lengthy preface, "Ai lettori," for this text expresses not the view of a theorist or scholar, but rather, a novelty, shows a composer discussing his own work, and in his capacity as singer discusses the music's performance. This claim is connected from the very start with a dismissal of normative music theory, in the way that Galilei himself had done: "Io veramente ne i tempi che fioriua in Firenze la virtuossima Camerata dell'Illustrissimo Signor Giovanni Bardi de' Conti di Vernio, oue concorreua

non solo gran parte della nobiltà, ma ancora i primi musici, & ingegnosi huomini, e Poeti, e Filosofi della Città, hauendola frequentata anch'io, posso dire d'hauere appreso più d i loro dotti ragionari, che in più di tren'anni non ha fatto nel contrapunto" (During the time when there flourished in Florence the most virtuous Camerata of the most illustrious Signor Giovanni Bardi, Count of Vernio, where not only a great number of the nobility competed, but also the most important musical scholars, and the most ingenious men, and poets, and philosophers of the city, and which I myself visited, I can say that from the learned conservations there I gained more advantages than through thirty years of studies in counterpoint).[33]

Music served, according to Caccini, for the representation of speech, attuned to both content and form, both "concetto" and "verso." While counterpoint and its rigid application was compositionally correct, it must of necessity destroy this dual focus on text: "Così ne ne madrigali come nelle arie ho sempre procurata l'imitazione de i concetti delle parole, ricercando quelle corde più, e meno affetuose, secondo i sentimenti di esse; e che particolarmente hauessero grazia, hauendo ascosto in esse quanto più ho potuto l'arte del contrappunto, e posato le consonanze nelle sillabe lunghe, e fuggito le breui, & oßervato l'istessa regola nel fare i passaggi" (In both the madrigals and in the *arie* I have always noted the imitation of the "concetti" of the words, in search of the stronger or less strong side of the affects, following the emotion represented; in particular these should have "grazia," and to this end under the powers of the art of counterpoint I have endeavored to put the consonances under the long syllables and avoided the short ones and minded these same rules in the "passaggi").[34] In Caccini we encounter the control of the term "grazia," also used by Vasari, and here likely taken from Baldassare Castiglione. For him *grazia* is connected with *virtus* or *virtù,* since it allows the virtue of the compositional effort to be forgotten. In this sense *grazia* or *intera grazia* also represents the premise for an open approach to the technical norms of composition, which in the end became a *pratica,* or craft.

In fact, for Caccini observance of the norms was only a necessary premise for the representation of affects, and what actually required attention was the regulated deviation from them. At this point there arise considerable terminological problems that indicate that new territory was being entered. For deviation from norms, in accordance with the poetically influenced sphere, there was no consistent nomenclature available. Caccini's text is full of terms that denote irregularities in both composition and performance—and even this unusual duality is in and of itself something of an innovation. But the

lack of clarity of these terms, often lamented in research, was not the result of a lack of theoretical acuity, but of the concern with describing musical conditions for which there was no normative terminology. At the center of the *Nuove musiche* stands a new relationship to words, which should be represented, on the one hand, as comprehensibly as possible, and, on the other, as expressively as possible. The purported sung speech of antiquity remained a frame of reference, which to a certain extent served as a key for the plenitude of licenses. Caccini advances this with a term not typical in music theory: "Veduto adunque, si com'io dico che tali musiche, e musici nondauano altro diletto fuori di quello, che poteua l'armonia dare all'vdito solo, poi che non poteuano esse muouere l'intelletto senza l'intelligenza delle parole, mi venne pensiero introdurre vna sorte di musica, per cui altri potesse quasi che in armonia fauellare, vsando in eßa (come alter vole ho detto), vna certa nobile sprezzatura di canto" (I have, as noted, seen that many musics and musicians have no other delight than to offer harmony in and of itself to the ears, and they are unable to move reason or comprehend the words; for this reason I came upon the idea of introducing a kind of music in which it is possible, to speak of harmony, to use [as has already been said on many occasions] a certain pleasing lightness of the singing).[35] This "nobile sprezzatura," also hearkening back to Castiglione (where it was used in a nonmusical context) and mentioned by Caccini in the preface to *Euridice,* imparted a marker of nobility, a norm of social behavior, to the craft of music, which would itself be ennobled in the process. The previously noted conflict cited by Alberti between the speed of work and accuracy, between *prestezza* and *diligenza,* was also valid for the craft or *pratica* of composition. Castiglione had painting in mind when he used the term "sprezzatura." By creating a bridge to music, Caccini made it possible for the art to participate in the tension between accuracy and the demands of the moment, which of course would dispense with certain compositional norms.

Caccini's agenda blurs the lines between composition and performance, and between the representation of affect in music and the representation of affect in the presentation of music. These now flowed together in a way that was previously unknown. For originally, accompanied solo singing was a non-notated practice, with writing reserved for polyphony. In Caccini the freedom of the unwritten practice was imported into the fixed text. Thus its execution by the singer becomes of utmost importance, and performance now stands as no longer a merely important but rather a central component of the musical work. In 1610 the composer Giacomo Moro da Viadana, who

was perhaps a Servite monk and about whom little is known, while working in Viadana, Bologna, and Carrara, added to the fourth book of his *Concerti Ecclesiastici* a *Avvertimento vtile et necessario ai Maestri di Cappella, et ai Cantori,* in which he discussed music's lack of mimetic qualities: "Quella imitatione, che ricercauano le parole" (the kind of imitation that seeks the words) is denied to music, and thus it should be introduced in performance "co'l variare, & con l'alterar la battuta, come fanno tutti I valent' huomini intelligenti della Musica, che con la loro misura variata à mille modi fanno soave, & armonioso ogni canto per brutto" (with changes and enhancements of the fundamental sounds, as all men proficient in music do, who with their changes to the sounds in a thousand different ways make ugly song sweet and harmonic).[36] The displacement onto performance created a new kind of musician, the virtuoso singer. The figure of the virtuoso singer had previously existed not at all or only provisionally, and was prototypically personified by Caccini himself. In the 1620s the painter Hendrick Terbrugghen (1588–1629), active mostly in Utrecht and influenced by Caravaggio, created a portrait of a singer that puts this new role on display (fig. 22). Regardless of whether this is a representation of an actual person, he appears behind a parapet, a theatrical boundary behind which the musician executed his representation. He is fantastically and opulently costumed, and his relationship to the notated text is revealing. In front of him, on the parapet, lies a book with a crumpled sheet of music inserted as well as an additional sheet. In his ecstatic rapture he turns away from the book of music held open in his hand, from which he is singing, and it appears to play a secondary role in his performance.

In the figure of the singer, which since Ficino and Poliziano has been connected with the figure of Orpheus, one can recognize a fundamental change in perception. The representation of a text by means of arousing affects produced by a single singer was a new musical experience—with a singer and the person being sung to, an actor and a recipient—and the affective power of the moment of performance was intended to blur the boundaries between them. This fundamental change stands as the "end of the Renaissance" in music, and the figure of the singer lends it a characteristic signature. The many premises of the era, whose enthusiasm for Ovid's *Metamorphoses* was evident in the subjects of the musical stage, were transformed in this figure in a performative situation that had not previously existed in music—at least not as a norm and not indebted to the musical work. The identification with the singing mythological figures of Daphne, Ariadne, and above all Orpheus, who inhabit the first operas, or *favole,* such as Monteverdi's *L'Orfeo,*

FIGURE 22. Hendrick Terbrugghen, *Singer,* oil on canvas, 104 × 85 cm, ca. 1620[?], Göteborg, Konstmuseum, Inv.–Nr. 1130. Early on it was noted that the singer represented by Hendrick Terbrugghen (1588–1629) around 1620 (the date cannot be clearly read) was in a state of ecstasy. Since the type of picture is not isolated, it is doubtful whether this is a portrait. Much more, the picture represents a new type of actor, the singer, who was characteristic of the seventeenth century.

underscores this paradigm shift. Its earliest traces can no doubt be found in Italy, which beginning in 1600 exerted a musical hegemony over Europe, or at least was entrusted with this authority. But this type spread with astounding speed and effectiveness to other countries. John Dowland (1563–1626), like Vincenzo Galilei a lutenist, within only a few years beginning in 1597 made lute songs into a spectacular genre, with the first book of his *Ayres* going through five editions, and the second published in 1600 with an initial print run of a thousand copies. The English doctor Thomas Campion (1567–1620) developed a poetics of the genre in his *Book of Ayres,* published in 1601 with Philip Rosseter, which focused on aspects of singing and elevated connections with antiquity (in the genre of the epigram).[37] The singer Pierre Guédron (d. 1619/20), the *Surintendant des musiques* under Louis XIII, published the first solo songs in 1608, following the 1571 publication by Adrian Le Roy in Paris of songs with lute, presented in tablature. It is also known that the court kapellmeister of Philip II, Mateo Romero (ca. 1575–1647), composed solo songs with guitar accompaniment.

With the turn to the affective language of the singer the contours of musical unity in Europe that characterized both the fifteenth and sixteenth centuries disintegrated. From this musical world there arose multiple and increasingly independent realities in various countries, regions, and centers, which represented themselves in a wide variety of musical cultures and only in isolated cases had much to do with one another. The intramusical distinction between "old" and "new," or "antiqui" and "moderni," was a determining factor of these realignments. The fashioning of the performative as the personal and unique message of a performer, in most cases a singer, remade music into a language not in a wider but rather a more narrow sense. In order to judge such a performance it was necessary to understand the demands of composition. The detailed discussions of compositional examples, evident in the controversy between Giovanni Maria Artusi and the Monteverdi brothers, became a signifier for discussions of music as a whole. Even Vincenzo Galilei, who denoted counterpoint as a "pratica," wanted the music of Rore and others to be examined the way he had done, using numerous examples, "spartire et con ogni diligenza essaminare."[38] Empirical inspection of musical works thus became a *pratica* or craft in and of itself. The *pratica* of composition was reserved for the *ingenium* of the individual, and the connoisseur participated in it through the joy of examination. This development in turn had an effect on the understanding of *ingenium*. Thus from the middle of the sixteenth century the inborn quality of genius, in contrast to learning, is

more explicitly discussed in relation to the arts—for example, in Paolo Pino's *Dialogo della pittura* (1548). As a means of arousing affect, solo singing made it easy to bring music into these discussions.

Parallel to this elevation of the singer, instrumental music emerged from the shadows of legitimacy, and the connection between mechanics and *virtus* became a topos outright. From the start instrumental music was connected to gesture and movement—that is, with dance music—but in the late sixteenth century written transmission of this dance music acquired greater weight. Instrumental music of the early seventeenth century is a mixture of multiple genres, within which dance plays a strong and physically powerful role. The analogy to the figure of the singer is instructive. The civilized domestication of dance music in the sixteenth century was of utmost importance for the independent instrumental music created after 1600. In the juxtaposition of "free" forms derived from the practice of diminution and dance forms two principles were encountered that were regarded as irreconcilable in the sixteenth century. Claudio Monteverdi included independent instrumental pieces, mostly dances, as structuring elements in his 1607 *Orfeo* and thus demonstrated the potential of this "gestural" practice. The worlds that the musical fantasia could evoke were obvious, and their colorful new forms were similarly suited for representation. Even the dancing master Antonio Cornazano (ca. 1430–1484), in regard to the instrumental music of Pietro Bono, diagnosed that the new forms brought the listener from one world into another that was usually off-limits. This power of *imaginatio,* of increasing importance in sixteenth-century poetics, here reserved for unwritten instrumental music, was appropriated by musical culture as a whole—in the spread of the practice of the flexible use of the concept of imitation promoted by Galilei—and now could be applied to the musical work. Thus the paradigm shift of 1600 reveals itself not as the result of compositional craft turning into a *pratica,* but was rather grounded in fundamental aesthetic transformation and a significant change in the forms of perception. The significant locus of this change if not its instigator was the stage—that is, the practice of spatially structured representation. This new form of representation incorporated music that around 1600 was experienced in multiple forms of daily life, and it now became the object of observation and of conscious experience and classification.

The kinds of relationships that human beings could create with music fundamentally changed during the Renaissance, under the considerable influence of the musical work. It has been the primary task of this book to

describe this more precisely and ground it in cultural-historical detail. Concentration on the work of art does not mean to exclude everything that humans otherwise produced or that surrounded them musically, what was musically accessible or meaningful, or what influenced or even repelled them. But it opened up a certain perspective by which all of this can be better understood. With the "end of the Renaissance," which was of course not a discrete event but rather a multifaceted process that has here been examined through a certain perspective, these paradigms changed in a lasting way. Many of these fundamental questions did not lead to ruptures but rather to changes and transformations. Everything that changed around 1600 was laid out in the previous events of the fifteenth century and can be observed in its forms and models of thought. If it is now easier for readers to understand the contours and long-term music-historical impact of the events and processes of the fifteenth and sixteenth centuries, then this earnest effort to understand them from a cultural-historical and music-historical perspective will have been worth the effort. Although the historical distance created by some of the qualities described above cannot be entirely eliminated, it can at least be significantly mitigated. That this is possible for such an unstable object and context as music represents one of the most striking changes to what we call the "Renaissance," and also to what we call music.

GLOSSARY

The following glossary offers short explanations of key technical terms and concepts.

ALTERNATIM. This term denotes a performance technique in which polyphonic and chant (monophonic) excerpts alternate. It was for the most part used for strophic forms that began to be set for multiple voices beginning in the middle of the fifteenth century, above all hymns and sequences. The technique could also be used for the singing of psalms, in which the chant excerpt was performed using a simplified psalm tone. Alternatim was used in this particular way for the entirety of the Renaissance, with a few notable exceptions, such as the papal chapel, where psalms could be sung only polyphonically.

ARTES LIBERALES. A complicated process in which human knowledge was canonized in late antiquity resulted in the emergence of the system of the *artes liberales*, which were codified during the Carolingian era. An *ars* (art) was considered *liberalis* (free) if it was practiced by a free man for the purposes of acquiring knowledge without an explicit end. It was not to be concerned with bodily labor or breadwinning. The *ars* was premised on *virtus* (virtue), which was expressed through *ingenium* (ability). In its ideal form the system was understood to be comprised of the trivium—the disciplines of grammar, rhetoric, and dialectic—and the quadrivium—arithmetic, geometry, astronomy, and music. The *artes liberales* were considered an important basis for preparatory studies at universities, in which music was always a component. In contrast to the *artes liberales* stood the craft-oriented or "unfree" *artes mechanicae*.

BALLADE. The ballade is a refrain form (one of the "formes fixes") whose musical parts were arranged in equivalent pairs with a refrain or several lines of a refrain, in the musical form AABR.

BICINIUM, TRICINIUM. Bicinia or tricinia are two- or three-voice compositions, which were especially significant in the printing and pedagogical practices of the sixteenth century. Notable composers used them to explore the possibilities of

two- or three-voice settings for the purposes of teaching or demonstration during a period when compositions of four, five, or even six parts became the norm.

CANTUS FIRMUS. The historically challenging term "cantus firmus," which came to be employed somewhat late, denotes a preexisting melody that serves as the basis for a polyphonic composition. As a rule the cantus firmus is found in the tenor. Cantus firmus melodies were mostly taken from chant, but over time secular songs became an increasingly common source for them as well. Beginning in the late fifteenth century settings without cantus firmus became increasingly common in liturgical compositions as well.

CASTRATO. The practice of castration was used throughout the Middle Ages, above all as a form of punishment. In the middle of the sixteenth century, however, it began to be used, for reasons that remain obscure, for professional castrato singers, above all in northern Italian courts, around the same time in which professional female singers began to be active. Castrato singers replaced male falsetto singers, including in the somewhat exceptional case of the papal chapel. For the most part the phenomenon of the castrato was confined to court contexts.

CHANSON. This term denotes polyphonic French secular songs from the Renaissance. At first chansons were part of the "formes fixes," but after 1500 the forms became increasingly free, more or less beginning with the large five- and six-voice chansons of Josquin Desprez. Well into the late fifteenth century French chansons circulated throughout Europe, but in the sixteenth century they were influential mostly in French (or French-influenced) regions. Initially chansons were transmitted in hybrid manuscripts along with other genres, subsequently in so-called chansonniers, and finally in individual or collected printed editions.

CHANT. The historically problematic term "chant" denotes, on the one hand, "Gregorian chant," the monophonic song used above all for the Roman Catholic mass and liturgy of the hours. During the Renaissance prior to the Council of Trent chant repertoire was continuously added to, for the most part notated in square notation on four-line staves (special forms such as the "Hufnagel" notation disappeared in the course of the fifteenth century). In addition to manuscript transmission, chant was increasingly transmitted in print beginning in the second half of the fifteenth century. Chant could be used for programmatic purposes, such as the liturgical books printed by the bishop of Münster after the end of Anabaptist rule in 1536/37 or the 1614 *Editio Medicaea*. There is a considerable lack of clarity surrounding both the composition and the performance of chant in the Renaissance but also considerable evidence of local variants and traditions. "Choral," the German word for "chant," also refers to German-language liturgical songs of the Lutheran Reformation, in contrast to the "anthem" of the English Reformation. Thus while there had previously been a rich tradition of vernacular song, its function (as a substitute for liturgical song) and transmission (in printed songbooks) fundamentally changed beginning in the 1520s.

EDITIO MEDICAEA. The *Editio Medicaea* was the edition of the gradual (music for the mass), published in 1614 with the imprimatur of the papacy (*Graduale de Sanctis. Iuxta ritum Sacrosanctae Romanae Ecclesiae. Cum Cantu. Pauli V. Pont. Max. iussu Reformato. Cum Privilegio* [Rome: Typographia Medicaea 1614]). This edition was the result of the reforms of the Council of Trent and contains versions of melodies prepared with the intention of "correction," under the auspices of Annibale Zoilo and Giovanni Pierluigi da Palestrina.

FAUXBOURDON. The origin of this term ("faburden" in English) is highly contested and has led to strenuous and sometimes bitter debates among researchers. It refers to a technique in evidence beginning in the 1420s in which a polyphonic setting (typically in three parts) is created by the schematic insertion of additional voices in intervals of the third and the sixth from the outer voices. What was notated was not a part but rather the instruction "a fau[l]xbourdon." The falsobordone technique of the sixteenth century was a comparable procedure (albeit in four parts), although it is unclear what relationship the two practices had to one another. The practice was used primarily for smaller liturgical compositions such as antiphons, hymns, or the Magnificat.

FORMES FIXES. Borrowed from Eustache Deschamps, the codification of the "formes fixes" denoted the forms of polyphonic secular song in the fourteenth and fifteenth centuries: ballade, rondeau, virelai, and bergerette. These were strophic and refrain forms that musically were always comprised of two different parts repeated according to specific patterns. In general these settings were written in three parts.

ISORHYTHM. First developed at the beginning of the twentieth century, this term denotes a compositional technique for which contemporary theory did not have a name. It refers to the repetition (either once or multiple times) of a cantus firmus in the tenor. For this cantus firmus the composer creates an individual rhythmic model that can likewise be repeated. But this model can be proportionally changed, mostly by being reduced, so that the absolute note values change, but their internal relations remain the same. For example, three repetitions could have a relation of 3:2:1. The technique, which was important for motets and masses and occasionally used for upper voices, suddenly lost its currency around 1450. Its remnants are evident in elaborate proportional works such as Josquin's *Miserere* and the motet *In hydraulis* of Antoine Busnois.

LAI. This term refers to a monophonic secular song that was last undertaken as a serious compositional activity in the fourteenth century. Parts of the repertoire were transmitted in the fifteenth century despite the fact that there were many other monophonic traditions that were not transmitted through written means.

MADRIGAL. Beginning in the 1530s the madrigal became the central secular genre of the sixteenth century. The etymology of the word is murky, and there is also a lack of clarity about whether it has any definitive connection to the madrigals of the fourteenth century (for the most part written in two parts). Its textual basis was Italian lyric poetry of various genres whose excerpts were set to music. This

structure meant that the genre offered considerable compositional freedom in the selection of homophonic or polyphonic declamation and—increasingly in the course of the century—affective textual interpretation. Although the madrigal was principally an Italian phenomenon (although by no means pursued only by Italian composers), it spread throughout Europe and in the last third of the century developed its own traditions in Germany and England.

MAÎTRISE. The *maître* (from *maître,* i.e., "master") was an educational institution associated with a cathedral or collegiate church, in which a small number of boys were given a basic education with specialized instruction in music. These schools were created in the wake of curial reforms in the fourteenth century and were especially significant in the northern French/Burgundian regions of the fifteenth century. They produced the professional musical progeny of the fifteenth and early sixteenth centuries, which meant that northern French musicians dominated European musical culture (and in earlier research were erroneously referred to as "Netherlandish"). Although *maîtrises* were in operation up to the time of the French Revolution, they slowly receded in importance as sites of recruitment during the sixteenth century. An importation of the model to Italy in the 1440s was not successful (in contrast to a later attempt in Vienna), but they did serve as a prototype for the Protestant Latin school. The significance of boy singers in the fifeenth century (who with the exception of the papal chapel were part of all cathedral chapels) began to abate in the course of the sixteenth century.

MASS. The polyphonic cyclical mass composition was a new development of the fifteenth century that emerged as a central genre and remained so until the end of the sixteenth century. It was comprised of the five parts of the mass ordinary (Kyrie, Gloria, Credo, Sanctus, Agnus Dei), which were brought together through a multitude of compositional techniques—for example, a single unifying cantus firmus. The proper of the mass was set separately and very rarely in a cyclical manner (such as in the *Choralis Constantinus*), and was generally less significant in meaning. The cyclical setting of both ordinary and proper (in the so-called plenary mass) remained an exception and attained a certain continuity only in the polyphonic Requiem up to the second half of the fifteenth century (with Dufay and Ockeghem as the earliest examples).

MENSURAL NOTATION. This modern term refers to the semiotic system of polyphonic music between the late thirteenth century and the end of the sixteenth century. This technical term did not exist in contemporary theory, in which the term "musica mensurabilis" deals with all of polyphonic music with the mode of notation. "Measured" music (in contrast to the "musica plana" of chant) refers to the denotation of the relationship between long and short notes (refered to by the key terms "longa" and "brevis"). In the Renaissance this complex system developed in the fourteenth century was simplified considerably by the universal adoption of French models as well as the introduction of hollow ("white") forms of notes. Mensural notation did not have any metrical structure, but consisted

of the possible two- or three-part division of individual note values that related to one another. The practice was not score-based but rather relied on the separate preparation of individual parts.

MODAL NOTATION. This was the manner of writing for polyphonic music up to the end of the thirteenth century. The concept that the duration of a single note could be recorded through an exact graphic sign (the underlying premise of mensural notation) was not in evidence here. Modal notation records only a group of notes within a set rhythmical model ("modus") that establishes a pattern. In theory there were at least six of these different modi, but in practice only three were widely used.

MODE. The term "mode" (or "modus" in Latin) originally denoted rhythmical models, and in mensural notation the separation of the levels of the longa. In the Renaissance, by contrast, the term came to refer above all to the set of tones used in a composition. These sets of tones or modes, derived from chant, were eight in number (based on the foundational tones d, e, f, and g) and were of two types, either authentic or plagal. Attempts to expand the system (for example, Glarean's system of twelve in 1547) were of passing significance but were ultimately without a great effect. The modern major and minor tonality developed from this system, and the lines between the two are fluid and indistinct.

MONODY. This term generally refers to solo singing with the harmonic accompaniment of a keyboard instrument or a lute. Although the practice is in evidence for the duration of the Renaissance, it was explicitly noted and written down only beginning in the 1570s. The resulting practice of singing with figured bass became the underlying mode of the new genre of opera, and the model was subsequently taken up by instrumental music.

MOTET. The motet is the oldest polyphonic genre but nevertheless underwent significant changes in the fifteenth century. At first the term "motet" denoted a highly differentiated range of pieces resulting in a series of "subgenres." Accordingly there is a great degree of uncertainty in contemporary theory regarding the phenomenon, although less in transmission of motets themselves. Motets at first were in three and later in four parts and beginning in 1500 more parts (with the upper limit continuously increasing). The motet was for the most part sacred in character, could be based on a cantus firmus, and employed Latin texts that (with a few exceptions) were newly written.

ORGANUM. This term refers to early polyphony that eventually coalesced into two types, the setting of melismata against a note (organum), and the setting of note against note (discantus). Its rhythmical organization followed the models of modal notation. A special type of organum was the conductus, a sacred song not based on chant.

POLYCHORAL SETTINGS. In the sixteenth century the interest in organizing sound in space that first arose in the previous century was systematically developed. The center of this interest was Venice, especially San Marco, the church of

the Doges. This term denotes the separation of the musical setting into two and later multiple independent ensembles positioned in different places.

RONDEAU. The most widespread genre of the *formes fixes* in the fifteenth century was the rondeau. The rondeau was strophic and generally had eight parts, with a refrain at the beginning and end. The resulting form was somewhat complex and generally consisted of eight parts divided into musical sections AB aAab AB (capital letters note that text and music were the same, and lowercase letters note where only the music was the same). The further differentiation of the rondeau contributed significantly to the development of secular songs.

TENORLIED. This term denotes German songs from around the 1470s that are in evidence through the late sixteenth century. Only then did they come under the influence of the madrigal (thanks in large part to Lasso) or other "smaller" genres such as the villanella. While in chansons the melody was in the upper voice, in German songs it was located in the tenor.

TRANSMISSION. Transmission of written music in the Renaissance occurred in liturgical books, as had been the case with chant, as well as menusural polyphony written out in separate parts. In addition there were special forms such as instrumental writing (tablatures) or songbooks. Generally speaking, parts were noted in single blocks on a single legible field, in what were somewhat confusingly referred to as choir books. In the last third of the fifteenth century the voices begin to be separated into separate part books, above all in print culture (beginning in Venice in 1501). Transmission through print and transmission through manuscript were of equal importance, and scores or definitive autographs exist only in exceptional cases, mostly in the late sixteenth century. While manuscripts from the fifteenth century are for the most part collections of various authors, with the advent of print the collection of works by a single author became more important. Print also led to the numeration of books, and eventually the practice of numbering according to opus.

VIRELAI. In the fifteenth century the virelai had only a rudimentary significance. Its structure was similar to that of a ballade, but was somewhat more complex, since its refrain—as in the rondeau—was also foregrounded, but different insofar as it was not in two parts but one. Virelais of the older tradition were a more complex double-strophic form, which in the fifteenth century was displaced by the bergerette, with the structure A (Refrain)-B B A-A (Refrain). The term "bergerette" is first used in the middle of the fifteenth century, and the genre played a more significant role as an alternative to the more repetition-intensive rondeau.

VOICE TYPES. Notated music in the Renaissance was at first exclusively vocal music. Only gradually did instrumental music come to be transmitted in a similar manner. Accordingly the designation of voice types is vocal in character, in which the spatial conception that a voice is "high" or "low" was one of the era's most interesting innovations. The tenor voice stood at the center, which was often the location of the cantus firmus. Along with the highest voice it determined the tonal character of a work. The other voices were termed the superius or discantus

(in many sources not noted as such) and the countertenor. The countertenor voice could be divided into a countertenor altus and bassus. With the spread of five-part polyphony shortly before 1500 designations became more pragmatic. In addition to the main voices (superius, altus, tenor, bassus), a "quinta" or "sexta" voice could be added, along with even more ambitious additions. In larger settings the names were simply divided (for example, bassus primus and secundus).

NOTES

CHAPTER ONE

1. Jacob Burckhardt, *Die Cultur der Renaissance in Italien: Ein Versuch* (Basel: Schweighauser, 1860).

2. Heinrich Besseler, *Bourdon und Fauxbourdon: Studien zum Ursprung der niederländischen Musik* (Leipzig: Breitkopf und Härtel, 1950). For a critique of the term, see also Besseler, "Das Renaissanceproblem in der Musik," *Archiv für Musikwissenschaft* 23 (1966): 1–10.

3. This is the epigraph of the fourth chapter of Burckhart's study. The formulation itself comes from Jules Michelet, *Histoire de la France au XVIe siècle,* vol. 7, *Renaissance* (Paris: Chamerot, 1855), 11.

4. Thomas S. Kuhn, *The Structure of Scientific Revolutions* (Chicago: University of Chicago Press, 1962).

5. Guillaume Dufay, *Opera Omnia,* ed. Heinrich Besseler, vol. 1, *Motets* (Rome: American Institute of Musicology, 1966), 46, 70.

6. Johan Huizinga, *Herfsttij der middeleeuwen: Studie over levens- en gedachtenvormen der veertiende en vijftiende eeuw in Frankrijk en de Nederlanden* (Haarlem: Willink, 1919).

7. August Wilhelm Ambros, *Geschichte der Musik im Zeitalter der Renaissance bis zu Palestrina,* vol. 3 of *Geschichte der Musik* (Breslau: Leuckart, 1868), 6.

8. Leo Schrade, "Renaissance: The Historical Conception of an Epoch," in *Internationale Gesellschaft für Musikwissenschaft, Fünfter Kongress, Utrecht, 3.–7. Juli 1952, Kongressbericht* (Amsterdam: Alsbach, 1953), 19–32.

9. In Boethius this is "cantilenam libentius auribus atque animo capit." Gottfried Friedlein, ed., *Anicii Manlii Torquati Severini Boetii De institutione arithmetica libri duo, De institutione musica libri quinque* (Leipzig: Teubner, 1867), 187.

10. Martin Warnke, *Bau und Überbau: Soziologie der mittelalterlichen Architektur nach den Schriftquellen* (Frankfurt am Main: Syndikat, 1976); Sabine Žak, *Musik als "Ehr und Zier" im mittelalterlichen Reich, Studien zur Musik im höfischen Leben, Recht und Zeremoniell* (Neuss: Päffgen, 1979).

11. Ludovico Antonion Muratori, ed., *Falconis Beneventani Chronicon; Julius de Syndicis Benevantanus,* in *Rerum Italicarum Scriptores* (Milan: Societas Palatina, 1724), 5:82–133, here 94.

12. Wendelin Toischer, ed., *Alexander von Ulrich von Eschenbach,* Bibliothek des Litterarischen Vereins in Stuttgart 183 (Tübingen: Litterarischer Verein in Stuttgart, 1888), 225.

13. Ernst Hoepffer, *Oeuvres de Guillame de Machaut* (Paris: Didot, 1911), 2:1–157, here vv. 3960–86.

14. Ernst Rohloff, *Der Musiktraktat des Johannes de Grocheo: Nach den Quellen neu herausgegeben mit Übersetzung ins Deutsche und Revisionsbericht,* Media Latinitas Musica 2 (Leipzig: Reinecke, 1943).

15. Michael Richard Buck, ed., *Ulrichs von Richenthal Chronik des Constanzer Concils: 1414 bis 1418,* Bibliothek des Litterarischen Vereins in Stuttgart 58 (Tübingen: Litterarischer Verein in Stuttgart 1882), 158. Richenthal reports on the festivities of the Englishmen for the feast of Saint Thomas Becket. In 1415 only drums are mentioned, and in 1416 there is also mention, in at least one edition, of "engelschem süssem gesang" (sweet English song) (ibid., 87, 97).

16. Martin Le Franc, *Le champion des dames,* vol. 4, ed. Robert Deschaux, Les Classiques Français du Moyen Age 130 (Paris: Champion; Geneva: Slatkine, 1999), 68 (vv. 16253, 16266, and 16268f); see 150ff.

17. An edition with a report on the sources is found in Caroline van Eck, "Giannozzo Manetti on Architecture: The 'Oratio de secularibus et pontificalibus pompis in consecratione basilicae Florentinae' of 1436," *Renaissance Studies* 12 (1998): 449–75; for the passages on music, 474; lines 236ff.; a further edition with English translation is provided in Christine Smith and Joseph F. O'Connor, *Building the Kingdom: Gianozzo Manetti on the Material and Spiritual Edifice,* Medieval and Renaissance Texts and Studies 317 (Turnhout: Brepols, 2006), 303ff.

18. Dijon, Archives de la Côte-d'Or, B 58 through February 21, 1433; quoted in Jeanne Marix, *Histoire de la musique et des musiciens de la cour de Bourgogne sous le règne de Philippe le Bon (1420–1467),* Collection d'Études Musicologiques 29 (Strasbourg: Heitz, 1939), 100.

19. London, British Library, MS Add. 29987. Facsimile of the manuscript reprinted in Gilbert Reaney, ed., *The Manuscript London, British Museum, Additional 29987: A Facsimile Edition with an Introduction,* Musicological Studies and Documents 13 (Dallas: American Institute of Musicology, 1965).

20. The edition consulted here is *Queste sono le canzonette et stramboti damore composte per el Magnifico miser Leonardo Giustiniano di Venezia* (Venice: Bonellis, 1495).

21. Oxford, Bodleian Library, Canonici misc. 213. Facsimile in David Fallows, ed., *Oxford, Bodleian Library, Ms. Canon. Misc. 213,* Late Medieval and Renaissance Music in Facsimile 1 (Chicago: University of Chicago Press, 1995).

22. Baldassare Castiglione, *Il libro del cortegiano* (Venice: d'Asola, 1528), Bg. [d viii] v.

23. Orlando di Lasso, *Libro de Villanelle, Moresche, et alter Canzoni* (Paris: Le Roy und Ballard, 1581). The composer first worked in this genre in 1555.

24. Adrian Petit Coclico, *Musica Reservata: Consolations piae ex psalmis Davidicis, ornatae suavissimis cantilenibus* (Nuremberg: Montanus and Neuber, 1552). In the same year the author also published a *Compendium musices,* which contains several passages that relate to this peculiar title.

25. Heinrich Glarean, *Dodekachordon* (Basel: Petri, 1547).

26. Ciconia's surviving works appear scarce at first glance. But his oeuvre was the first set of works by any composer to be systematically transmitted and thus was preserved in all of its multiplicity.

27. Johannes Ciconia, *Nova musica; and, De proportionibus: New Critical Texts and Translations on Facing Pages, with an Introduction, Annotations, and indices verborum and nominum et rerum by Oliver B. Ellsworth,* Greek and Latin Music Theory 9 (Lincoln and London: University of Nebraska Press, 1994), 52.

28. Johannes Tinctoris, *Liber de arte contrapuncti,* ed. Albert Seay, in *Opera theoretica* 2, Corpus Scriptorum de Musica 22 (Dallas: American Institute of Musicology, 1975), 156.

29. Petrus Tritonius, *Melopoiae sive harmoniae tetracenticae super xxii genera carminum heroicorum elegiacorum lyricorum & ecclesiasticorum hymnorum* (Augsburg: Oeglin, 1507).

CHAPTER TWO

1. Giovanni Pico della Mirandola, *Oratio de hominis dignitate,* in *De hominis dignitate, Heptalus, De ente et uno, e scritti vari,* ed. Eugenio Garin (Turin: Aragno, 2004), 101–65, here 104.

2. Stefano Vanneo, *Recanetvm de mvsica avrea [. . .]* (Rome: Doricus, 1533).

3. Titian used this motif, inspired by Giorgione's *Sleeping Venus* (Dresden, Gemäldegalerie), on multiple occasions, also with a lutenist (New York, Metropolitan Museum) or an organist (without written notation or flute, and in fact with a fictional instrument; Madrid, Museo del Prado; Berlin, Gemäldegalerie).

4. Emil Friedberg, ed., *Corpus iuris canonici: Editio lipsiensis secunda post Aemilii Ludouici Richteri [. . .],* pt. 2, *Decretalium collectiones* (Leipzig: Tauschnitz, 1881), 1255–57.

5. The only surviving visible evidence of the system are the bronze doors created for St. Peter's by Filarete (ca. 1400–ca. 1469), subsequently incorporated into the new structure of the Holy Door.

6. *Verhandelingen over de vraag, Welke Verdiensten hebben zich de Nederlanders vooral in de 14e, 15e, e 16e eeuw in het vad der toonkunst verworven [. . .],* Door R[afael] G[eorg] Kiesewetter en F[rançois] J[oseph] Fétis (Amsterdam: Muller, 1829).

7. London, British Library, MS Royal 12 C.vi, f. 59r–80v; according to this manuscript, edited by Fritz Reckow in *Der Musiktraktat des Anonymous 4,* pt. 1,

Edition, Beihefte zum Archiv für Musikwissenschaft 4, 1 (Wiesbaden: Steiner, 1967), 46.

8. The most famous of these, the Squarcialupi Codex (Florence, Biblioteca Medicea Laurenziana, MS Med. Pal. 87), contains most of his works (145 compositions). It was created perhaps in 1415, perhaps also considerably later (in the 1430s).

9. Bologna, Museum Internazionale e Biblioteca della Musica di Bologna, MS Q15; facsimile in *Bologna Q15: The Making and Remaking of a Musical Manuscript,* introductory study and facsimile edition by Margaret Bent, vol. 2, *Facsimile,* Ars Nova, Nuova serie II (Lucca: Libreria Musicale Italiana, 2008).

10. Fort Worth, Kimbell Art Museum, AP 1993.02.

11. Munich, Bayerische Staatsbibliothek, Mus. MS A. In this famous Busspsalm Codex the functions of the court chapel in church and at courtly celebrations are depicted on opposing pages (186–87).

12. Naples, Biblioteca Nazionale, MS VI.E.40.

13. Josquin Desprez, *Liber primus missarum* (Venice: Petrucci, 1502).

14. Vatican City, Biblioteca Apostolica Vaticana, Chigi C VIII. 234; facsimile in Herbert Kellman, ed., *Vatican City: Biblioteca Apostolica Vaticana, Chigi C VIII.234,* Renaissance Music in Facsimile 22 (New York and London: Garland, 1987).

15. Orlando di Lasso, *Magnum opus musicum [. . .] complectens omnes cantiones quas motetas vulgo vocant* (Munich: N. Heinrich, 1604). This was the first of the large-format memorial editions produced by the sons.

16. Guillame Dufay, *Opera omnia,* vol. 6, *Cantiones,* ed. Henrich Besseler, rev. David Fallows, Corpus Menusrabilis Musicae I, 6 (Neuhausen: Hänssler, 1995), 68ff. and 72.

17. Jeanne Marix, *Histoire de la musique et des musiciens de la cour de Bourgogne sous le règne de Philippe le Bon (1420–1467),* Collection d'Études Musicologiques 29 (Strasbourg: Heitz, 1939), 180.

18. Ibid., 124 ff.

19. This notable letter was published in Lothar Hoffmann-Erbrecht, *Thomas Stoltzer: Leben und Schaffen,* Die Musik im alten und neuen Europa 5 (Kassel: Hinnenthal, 1964), 33ff., here 33. A facsimile reproduction is in the same volume.

20. Hoffmann-Erbrecht, *Thomas Stoltze*r, 34.

21. Doris Esch, "Musikinstrumente in den römischen Zollregistern der Jahre 1470–1483," in *Studien zur italienischen Musikgeschichte* 15, 1, ed. Friedrich Lippmann, Analecta Musicologica 30 (Laaber: Laaber, 1998), 41–68.

22. Elena Quaranta, *Oltre San Marco: Organizzazione e prassi della musica nelle chiese di Venezia nel Rinascimento,* Studi di Musica Veneta 26 (Florence: Olschki, 1998), 261 (Venice, Archivo di Stato, Provveditori di Comun, reg. U [San Marco II], c. 38v.).

CHAPTER THREE

1. Gioseffo Zarlino, *Istitutioni Harmoniche,* 2nd ed. (Venice: Franceschi, 1573), Proemio, 1–4, 3.

2. Bonnie Blackburn et al., eds., *A Correspondence of Renaissance Musicians* (Oxford: Clarendon, 1991).

3. Nicola Vicentino, *L'antica mvsica ridotta alla moderna prattica, con la dichiaratione et con gli essempi de i tre generi, con le loro spetie. Et con l'inventione div no nvovo stromento, nelqvale si contiene tvtta la perfetta mvsica, con molti segreti mvsicali* (Rome: Barre, 1555); Vincenzo Galilei, *Dialogo della mvsica antica, et della moderna* (Florence: Marescotti, 1581).

4. Giov[anni] Maria Artusi, *L'artusi. Ouero delle Imperfettioni della Moderna Musica. Ragionamenti dui. Ne' quail si ragiona di molte cose vitile, & necessarie alli Moderni Compositori* (Venice: Vincenti, 1600); the attacks on Monteverdi (who is not mentioned by name) are in the second *Ragionamento.*

5. Heinrich Faber, *Compendiolum musicae pro incipientibus* (Braunschweig, 1548); the edition consulted here is Frankfurt an der Oder: Eichhorn o. J. [ca. 1548], Bg. A3r.—which includes a further condensed version: *Brevissima Rudimenta Musicae, pro incipientibus.*

6. Thomas Morley, *A Plaine and Easie Introduction to Practicall Musicke, Set downe in forme of dialogue: Diuided into three partes [. . .]* (London: Short, 1597).

7. Nikolaus Wollick, *Opus Aureum, Musice castigatissimum de Gregoriana et Figuratiua atque contrapuncto simplici per commode tractans omnibus cantu oblectantibus vtile et necessarium e diuersis exerptum* (Cologne: Quentell, 1501). At the very start Wollick is insistent about the place of music within the liberal arts.

8. Balthasar Prasberg, *Clarissima plane atque choralis musice interpretatio* (Basel: Furter, 1501).

9. Sylvestro di Ganassi, *Opera Intitulata Fontegara. Laquale insegna asonare di flauto chon tutta l'arte opportune a eßo instrumento massime il diminuire il quale sara utile adogni instrumento di fiato et chorde: et anchora a chi si dileta di canto* (Venice, 1535).

10. Arnolt Schlick, *Spiegel der Orgelmacher vnd Organisten allen Stifften vnd kirchen so Orgel halten oder machen lassen hochnützlich* (Mainz: Schöffer, 1511).

11. Gregor Reisch, *Aepitoma omnis phylosophiae, alias margarita phylosophica tractans de omni genere scibili: Cum additionibus: que in alijs non habentur* (Strasbourg: Grüninger, 1504), Bg. OIff. Reisch differentiates between *musica speculativa* and *practica,* but makes no reference to polyphony.

12. The *Roman de Fauvel,* likely by Gervais de Bus, was created between 1310 and 1314 and is transmitted in thirteen manuscripts. The oldest of these (Paris, Bibliothèque Nationale, MS 146) contains elaborate miniatures and inserted compositions.

13. Bamberg, Staatsbibliothek, MS Lit. 115; Montpellier, Faculté de Médicine, MS H 196.

14. Paris, Bibliothèque Nationale, MS Nouv. Acqu. Fr. 6771.

15. Chantilly, Musée Condé, MS 564.

16. Bologna, Biblioteca universitaria, MS 2216; Bologna, Museo Internazionale e Biblioteca della Musica di Bologna, MS Q15; Oxford, Bodleian Library, MS Canonici misc. 213; Vatican City, Biblioteca Apostolica Vaticana, MS Urbinat. Lat. 1411;

Padua, Biblioteca Universitaria, MSS 675, 684, 1106, 1115, 1225, and 1475 (all fragments); Modena, Biblioteca estense universitaria, MS α.X.I.11; Trient, Museo provinciale d'arte, MSS 1374–79. Some of the manuscripts are in facsimile editions previously cited. See note 21 in chapter 1 and note 9 in chapter 2.

17. Munich, Bayerische Staatsbibliothek, Clm 14274; Krakow, Biblioteka Jagiellońska, MS 2464; Krakow, Klasztor SS. Klarysek, S. Andrea, MS o. S.

18. London, British Library, MS Egerton 2020.

19. The Bamberg Codex, ca. 1300 (see note 13 in chapter 3), represents an interesting intermediate step. The music is recorded in single voices but located underneath one another in a kind of pseudosimultaneity.

20. "Notula musicalis est figura quadrilatera soni numerati tempore mensurati significativa ad placitum" (Johannes de Muris, *Notitia artis musicae* [1321] *et Compendium musicae practicae [. . .],* ed. Ulrich Michels, Corpus Scriptorum de Musica 17 (Rome: American Institute of Musicology, 1972); here *Notitia* [pages 11–110], 75); later the theory of the signs is summed up: "Figura autem signum est, res musicalis significatum" (ibid., 91).

21. Apt, Basilique Saint-Anne, MS 16bis.

22. Johannes Tinctoris, *Terminorum musicae diffinitiorum* (Treviso: Gerardus de Lisa, [ca. 1494]), in the entries "missa," "motetus," and "cantilena"—that is, not in a systematic overview.

23. Ernst Gombrich, "Norma e forma," *Filosofia* 14 (1963): 445–64.

24. Apt, Biblioteca del Seminario Maggiore, MS 15 (olim A I° D 19).

25. Oxford, Bodleian Library, MS Canonici misc. 213 (see note 21 in chapter 1).

26. Florence, Biblioteca Nazionale Centrale, MS Panciatichiano 26.

27. Modena, Biblioteca estense universitaria, MS α.X.I.11 (see fig. 15).

28. Schalreuter (1486/87–1550) constructed his books over many years (Zwickau, Ratsschulbibliothek, MS 69 1.57–62).

29. Guillaume Dufay, *Opera omnia,* vol. 6, *Cantiones,* ed. Heinrich Besseler and rev. David Fallows, Corpus Mensurabilis Musicae I, 6 (Neuhausen: Hänssler, 1995), 69ff.

30. The term "cantus firmus" is first encountered in Boncompagno da Siena (*Rhetorica novissima,* 1235), synonymous with "cantus planus," which does mean chant. The voice of the cantus firmus, dealing with chant, is thus called a tenor, and an identical use (tenor in the sense of a cantus-firmus part) is first seen in the sixteenth century—for example, in Zarlino.

31. Gian de Artiganova, September 2, 1502, letter located in Modena, Archivio di Stato; facsimile of the much-edited document in *Die Musik in Geschichte und Gegenwart,* vol. 7 (1958), Table 10.

32. Ibid. Gian says that Isaac is "molto prompto Jn larte de lo componere."

33. Although Palestrina is posited as the reviver of the genre in the spirit of the Council of Trent, more than half of his 104 surviving masses are parody masses.

34. Georg Sigmund Seld, December 23, 1559 to Albrecht V; Munich, Bayerisches Staatsarchiv. Geh. Staatsarchiv, K.sch. 229/3, tom. XIV, part II; cited from the partial edition by Adolf Sandberger, *Beiträge zur Geschichte der bayerischen Hofka-*

pelle under Orlando di Lasso, in drei Büchern: Drittes Buch, Dokumente; Erster Theil und mit zwei Abbildungen (Leipzig: Breitkopf und Härtel, 1895), 303ff.

35. Girolamo Savonarola, *Expositio ac meditatio in psalmum Miserere. fratris Hieronymi de Farraria ordinis predicatorum quam in vltimis diebus vite sue edidit* (Augsburg: Froschauer, 1499).

36. Jacob Arcadelt, *Il primo libro di madrigali a quatro* (Venice: Gardano, 1539).

37. Anneliese Maier, "Die Subjektivierung der Zeit in der scholastischen Philosophie," *Philosophia Naturalis* 1 (1950): 361–98.

38. Prosdocimus de Beldemandis, *Tractatus practice de musica mensurabili ad modum italicorum,* in E[dmond] de Coussemaker, *Scriptorum de musica medii aevi: Novam seriem a Gerbertina alteram colligit nuncque primum edidit* (Paris: Durand, 1869), 3:228–48, here 228.

39. Leon Battista Alberti, *De pictura,* in *Opere volgari,* vol. 3, ed. Cecil Grayson (Bari: Laterza and Figli, 1973), 11ff.

40. Charles E[dward] Hamm, "Manuscript Structure in the Dufay Era," *Acta Musicologica* 34 (1962): 166–84.

41. Trient, Museo provinciale d'arte, MS 1374, f. 86/95 and f. 85/96.

CHAPTER FOUR

1. London, British Library, MS RM 24.d.2; facsimile in Jessie Ann Owens, ed., *London, British Library RM 24.d.2,* Renaissance Music in Facscimile 8 (New York and London: Garland, 1987).

2. Scholarship has yet to offer a satisfying explanation of the singular case of the shared nominal identity of two genres separated by several centuries (madrigal). The question of how and in what ways the works of the fourteenth century were present or received around 1530 has not yet been systematically researched.

3. John Dunstable, *Complete Works,* ed. Manfred Bukofzer, 2nd rev. ed. by Margaret Bent et al., Musica Britannica 8 (London: Stainer and Bell, 1970), 119ff.

4. Martin Le Franc, *Le champion des dames,* vol. 4, ed. Robert Deschaux, Classiques Français du Moyen Age 130 (Paris: Champion, Geneva: Slatkine 1999), 68 (vv. 16265ff.); roughly translated as "For you have a new way of making unusual chords in the musica alta and bassa, in song, in pause, and in silence. And you have taken up the English concordance, and then Dunstable, with wonderful pleasure, made his song happy and noble."

5. Bartolomeo Ramos de Pareja, *Musica Practica* (Bologna: Baltasar de Hiriberia 1482); the connection between pulse and music is first discussed, not coincidentally, in the environs of the University of Padua, in the *Conciliator* (1303) of Pietro d'Abano.

6. Windsor, Eton College, MS 178.

7. Modena, Biblioteca estense universitaria, MS α.M.I.11 and 12; the anonymously transmitted pieces were likely by Johannes Martini and Johannes Brebis.

8. Modena, Biblioteca estense universitaria, MS αX.1.11.

9. Vatican City, Biblioteca Apostolica Vaticana, MS San Pietro B 80.

10. Munich, Bayerische Staatsbibliothek, Mus. MS B.

11. Zwickau, Ratsschulbibliothek, MS 69 1.57–62 (see note 28 in chapter 3).

12. Oxford, Bodleian Library, MS Canonici misc. 213, f. 129v/130r.

13. Basel, Unversitätsbibliothek, MS AG V 30, 208ff., here 238.

14. Erasmus von Rotterdam, *Novvm instrumentum omne, diligenter ab Erasmo Rotterodamo recognitum & emendatum, non solum ad graecam ueritatem, uerumetiam ad multorum utriusque linguae codicum, eorumque ueterum simul & emendatorum fidem, postremo ad porbatissimorum autorum citationem, emendationem & interpretationem praecipue [. . .], una cum Annotationibus, quae lectorem doceant, quid qua ratione mutatum sit* (Basel: Opporinus, 1516).

15. *Graduale de Santics, Iuxta ritum Sacrosanctae Romanae Ecclesiae. Cum Cantu. Pauli V. Pont. Max. iussu Reformato. Cum Privilegio* (Rome: Typographia Medicaea, 1614).

16. Cited in Adolf Aber, *Die Pflege der Musik unter den Wettinern und wettinischen Ernestinern: Von den Anfängen bis zur Auflösung der Weimarer Hofkappelle 1622,* Veröffentlichungen des Fürstlichen Instituts für musikwissenschaftliche Forschung Bückeburg 4, 1 (Bückeburg and Leipzig: Siegel, 1921), 83.

17. *Enchiridion Geistlicher leder vnde Psalmen vppet nye gecorrigeret. Sampt der Vesper Complet / Metten vnde Missen* (Magdeburg: Lotter, 1536).

18. Modena, Biblioteca estense universitaria, MS α.N. 1.1.

19. Naples, Biblioteca Nazionale Centrale, MS VI.E.40, f. 64r.

20. Nuremberg, Stadtbibliothek, Cod. Cent. VII 62, f. 114v ff., here f. 115r. Edition by Rudolf Denk, *Musica getutscht: Deutsche Fachprosa des Spätmittelalters im Bereich der Musik,* Münchener Texte und Untersuchungen zur deutschen Literatur des Mittelalters 69 (Munich and Zurich: Artemis, 1981), 50–53.

21. Pietro Aaron, *Libri tres de institutione harmonica* (Bologna: Hector, 1516); Aaron, *Thoscanello de la musica* (Venice: Vitali, 1523).

22. Michel de Menehou, *Novvelle intrvction familière en laquelle sont contenus les difficultés de la Musique, auecques le nombre des concordances, & accords: ensemble la manière d'en vser tant à deux, à trios, à quatre, qu'à cinq parties* (Paris: Du Chemin, 1558).

23. Aosta, Biblioteca del Seminario Maggiore, A1 D 19, f. 4v–7r.

24. Melchior Borchgrevink, ed., *Giardino Novo Bellissimo Di Varii Fiori Mvsicali Scieltissimi. Il Primo Libro de Madrigali A Cinque Voci* (Copenhagen: Waltkirch, 1605).

25. Innsbruck, Tiroler Landesarchiv, Kunstsachen 710, 1565, Nov, 16; reference to partial edition in Walter Senn, *Musik und Theater am Hof zu Innsbruck: Geschichte der Hofkapelle vom 15. Jahrhundert bis zu deren Auflösung im Jahre 1748, unter Verwertung von Vorarbeiten Lambert Streiter*s (Innsbruck: Österreichische Verlaganstalt, 1954), 73ff., here 73.

26. Cited in Martin Ruhnke, *Beiträge zu einer Geschichte der deutschen Hofmusikkollegien im 16. Jahrhundert* (Berlin: Meresburger, 1963), 206.

27. Employment decree for Johan Wesalius, November 11, 1572; cited in Martin Ruhnke, *Beiträge*, 206.

28. Cited in Sandberger, *Beiträge*, 311.

29. Certificate of installation for Thomas Mancinus on October 1, 1587; Wolfenbüttel, Niedersächsiches Staatsarchiv, L Alt Abt. 3 Gr. I Herzog Julius Nr. 51 Teil I, Bl. 38ff; published in Werner Flechsig, *Thomas Mancinus, der Vorgänger von Praetorius im Wolfenbütteler Kapellmeisteramt: Mit neuen Beiträgen zur Geschichte der Wolfenbütteler Hofkapelle im 16. Jahrhundert* (Wolfenbüttel: Kallmeyer, 1932), 38ff.

30. Lorenzo Ghiberti, *I commentariii (Biblioteca Nazionale di Firenze, II, I. 333)*, ed Lorenzo Bartoli, Biblioteca della Scienza Italiana 17 (Florence: Giunti, 1998), 48.

31. Cited in Otto Kade, "Biographisches zu Antonio Squarcialupi, dem Florentiner Organisten im XV. Jahrhundert," *Monatshefte für Musikgeschichte* 17.2 (1885): 1–7 and 13–19, here 4.

32. Hans Rosenplüt, *Der Spruch von Nürnberg, Beschreibendes Gedicht: Der ursprüngliche Text mit Erläuterungen [. . .]*, ed. Georg Wolfgang Karl Lochner (Nuremberg: Campe, 1854), 6, vv. 257ff. In the first edition (Nuremberg: Hoffmann, 1490) these passages about Paumann are not present.

33. Roberto da Sanseverino, 1472, to Galeazzo Maria Sforza; cited in Johannis Burckardi, *Liber notarum ab anno MCCCCLXXXIII usque ad annum MDVI*, ed. Enrico Celani, Rerum Italicarum Scriptores 32, 1 (Città di Castello: Lapi, 1907), 386.

34. Giorgio Vasari, *Le vite de' piv eccellenti pittori, scvltori e architettori. [. . .] Di nuouo dal medesimo riuiste et ampliate con I ritratti loro et con l'aggiunta delle vite de' viui, & de' morti dall'anno 1550 insino al 1567* (Florence: Giunti 1568), 468.

35. Kiel, Stadtarchiv, Copialbuch 5256, 311; cited in Heinrich W. Schwab, *Zur sozialen Stellung des Stadtmusikanten,* in *Der Sozialstatus des Berufsmusikers vom 17. bis 19. Jahrhundert,* ed. Walter Salmen, Musikwissenschaftliche Arbeiten 24 (Kassel: Bärenreiter, 1971), 9–25, here 19.

36. Sebastian Virdung, *Musica getutscht vnd außgezogen [. . .] vnd alles gesang auß den noten in die tabulaturen diser benanten dryer Instrumenten der Orgeln: der Lauten vnd der Flöten transferieren zu lernen [. . .]* (Basel: Furter, 1511), Bg. E. [I]r.

37. *Musica nova accomodata per cantar et sonar sopra organi, et altri strumenti, composta per diversi eccellentissimi musici* (Venice, 1540).

38. Virdung, *Musica getutscht*, Bg. [AIII]v.

39. Girolamo Baglioni, *Sacrarum cantionum, quae una, binis, ternis, quatuor, quinque, et sex vocibus concinuntur. Liber primus. Opus secundum* (Milan: Simoni and Lonati, 1608).

40. Guillaume Dufay, *Opera omnia*, vol. 6, *Cantiones*, ed. Heinrich Besseler, rev. David Fallows, Corpus Mensurabilis Musicae I, 6 (Neuhausen: Hänssler, 1995), 50.

41. Sophokles, *Edipo Tiranno. Tragedia. In lingua volgare ridotta dal Clariß. Signore Orsatto Giustiniano, Patritio Veneto. Et in Vicenza con contuossimimo apparato da quei Signori Academici recitata l'anno 1585* (Venice: Ziletti, 1585).

42. Andrea Gabrieli, *Chori in Musica. Sopra li Chori Della Tragedia di Edippo Tiranno. Recitati in Vicenza l'Anno M.D.LXXXV. Con solenisimo apparato, Et nouamente dati alle Stampe* (Venice: Gardano, 1588).

43. Johannes Mathesius, *Historien / Von des Ehewirdigen in Gott seligen theuren Manns Gottes / D. Martin Luthers / Anfang / Lere / Leben / Stand = hafft bekenntnuß seines Glaubens / und Sterben / Or = dentlich der Jarzal nach / wie sich solches alles habe zugetragen / Beschrieben [. . .]* (Nuremberg: Gerlach, 1573), 113.

44. Martin Agricola, *Musica Figuralis Deudsch* (Wittenberg: Rhau, 1532), Bg. BVv.

45. Caspar Othmayr, *Bicinia Sacra, Schöne geistliche Lieder vnnd Psalmen / mit zwo stimmen lieblich zu singen* (Nuremberg: Berg und Neuber, [ca. 1547]), dedicatory preface.

46. Johann Jacob Fugger to Antoine Perrenot de Granvelle, September 29, 1556; quoted in Ignace Bossuyt, "Lassos erste Jahre in München (1556–1559): Eine 'cosa non riuscita'?," in *Festschrift für Horst Leuchtmann zum 65. Geburtstag,* ed. Stephan Hörner and Bernhold Schmid (Tutzing: Schneider, 1993), 55–67, here 57.

47. Ferdinand II of Tyrol to Francesco della Torre, May 11, 1564; Innsbruck, Tiroler Landesarchiv, Hofregistratur, Chronologische Ambraser Akten, Kc. 1564 Nov. 5; quoted in Senn, *Musik und Theater am Hof zu Innsbruck,* 154.

CHAPTER FIVE

1. Johannes Ockeghem, *Mort tu as navré / Miserere pie,* in Johannes Ockeghem, *Collected Works,* ed. Richard Wexler (Philadelphia: American Musicological Society 1992), vol. 3:77ff, esp. LXXXIV ff.

2. Adriano Banchieri, *Conclvsioni nel svono dell'organo. Nouellamente tradotte, & Dilucidate, in Sctrittori Musici, & Organisti Cellebri. Opera vigesima. Alla gloriosa vergine et Martire Santa Cecilia Deuota de gli Musici, & Organisti. Dedicata* (Bologna: Rossi, 1609), 13.

3. Pedro Cerone, *El melopeo y maestro. Tractado de musica theorica y pratica: en que se pone por extenso, lo que vno para hazerse perfecto Musico ha menester saber: y por mayor facilidad, comodidad, y claridad del Lector, esta repartido en XXII. Libros [. . .]* (Naples: Gargano and Nucci, 1613), vol. 1:173.

4. *Las ensaladas de flecha [. . .] Recopiladas por F. Matheo Flecha su sobrino [. . .] con algunas suyas y de otros authores, por el mesmo corregidas y echas estampar* (Prague: Negrino, 1581).

5. Francesco Stivori, ed., *Il quinto libro di madrigali, del cavaliero Paolo Bellasio* (Verona: Dalle Donne, 1595).

6. Giovanni Andrea Dragoni, *Motectorum Io. Andrea Draconis in Basilica Lateranensi chori magistri quae quinque vocibus concinuntur, super omnia fere festa sanctorum, tres in partes divisa, quarum quaelibet continet festa quatuor mensium. Liber primus* (Rome: Muzi, 1600).

7. Quoted in Johann Baptist Götz, *Die Grabsteine der Ingolstädter Frauenkirche (1428–1829)* (Ingolstadt: Ganghofer, 1925), 49.

8. Quoted in Carl Philipp Reinhardt, *Die Heidelberger Liedmeister des 16. Jahrhunderts* (Kassel: Bärenreiter, 1939), 49.

9. Text from the funeral monument with a picture in Josef Mantuani, *Die Musik in Wien: Von der Römerzeit bis zur Zeit Kaiser Max. I*, in *Geschichte der Stadt Wien*, vol. 3, *Von der Zeit der Landefürsten aus Habsburgischem Hause bis zum Ausgange des Mittelalters*, vol. I, I (Vienna, 1907), 117–458, 384ff.

10. I wish to thank Margaret Bent for her insights into the late transmission of Ciconia.

11. Niccolò Machiavelli, *Il principe* (Rome: Blado, 1532), 42.

12. *Ecclesiastica Historia, integram Ecclesiae Christi ideam [. . .] secundum singulas Centurias, perspicuo ordine complectens: singulari diligentia & fide ex uetustissimis &optimis historicis, patribus, & alijs scriptoribus congesta: Per aliquot studiosos & pios uiros in urbe Magdeburgica* [vol. 1] (Basel: Oporinus, 1559).

13. Heinrich Glarean, *Dodekachordon* (Basel: Petri, 1547), 441.

14. Johannes Manlius, *Locorum communium collectanea. In Qvibus Varia, Non solùm uetera, sed in primis recentia nostri temporis Exempla, Similitudiens, Sententiae, Co[n]similia continentur [. . .]* (Basel: Oporinus, 1563), 93.

15. Glarean, *Dodekachordon*, 113.

16. Martin Luther, January 1, 1537, in Martin Luther, *Werke: Kritische Gesamtausgabe, Tischreden*, vol. 3 (Weimar: Böhlau, 1914), 371 (No. 3516).

17. Martin Luther, prior to December 14, 1531, in Martin Luther, *Werke: Kritische Gesamtausgabe, Tischreden*, vol. 2 (Weimar: Böhlau, 1913), 11ff. (No. 1258).

18. Johann Ott, ed., *Novum et insigne opus musicum* (Nuremberg: Graphaeus, 1537), preface.

19. Giovanni del Lago, August 23, 1532, to Giovanni Spataro; quoted in Bonnie Blackburn et al., eds., *A Correspondence of Renaissance Musicians* (Oxford: Clarendon, 1991), 498.

20. Cosimo Bartoli, *Ragionamenti accademici sopra alcuni luoghi difficili di Dante. Con alcuni inventioni & significanti, & la Tavola di piu cose notabili* (Venice: Franscheschi, 1567), Bg. 35v.

21. Hermann Finck, *Practica musica* (Wittenberg: Rhau, 1556), Bg. Aijr.

22. Philipp Melanchthon, *Initia doctrinae physicae, dictata in Academia Vuitebergensi* (Wittenberg: Lufft, 1549); I thank Rob Wegman of Princeton University for advising me of this.

23. William Byrd, *Ye sacred muses*, in *The Collected Works of William Byrd*, ed. Edmund H. Fellowes, vol. 15, *Songs* (London: Stainer and Bell, 1948), 141–46, here 145ff.

24. August Wilhelm Ambros, *Geschichte der Musik im Zeitalter der Renaissance bis zu Palestrina*, vol. 3 of *Geschichte der Musik* (Breslau: Leuckart, 1868), 6.

25. Giulio Caccini, *L'Euridice. Composta in mvsica. In Stile Rappresentatiuo* (Florence: Marescotti, 1600), Bg. [A2] r.: "gli antichi Greci nel rappresentare le loro Tragedie."

26. Vincenzo Galilei, *Dialogo della mvsica antica, et della moderna* (Florence: Marescotti, 1581).

27. Vincenzo Galilei, *Fronimo. Diaologo, nel quale si contegnono le vere, et necessarie regole del Intauolare la Musica nel Liuto* (Venice: Scotto, 1568).

28. Ibid., 61; in the 1584 edition, 117.

29. Lodovico Angostini Ferrarese, *Il nvovo echo à cinque voci. Libro terzo, Opera Decima* (Ferrara: Baldini, 1583), No. 11.

30. Giovanni Battisti Doni, *Compendio del trattato de' generi e de' modi della mvsica. Con vn discorso sopra la perfettione de' concenti. Et vn saggio a due voci di mutationi di genere, e di tuono in tre maniere d'intauolatura: e d'vn principio di madrigale del principle, ridotto nella medesima intauolatura* (Rome: Fei, 1635), 121.

31. Adrian Willaert, *Musica Nova* (Venice: Gardano, 1559), Bg. Aiir.

32. Giulio Caccini, *Le nvove musiche* (Florence: Marescotti 1601; appeared in 1602).

33. Ibid., Bg. Aiv.

34. Ibid., Bg. Br.

35. Ibid., Bg. Aiv.

36. Giacomo Moro, *Quarto libro de' concerti ecclesiastici a una, a due, et a Quattro voci: per cantar nel organo con la sua partitura corrente a commodi de gli organisti* (Venice: Vincenti, 1610), Bg. B2v.

37. *A Book of Ayres, Set foorth to be song to the lute, Orpherian, and Base Viol, by Philip Rosseter Lutenist [. . .]* (London: Short, 1601), here the preface "To the Reader."

38. Vincenzo Galilei, *Il primo libro della prattica de Contrapunto* (Florence: Biblioteca Nazionale Centrale); MSS Galileiani, Anteriori a Galileo II, f. 55r–103v (one of three versions), here f. 100v; quoted from the edition by Frieder Rempp, *Die Kontrapunkttraktate Vincenzo Galileis,* Veröffentlichungen des Staatlichen Instituts für Musikforschung Preußischer Kulturbesitz 9 (Cologne: Volk, 1980), 73.

BIBLIOGRAPHY

In the last decades of the twentieth century, research on Renaissance music has expanded exponentially. The following bibliography offers only a small sample of significant works that are especially relevant to the discussions and arguments of this book. Monographs on individual composers are not included nor are catalogues and critical editions of works. Reference articles in the encyclopedia *Die Musik in Geschichte und Gegenwart* (completed in 2008 and now online) offer excellent overviews of these figures along with detailed bibliographies and work indices.

GENERAL

Ambros, August Wilhelm. *Geschichte der Musik im Zeitalter der Renaissance bis zu Palestrina*. Vol. 3 of *Geschichte der Musik*. Breslau, 1868.

Baron, Hans. *The Crisis of the Early Italian Renaissance*. Princeton, 1955.

Besseler, Heinrich. *Bourdon und Fauxbourdon—Studien zum Ursprung der niederländischen Musik*. Leipzig, 1950.

———. *Die Musik des Mittelalters und der Renaissance*. Handbuch der Musikwissenschaft [2]. Potsdam, 1931.

Blume, Friedrich. "Art 'Renaissance.'" In *Die Musik in Geschichte und Gegenwart* 11 (1963), 224–91 (bibliography by Wilhelm Pfannkuch).

Brown, Howard Mayer. *Music in the Renaissance*. Englewood Cliffs, NJ, 1976.

Buck, August, ed. *Zu Begriff und Problem der Renaissance*. Wege der Forschung 204. Darmstadt, 1969.

Bukofzer, Manfred F. *Studies in Medieval and Renaissance Music*. New York, 1950.

Burckhardt, Jacob. *Die Cultur der Renaissance in Italien: Ein Versuch*. Basel, 1860.

Burke, Peter. *Culture and Society in Renaissance Italy*. 1st ed. London, 1972.

———. *The Historical Anthropology of Early Modern Italy*. Cambridge, 1987.

———. *The Renaissance*. London, 1987.

Cassirer, Ernst. "Some Remarks on the Question of the Originality of the Renaissance." *Journal of the History of Ideas* 4 (1943): 59–56.

Ferguson, Wallace K. *The Renaissance in Historical Thought: Five Centuries of Interpretation.* Boston, 1948.

Finscher, Ludwig, ed. *Die Musik des 15. und 16. Jahrhunderts.* 2 vols. Neues Handbuch der Musikwissenschaft 3. Laaber, 1989–90.

Gallico, Claudio. *L'età dell' Umanesimo e del Rinascimento.* Storia della Musica 3. Turin, 1978.

Gallo, F. Alberto. *Il Medioevo II.* Storia della Musica 2. Turin, 1977.

Hughes, Anselm, and Gerald Abraham. *Ars Nova and the Renaissance.* New Oxford History of Music 3. London, 1960.

Huizinga, Johan. *Das Problem der Renaissance.* In *Wege der Kulturgeschichte: Studien,* 89–139. Munich, 1930. Originally published in *De Gids* (1920).

———. *Herfsttij der middeleeuwen: Studie over levens- en gedachtenvormen der vertiende en vijftiende eeuw in Frankrijk en de Nederlanden.* Haarlem, 1919.

Kablitz, Andreas, and Gerhard Regn, eds. *Renaissance—Episteme und Agon: Für Klaus W. Hempfer anläßlich seines 60. Geburtstages.* Neues Forum für allgemeine und vergleichende Literaturwissenschaft 33. Heidelberg, 2006.

Lockwood, Lewis. "Renaissance." In *New Grove Dictionary of Music and Musicians* 15 (1980), 736–41.

Lütteken, Laurenz. "Renaissance." In *Die Musik in Geschichte und Gegenwart,* 2nd ed., vol. 8 (1998), 143–56.

Martin, Alfred von. *Soziologie der Renaissance: Zur Physiognomik und Rhythmik bürgerlicher Kultur.* Stuttgart, 1932.

Michelet, Jules. *Histoire de la France au XVIe siècle.* Vol. 7, *Renaissance.* Paris, 1855.

Nauert, Charles G. *Humanism and the Culture of Renaissance Europe.* New Approaches to European History 6. Cambridge, 1995.

Owens, Jessie Ann. "Music Historiography and the Definition of 'Renaissance.'" *Notes* 47 (1990): 305–30.

Reese, Gustave. *Music of the Renaissance.* New York, 1954.

Schrade, Leo. "Renaissance: The Historical Conception of an Epoch." In *Internationale Gesellschaft für Musikwissenschaft, Fünfter Kongress, Utrecht, 3.–7. Juli 1952, Kongressbericht,* 19–32. Amsterdam, 1953.

Stierle, Karlheinz. "Renaissance: Die Entstehung eines Epochenbegriffs aus dem Geist des 19. Jahrhunderts." In *Epochenschwelle und Epochenbewusstsein,* ed. Reinhart Herzog and Reinhart Koselleck, 453–92. Poetik und Hermeneutik 12. Munich, 1987.

Strohm, Reinhard. *The Rise of European Music, 1380–1500.* Cambridge, 1993.

Voigt, Georg. *Wiederbelebung des classischen Alterthums oder das erste Jahrhundert des Humanismus.* 2 vols. Berlin, 1859.

SPECIALIZED STUDIES

Baxandall, Michael. *Painting and Experience in Fifteenth-Century Italy.* Oxford, 1972.

Bent, Margaret. "'Sounds perish': In What Senses Does Renaissance Music Sur-
vive?" In *The Italian Renaissance in the Twentieth Century: Acts of an Interna-
tional Conference, Florence, Villa I Tatti, June 9–11, 1999,* ed. Allen J. Grieco et al.,
247–65. Florence, 2002.

Besseler, Heinrich. "Das Renaissanceproblem in der Musik." *Archiv für Musikwis-
senschaft* 23 (1966): 1–10.

Bridgman, Nanie. *La vie musicale au quattrocento et jusqu'à la naissance du madrigal
(1400–1530).* Paris, 1964.

Brinkmann, Brigitte. *Varietas und Veritas: Normen und Normativität in der Zeit
der Renaissance; Castigliones "Libro del Cortegiano."* Theorie und Geschichte der
Literatur und der schönen Künste 103. Munich, 2001.

Brucker, Gene. *Renaissance Florence.* New Dimensions in History: Historical Cities.
New York, 1969.

Buck, August. *Das Geschichtsdenken der Renaissance.* Schriften und Vorträge des
Petrarca-Instituts Köln. Krefeld, 1957.

———. *Italienische Dichtungslehren vom Mittelalter bis zum Ausgang der Renais-
sance.* Beihefte zur Zeitschrift für Romanische Philologie 94. Tübingen, 1952.

Busse Berger, Anna Maria, and Massimiliano Rossi, eds. *Memory and Invention:
Medieval and Renaissance Literature, Art and Music; Acts of an International
Conference, Florence, Villa I Tatti, May 11, 2006.* Florence, 2009.

Cassirer, Ernst. *Individuum und Kosmos in der Philosophie der Renaissance.* Leipzig
and Berlin, 1927.

Collins Judd, Cristle. *Reading Renaissance Music Theory: Hearing with the Eyes.*
Cambridge Studies in Music Theory and Analysis 14. Cambridge, 2002.

De Grazia, Margareta, ed. *Subject and Object in Renaissance Culture.* Cambridge
Studies in Renaissance Literature and Culture 8. Cambridge, 1996.

Ellefsen, Roy Martin. "Music and Humanism in the Early Renaissance: Their Rela-
tionship and Its Roots in the Rhetorical and Philosophical Traditions." PhD
diss., Florida State University, 1981.

Fenlon, Iain, ed. *Music in Medieval and Early Modern Europe: Patronage, Sources,
and Texts.* Cambridge, 1981.

Finscher, Ludwig. "Was heißt und zu welchem Ende studiert man musikalische
Gattungsgeschichte." In *Passagen: IMS Kongress Zürich 2007; Fünf Hauptvor-
träge/Five Keynote Speeches,* ed. Laurenz Lütteken and Hans-Joachim Hinrich-
sen, 21–37. Kassel, 2008.

Gombrich, Ernst H. *Norm and Form: Studies in the Art of the Renaissance.* Oxford,
1966.

Gosebruch, Martin. "Varietà bei Leon Battista Alberti und der wissenschaftliche
Renaissancebegriff." *Zeitschrift für Kunstgeschichte* 20 (1957): 233–35.

Guidobaldi, Nicoletta. *La musica di Federico: Immagini e suoni alla corte di Urbino.*
Florence, 1995.

Holmes, George. *Florence, Rome, and the Origins of Renaissance.* Oxford, 1986.

Hortschansky, Klaus. "Musikwissenschaft und Bedeutungsforschung: Überlegun-
gen zu einer Heuristik im Bereich der Musik der Renaissance." In *Zeichen und*

Struktur in der Musik der Renaissance: Ein Symposium aus Anlaß der Jahresta-
gung der Gesellschaft für Musikforschung Münster (Westfalen) 1987; Bericht,
65–86. Musikwissenschaftliche Arbeiten 28. Kassel, 1989.

Kaden, Christian. "Abschied von der Harmonie der Welt: Zur Genese des neuzeitli-
chen Musik-Begriffs." In *Gesellschaft und Musik: Wege zur Musiksoziologie,* ed.
Wolfgang Lipp, 27–53. Sociologia Internationalis, Beiheft 1. Berlin, 1992.

Kempers, Bram. "Kunst, macht en mecenaat." PhD diss., University of Amsterdam,
1987.

Kent, Francis William, and Patricia Simons, eds. *Patronage, Art, and Society in*
Renaissance Italy. Oxford, 1987.

Kristeller, Paul Oskar. *Humanismus und Renaissance.* Vol. 2, *Philosophie, Bildung*
und Kunst. Ed. Eckart Keßler. Humanistische Bibliothek I, vol. 22. Munich,
1976.

Lodes, Birgit, and Laurenz Lütteken, eds. *Institutionalisierung als Prozess—Organi-*
sationsformen musikalischer Eliten im Europa des 15. und 16. Jahrhunderts; Bei-
träge des internationalen Arbeitsgesprächs im Istituto Svizzero di Roma in Verbind-
ung mit dem Deutschen Historischen Institut in Rom, 9.–11. Dezember 2005.
Analecta Musicologica 43. Laaber, 2009.

Lytle, Guy Fitch, and Stephen Orgel, eds. *Patronage in the Renaissance.* Princeton,
1981.

Martines, Lauro. *The Social World of the Florentine Humanists.* Princeton, 1963.

Palisca, Claude V. *Humanism in Italian Renaissance Musical Thought.* New Haven,
1985.

Panofsky, Erwin. *Idea: Ein Beitrag zur Begriffsgeschichte der älteren Kunsttheorie.*
Studien der Bibliothek Warburg 5. Leipzig and Berlin, 1924.

———. *Renaissance and Renascences in Western Art.* 2 vols. Figura 10. Uppsala,
1960.

Perpeet, Wilhelm. *Das Kunstschöne: Sein Ursprung in der italienischen Renaissance.*
Orbis Academicus, Sonderband 7. Freiburg and Munich, 1987.

Quinones, Riccardo J. *The Renaissance Discovery of Time.* Cambridge, 1972.

Rudolph, Enno, ed. *Die Renaissance und die Entdeckung des Individuums in der*
Kunst. Vol. 2 of *Die Renaissance als erste Aufklärung.* Religion und Aufklärung 2.
Tübingen, 1998.

Strohm, Reinhard. *Guillaume Dufay, Martin Le Franc und die humanistische Leg-*
ende der Musik. Neujahrsblätter der Allgemeinen Musikgesellschaft Zürich 192.
Winterthur, 2007.

———. "Neue Aspekte von Musik und Humanismus im 15. Jahrhundert." *Acta*
Musicologica 76 (2004): 135–57.

Taruskin, Richard. *The Oxford History of Western Music.* Vol. 1, *The Earliest Nota-*
tions to the Sixteenth Century. Oxford, 2005.

Tomlinson, Gary. *Music in Renaissance Magic: Toward a Historiography of Others.*
Chicago and London, 1993.

Van Tieghem, Paul. *La littérature latine de la Renaissance: Étude d'histoire littéraire*
européenne. Geneva, 1943.

Vendrix, Philippe, ed. *Music and Mathematics in Late Medieval and Early Modern Europe.* Collection Epitome Musical 13. Turnhout, 2008.

Wackernagel, Martin. *Der Lebensraum des Künstlers in der florentinischen Renaissance.* Leipzig, 1938.

Warburg, Aby. *Sandro Botticellis "Geburt der Venus" und "Frühling": Eine Untersuchung über die Vorstellungen von der Antike in der italienischen Frührenaissance.* Hamburg and Leipzig, 1893.

Warnke, Martin. *Hofkünstler: Zur Vorgeschichte des modernen Künstlers.* Cologne, 1985.

Wegman, Rob. *The Crisis of Music in Early Modern Europe, 1470–1530.* New York, 2005.

Wind, Edgar. *Pagan Mysteries in the Renaissance.* London, 1958.

Wittkower, Rudolf. *Architectural Principles in the Age of Humanism.* London, 1949.

Wunenburger, Jean-Jacques, ed. *La Renaissance ou l'invention d'un espace: Figures libres.* Dijon, 2000.

MUSICOLOGICAL CASE STUDIES

Bent, Margaret. "Music and the Early Veneto Humanists." *Proceedings of the British Academy* 101 (1999): 101–30.

Blackburn, Bonnie J. "On Compositional Process in the Fifteenth Century." *Journal of the American Musicological Society* 40 (1987): 210–84.

Borghi, Renato, and Pietro Zappalà, eds. *L'edizione critica tra testo musicale e testo letterario: Atti del convegno internazionale (Cremona, 4–8 Ottobre 1992).* Studi e Testi Musicale, Nuova Serie 3. Lucca, 1995.

Busse Berger, Anna Maria. "Musical Proportions and Arithmetic in Late Middle Ages and Renaissance." *Musica Disciplina* 44 (1990): 89–118.

Dahlhaus, Carl. *Untersuchungen über die Entstehung der harmonischen Tonalität.* Saarbrücker Studien zur Musikwissenschaft 2. Kassel, 1968.

Drake, Stillman. "Renaissance Music and Experimental Science." *Journal of the History of Ideas* 31 (1970): 483–500.

Einstein, Alfred. *The Italian Madrigal.* 3 vols. Princeton, 1949.

Elders, Willem. "Humanism and Early Renaissance Music: A Study of the Ceremonial Music by Ciconia and Dufay." *Tijdschrift van der Vereniging voor Nederlands Muziekgeschiedenis* 27 (1977): 65–101.

———. *Symbolic Scores: Studies in the Music of the Renaissance.* Symbola et Emblemata 5. Leiden, 1994.

Feldman, Martha. *City Culture and the Madrigal at Venice.* Berkeley, 1995.

Finscher, Ludwig. "Die 'Entstehung des Komponisten': Zum Problem Komponisten-Individualität und Individualstil in der Musik des 14. Jahrhunderts." *International Review of the Aesthetics and Sociology of Music* 6 (1975): 29–45.

———. "Von Josquin zu Willaert—ein Paradigmenwechsel." In *Festschrift Georg Knepler,* ed. Hanns-Werner Heister, vol. 1:145–73. Hamburg, 1997.

Gallo, F. Alberto. "Die Kenntnis der griechischen Theoretikerquellen in der italienischen Renaissance." *Geschichte der Musiktheorie* 7 (1989): 7–38.

Groos, Ulrike. *"Ars musica" in Venedig im 16. Jahrhundert*. Studien zur Kunstgeschichte 108. Hildesheim, 1996.

Gülke, Peter. *Guillaume Dufay: Musik des 15. Jahrhunderts*. Stuttgart and Kassel, 2003.

Haar, James. *The Science and Art of Renaissance Music*. Ed. Paul Corneilson. Princeton, 1998.

Hamm, Charles. "Manuscript Structure in the Dufay Era." *Acta Musicologica* 34 (1962): 166–84.

Harràn, Don. *In Search of Harmony: Hebrew and Humanist Elements in Sixteenth-Century Musical Thought*. Musicological Studies and Documents 42. Neuhausen-Stuttgart, 1988.

Kahl, Willi. "Das Geschichtsbewußtsein in der Musikanschauung der italienischen Renaissance und des deutschen Humanismus." In *Gedenkschrift Hans Albrecht,* ed. Winfried Brennecke and Hans Haase, 39–47. Kassel, 1962.

LaRue, Jan, ed. *Aspects of Medieval and Renaissance Music: A Birthday Offering to Gustave Reese*. New York, 1966.

Lockwood, Lewis. *Music in Renaissance Ferrara, 1400–1505: The Creation of a Musical Centre in the Fifteenth Century*. Oxford, 1984.

Lowinsky, Edward E. "Music of the Renaissance as Viewed by Renaissance Musicians." In *The Renaissance Image of Man and World,* ed. Bernard O'Kelly, 129–77. Columbus, 1966.

Lütteken, Laurenz. "Padua und die Entstehung des musikalischen Textes." *Marburger Jahrbuch für Kunstwissenschaft* 24 (1997): 25–39.

Niemöller, Klaus W. *Untersuchungen zu Musikpflege und Musikunterricht an den deutschen Lateinschulen vom ausgehenden Mittelalter bis um 1600*. Kölner Beiträge zur Musikforschung 54. Regensburg, 1969.

Owens, Jessie Ann. *Composers at Work: The Craft of Musical Composition, 1450–1600*. New York and Oxford 1997.

Pöhlmann, Egert. "Antikenverständnis und Antikenmißverständnis in der Operntheorie der Florentiner Camerata." *Die Musikforschung* 22 (1969): 5–13.

Reckow, Fritz. "Rectitudo—pulchritudo—enormitas: Spätmittelalterliche Erwägungen zum Verhältnis von materia und cantus." In *Musik und Text in der Mehrstimmigkeit des 14. und 15. Jahrhunderts: Vorträge des Gastsymposions in der Herzog August Bibliothek Wolfenbüttel 8. bis 12. September 1980,* ed. Ludwig Finscher and Ursula Günther, 1–36. Göttinger Musikwissenschaftliche Arbeiten 10. Kassel, 1984.

Schmidt, Lothar. *Die römische Lauda und die Verchristlichung von Musik im 16. Jahrhundert*. Schweizer Beiträge zur Musikforschung 2. Kassel, 2003.

Sherr, Richard, ed. *Papal Music and Musicians in Late Medieval and Renaissance Rome*. Oxford, 1998.

Starr, Pamela F. "The 'Ferrara Connection': A Case of Musical Recruitment in the Renaissance." *Studi Musicali* 18 (1989): 3–16.

Strohm, Reinhard. "European Politics and the Distribution of Music in the Early Fifteenth Century." *Early Music History* 1 (1981): 305–23.

Wegman, Rob C. "From Maker to Composer: Improvisation and Musical Authorship in the Low Countries, 1450–1500." *Journal of the American Musicological Society* 49 (1996): 409–79.

INDEX

Schedel, Hartman, 137
Schiller, Friedrich von, 180
Schlick, Arnolt, 88, 149
Schrade, Leo, 10
Schütz, Heinrich, 64, 112
Schuyt, Cornelius, 143
Seld, Georg Sigmund, 110
Seneca, 42
Senfl, Ludwig, 41, 61, 64, 71, 76, 81, 101
Serafino de' Ciminelli dall'Aquila, 27,
 143
Sforza (Family), 35
Sforza, Ascanio Maria, 27
Sforza, Costanzo I, 174, 175fig.
Sforza Galeazzo Maria, Duke of Milan, 60,
 80, 150
Sigismund, Emperor, 33, 100
Signorelli, Luca, 44, 45fig.
Simon VI, Count of Lippe, 78, 80
Sixtus IV, Pope, 58, 80
Slatkonia, Georg, 66, 79, 164
Sophocles, 156, 177
Spataro, Giovanni, 51, 85
Spranger, Bartholomäus, 167
Stoltzer, Thomas, 81, 92, 111, 138
Striggio, Alessandro, 179
Strohm, Reinhard, xiii
Strozzi, Piero, 176–177, 182,
Squarcialupi, Antonio, 89, 98, 148, 164,
 202n8

Tallis, Thomas, 25, 79, 151, 173
Tansillo, Luigi, 103
Tasso, Torquato, 180
Terbrugghen, Hendrick, 185, 186fig.
Theoderic the Great, King of the
 Ostrogoths, 13
Tinctoris, Johannes, 39–40, 49–50, 84, 97,
 147, 165, 167–168, 204n22
Tintoretto (Jacopo Robusti), 130, 150–152
Titian (Tiziano Vecellio), 52, 54fig., 130,
 201n3
Tritonius, Petrus, 41
Tromboncino, Bartolomeo, 128

Ulrich, Duke of Württemberg, 135
Ulrich von Etzenbach, 14
Ulrich von Richenthal, 6, 15, 200n15
Urban VIII, Pope, 180

Vaet, Jacobus, 110
Valente, Antonio, 149
Valla Lorenzo, 4, 58, 126, 148
Vanneo, Stefano, 44, 52, 53fig.
Varèse, Edgard, 123
Vasari, Giorgio, 51, 65, 69, 119, 150, 181, 183
Vecchi, Orazio, 112, 179
Verdelot, Philippe, 20, 63, 151, 161
Veronese, Paolo, 130
Vicentino, Nicola, 177
Victoria, Tomás Luis de, 75
Vinci, Leonardo da, 51, 124, 179
Vinders, Hieronymus, 161
Viola, Francesco, 181
Virdung, Sebastian, 150–151
Virgil, 20, 42–45, 141, 169
Vitruvius, 148
Vitry, Philippe de, 49, 62, 66

Waldburg, Otto Truchseß von, 85
Waldeysen, Leonhard, 164
Walter, Johann, 59
Warburg, Aby, 112
Warnke, Martin, 14
Weelkes, Thomas, 143
Wesalius, Johann, 145
Wilhelm IV, Duke of Bavaria, 61
Wilhelm V, Duke of Bavaria, 146
Willaert, Adrian, 24, 60, 69, 70fig., 76, 82,
 99, 108, 129, 137, 145, 161, 165, 167, 172,
 178, 181–182
Wollick, Nicolaus, 86, 203n7

Žak, Sabine, 14
Zarlino, Gioseffo, 85, 140, 165, 167, 177,
 204n30
Zedler, Johann Heinrich, 63
Zoilo, Annibale, 23fig., 73, 193
Zwingli, Ulrich, 31